IR

OGY

FROM THE AIR

UNDERSTANDING AERIAL ARCHAEOLOGY

KENNETH BROPHY AND **DAVID COWLEY**

TEMPUS 2005

This volume is dedicated to Gordon Maxwell. As the pioneer of aerial survey at RCAHMS he has had a dramatic impact on the archaeological record in Scotland across a number of different fields, most notably Roman Scotland. He is responsible for the identification of many new types of site amongst the cropmarks and has played a pivotal role in putting in place the building blocks of so much of our understanding of the archaeology of lowland Scotland. He has also fostered and trained many other workers, ourselves included. A simple query of Gordon would so often (usually!) end up as a master class in aerial photographic interpretation, where the points raised by way of digression and amplification alone enriched your experience and knowledge of the material – shared as ever with enthusiasm and kindness.

His impact on the editors, within and beyond RCAHMS, made this volume possible.

Kenneth Brophy and David Cowley, January 2005

First published 2005

Tempus Publishing Limited
The Mill, Brimscombe Port,
Stroud, Gloucestershire, GL5 2QG
www.tempus-publishing.com

British Library Cataloguing in Publication Data.
A catalogue record for this book is available from the British Library.

ISBN 0 7524 3130 7

Typesetting and origination by Tempus Publishing Limited
Printed in Great Britain

CONTENTS

CONTRIBUTORS

Dr Andrew Baines is a freelance archaeologist. He has worked throughout Scotland on both commercial and research projects, and has published on various aspects of Scottish prehistory and archaeological theory. Research interests include the prehistory of northern mainland Scotland, the relationship between prehistoric monuments and landscape on Arran, the role of classification in archaeological interpretation and the relationship between practice and theory in archaeology.

Dr Kenneth Brophy is a lecturer in archaeology at the Department of Archaeology, University of Glasgow. He has previously worked for the Royal Commission on the Ancient and Historical Monuments of Scotland (RCAHMS) as aerial photographic liaison officer, and has several years experience of both aerial reconnaissance and air photo interpretation. His research interests include the British Neolithic and later prehistory, archaeological theory and aerial photography; and he has excavated several cropmark sites.

David Cowley is an archaeologist with RCAHMS and has been undertaking field survey across Scotland since 1989. He is also involved in a range of activities for the RCAHMS aerial survey programme, including reconnaissance, interpretation and publication of the results. His research interests include archaeological landscapes, Iron Age settlement and the analysis of aspects of aerial reconnaissance and interpretation.

Tim Gates is a freelance archaeologist specialising in air photographic interpretation and aerial photography, his work concentrating on north-east England. He has made a major contribution to the recording of upland landscapes through his aerial photography, especially in Northumberland.

Dr Simon Gilmour is currently the oblique aerial photographic curator at RCAHMS. His main interest is in the Iron Age archaeology of Europe, and particularly the Western Seaways in the first millennia BC and AD, a subject that he researched for his doctoral thesis.

W.S. Hanson is Professor of Roman Archaeology and Head of the Department of Archaeology at the University of Glasgow. His main research interests are Roman

Britain, Roman frontiers, and archaeological aerial photography. His current research projects include: the report on the complete excavation of a first century AD timber-built Roman auxiliary fort near Edinburgh; a book on the expansion of the Roman Empire; the report on a long-term aerial photographic and fieldwork project in the Upper Clyde Valley; and completion of a programme of aerial reconnaissance in western Transylvania, Romania. He teaches a postgraduate course on aerial photography and geophysical survey in archaeology, which is unique in Europe.

Rebecca H. Jones is an archaeologist at RCAHMS and has also worked for the Board of Celtic Studies, University of Wales. Her research interests centre on the temporary encampments of the Roman army in Britain, particularly in the frontier zones of Wales and Scotland.

Gordon S. Maxwell served as an investigator with RCAHMS from 1964, specialising in the recording of Iron Age and Roman monuments, as well as air photographic interpretation, for the Inventory surveys of Lanarkshire and Argyll. The Commission's aerial survey programme commenced under his direction in 1976, his official flying duties continuing until 1998, although he retired (as Head of Archaeology) in 1995. A decade later, he is still possessed (literally and metaphorically) of the aerial perspective.

Jessica Mills is a final year PhD student in the Department of Archaeology, Cardiff University. Her doctoral research focuses upon Neolithic and Bronze Age mobility in the East Midlands and East Anglia. She is an active participant in the Aerial Archaeology Research Group, and is also engaged in research concerning the aerial detection of archaeological sites on clay geologies.

Matthew Oakey studied Archaeology at Liverpool University and has completed an MPhil thesis on analysing bias in past programmes of aerial survey. He now works as an Aerial Survey Investigator with West Yorkshire Archaeology Service and has three years experience working on various National Mapping Programme projects in the north of England with English Heritage.

Rog Palmer discovered his interest in archaeology while studying engineering at Farnborough in the 1960s. A move to London (with hopes of becoming a jazz musician) led to five years of employment in the newly created Air Photo Unit in the Royal Commission on the Historical Monuments of England, where he was involved in developing methods for transforming and mapping air photos. This interest was later pursued at Cambridge where he took a degree in archaeology and continued as a research student. Rog now runs his own business, Air Photo Services Cambridge, to interpret air photos and prepare maps of archaeological and other features at sites threatened by development. He is a member of the AARG Committee, editor of the group's newsletter and a tutor

in its teaching activities in Europe. A current research project, part-funded by the British Academy, is to help establish aerial survey in Armenia.

Dr hab. Włodzimierz (Włodek) Rączkowski, a graduate of both history and archaeology, is a lecturer at the Institute of Prehistory, Adam Mickiewicz University of Poznań (Poland). His main research interests are archaeological theory, settlement pattern studies and aerial archaeology. He has excavated several sites in north Poland (Pomerania) ranging in date from the Neolithic to the Early Middle Ages. His current projects include the protection of archaeological landscapes in central Pomerania and the aerial survey, interpretation and mapping of central and western Poland and, more generally, the Baltic Sea region.

David Wilson learnt his archaeology as a schoolboy volunteer on the post-war Canterbury excavations under Sheppard Frere. Later, he was successively Scholar and then Fellow of the British Institute of Archaeology at Ankara when researching the Historical Geography of Bithynia, Paphlagonia and Pontus. As research assistant to Professor Ian Richmond at Oxford, he both took over the annual summary of 'Sites explored in Roman Britain' (*Britannia*) and helped Richmond with his revision of Collingwood's *Archaeology of Roman Britain* (which he saw through the press on Richmond's death). From 1965 until retirement in 1998 he was engaged in aerial photography at Cambridge, first as assistant to Dr J.K. St Joseph, then as his successor. His book on *Air Photo Interpretation for Archaeologists* (second edition, 2000, Tempus) is the standard English-language work on this subject in Europe. He has published numerous papers on Roman archaeology and on aerial archaeology.

Aerial Archaeology Research Group (AARG)

All of the contributors to this volume are members of AARG and many of the issues that are addressed here have been the subject to both formal and informal debate at AARG meetings over the years.

More generally, AARG provides an international forum for the exchange of ideas and information for all those actively involved in aerial photography, photo interpretation, field archaeology and landscape history. Formed in 1980, AARG has become increasingly active in projects designed to reach a wider audience of archaeologists and those engaged in the management of cultural and heritage resources. With membership worldwide, and recent involvement in European aerial archaeology training courses, AARG provides opportunities for the establishment of new networks for the exchange of skills and ideas. AARG keeps in touch with its members through its biannual newsletter, regularly updated homepage and annual conference. By joining this group you can keep in touch with, and contribute to, the latest news and developments in this important subject.
http://aarg.univie.ac.at

ACKNOWLEDGEMENTS

The editors are grateful to RCAHMS and AARG for supporting this volume.

RCAHMS has supported the project, providing illustrative material and has always proved a stimulating environment as a workplace, which has done much to foster our interests in aerial archaeology. The RCAHMS database, Canmore, is available online (www.rcahms.gov.uk) and contains the results of nearly 30 years of aerial survey. Selected images, including many aerial photographs, are also available online through the database.

AARG has provided a valuable forum for the flow of ideas, its membership drawing together a wide range of experience, expertise and views that never fails to be stimulating. As well as those AARG members represented in contributions to this volume, we would like to take the opportunity to thank other AARG members for their encouragement and interest in this project.

KB would also like to thank the Department of Archaeology, University of Glasgow, for support throughout the editorial process.

Our thanks to the National Galleries of Scotland for permission to reproduce the aerial view of Edinburgh by Capt. Alfred Buckham (1).

At Tempus, Peter Kemmis Betty, Laura Perehinec, Fran Gannon and Tim Clark have dealt with us efficiently and patiently – for which our thanks.

Lastly, but not least, our thanks to Jan and Sharron for bearing with us.

ABBREVIATIONS AND ACRONYMS USED IN THE TEXT

AARG – Aerial Archaeology Research Group

AARGnews – The Newsletter of the Aerial Archaeology Research Group

CUCAP – Cambridge University Committee for Aerial Photography

GPS – Global Positioning System

NMRS – National Monuments Record of Scotland

OS – Ordnance Survey

RAF – Royal Air Force

RCAHMS – Royal Commission on the Ancient and Historical Monuments of Scotland

RCHME – Royal Commission on the Historical Monuments of England

RCAHMW – Royal Commission on the Ancient and Historical Monuments of Wales

I

FROM THE AIR –
AN INTRODUCTION

Kenneth Brophy & David C. Cowley

INTRODUCTION

This is not a typical book about aerial photographs and archaeology. It is not a glossy ' _____ from the air' volume of images, and nor is it a handbook of how to do aerial archaeology.

This book instead explores the processes that lie behind the sanitised presentation of aerial photography, both in popular media and academic texts. It offers a 'behind the scenes' view of the practice and processes that lie behind the images and other products of aerial archaeology. Aerial photography lies at the core of substantial parts of the archaeological record, but there has been precious little published discussion of the role that subjectivity, bias and perception have on the creation of the record. This leads to a situation where, beyond the handful of aerial archaeology practitioners that may be working in any given country, these issues are relatively unknown and end-users may work with photography and mapping which are biased in ways they can have no inkling of. In Britain, and elsewhere in Europe, 'aerial archaeology' is the domain of a few, many of who are contributors to this volume. We hope that the exploration of these themes in this volume will illuminate the inner workings of this important area of archaeological endeavour to a wider community.

This book presents a 'warts and all' view and contributors, who are drawn from the whole range of activities encapsulated by the umbrella term of 'aerial archaeology', were asked to adopt a critical stance in examining aspects of practice, reflecting on their own approaches and those of the discipline as a whole. Throughout, there is openness about the very real issues that lie behind the idealised version that is most often presented.

Reflection on archaeological practice over the past decade has focussed on an increasing interest in understanding the subjective elements of archaeological

fieldwork. Archaeological processes, such as excavation, have long been regarded as objective and empirical, with interpretation and description detached from one another (*cf.* Barker 1993). Increasingly, however, this orthodoxy has been challenged with a re-thinking of the role of subjectivity within archaeological endeavours such as excavation (Bender *et al.* 1997; Hodder 1999; Lucas 2001), field survey (Bradley *et al.* 1993; Bender *et al.* 1997) and archaeological science (Jones 2001). In essence, this reflexive turn has been driven by the recognition that subjectivity is inherent to everything we do as archaeologists, and to ignore it is more problematic than reflecting upon its impact.

Contributors to this volume have taken up the challenge of reflecting on aerial archaeological methods and outcomes, based either on their unique experiences, or research on the results of aerial survey. Below, we summarise the rationale and structure of the volume. Following that, in this introduction we highlight some of the issues that are important to us, providing case studies of the pervasiveness of subjectivity and bias in aerial archaeology.

CONTRIBUTORS AND STRUCTURE

Contributions begin with an essay by Gordon Maxwell that reflects on aspects of experience, perception and memory in the processes of discovery and interpretation and draws on decades of experience in the air. Brophy then explores the spirit and theoretical context of this reflection, discussing subjectivity, bias and perception and providing some definitions of terminology and points of reference. Aspects of the process of aerial survey are examined by Cowley & Gilmour, and papers by Wilson, Hanson and Jones discuss types of bias, the role of bias in the creation of the archaeological record and the benefits of positive bias in exploring particular interests.

Aerial photographs are the raw material for what we do and papers by Palmer, Mills and Gates look at the way photographs are collected and the uses to which they are put; in the case of Palmer challenging the basis on which much archaeological aerial survey in Britain is undertaken. Palmer and Mills identify the importance of 'unbiased' block-coverage photography and the roles that differing types of photography may have, while Gates provides a case study of the need to develop approaches that deal with particular conditions or demands in a model of reflective practice.

Analysis of work practices and the products of aerial survey is not often articulated (see Cowley 2002 for a rare example), rather sometimes taken as a given or even ignored. While many practitioners do reflect on practice as a matter of routine, there is also a pressing need for structured analysis that takes a retrospective overview, and Oakey's paper provides examples of the ways in which past patterns of survey may be examined for bias to identify its potential impact on the archaeological record.

In Britain, while appropriate funding for aerial survey remains an issue for debate (British Academy 2001), aerial survey has been established as a vital component of archaeological recording. Rączkowski's paper reminds us that this is not true across the whole of Europe and that what are regarded as appropriate recording techniques in any one country or region are bound up in archaeological traditions that are heavily influenced by social and political contexts. Rączkowski's study of approaches to survey in Poland is a powerful illustration of the importance of the battle for hearts and minds in securing a future for aerial survey in any part of the world.

The volume is rounded off by Baines' paper, which reflects on the uses of photography in archaeology as a whole, drawing on theory from the world of photography that may be unfamiliar to many archaeologists, even those that work with images or cameras as a matter of routine. This paper is an appropriate reminder of the wider world that archaeological recording and discourse draws on and the need to explore beyond the narrow remit of our own interests.

THE INDIVIDUAL IN SURVEY AND INTERPRETATION

A central theme running through this volume is the role of the individual – the human element – in the intertwined processes of survey and interpretation. The following examples in this introductory essay and the other contributions to this volume will illustrate that the practice of aerial archaeology is fundamentally subjective, riddled with biases and highly dependent on individual perception and experience. We do not regard this as a bad thing – it is, however, an issue that requires recognition and exploration. Another way of expressing this issue is to see the archaeological record as containing 'something' of the contributors to the formation of that record. This may range from the role of an individual noticing an apparently insignificant element of a site on a photograph to the compilation of corpora of entire sites. The view of Edinburgh (*1*) encapsulates this perspective. It is the work of Captain Alfred Buckham, a pilot in the RAF and artist, whose ambiguous images – part painting, part photograph – capture both the detachment (from the ground where our sites are) and the intensity of the aerial survey experience, in this case set against the dramatic sky and cityscape. Buckham took the photograph, and by placing his plane in the image he has explicitly put himself into the frame (Carter 1990; see Brophy this volume), an iconic metaphor for the embedded role of individual subjectivity, bias and perception in aerial archaeology.

The role of the individual

Too often, any critique of an aspect of survey practice is regarded (and may be intended!) as an attack on an institution or individual. And aerial reconnaissance is an area of archaeological practice where the role of the individual is

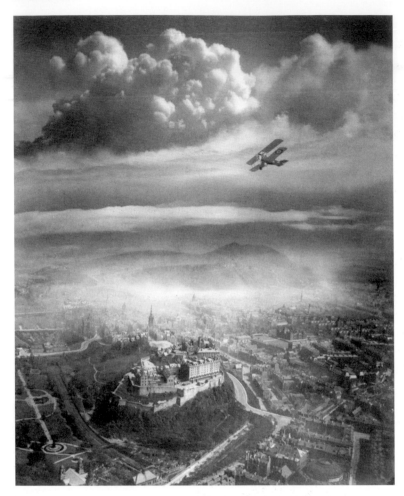

1 Alfred
G. Buckham: aerial
view of Edinburgh.
Copyright:
Scottish National
Photography
Collection, Scottish
National Portrait
Gallery

paramount. Indeed there may not be any other area of archaeological recording where the individual has played such a major role in creating the archaeological record. This can be illustrated with reference to the patterns of flying in Scotland by RCAHMS. The practicalities of aerial survey at RCAHMS are described elsewhere (Cowley & Gilmour this volume), but at a basic level sorties are directed by an archaeologist (usually) or an architectural historian, who is responsible for deciding where to fly, what targets to examine and photograph and the subsequent cataloguing of the images.

Since the inception of the RCAHMS aerial survey programme in 1976 over 1,000 sorties have been flown and the pie chart (*2*) illustrates the proportions of those flights that have been directed by any individual. It is immediately apparent that here have not been many staff involved, and much of the expansion in the numbers of staff involved is recent. The majority (60%) of sorties have been directed by one member of staff, amounting to the greater part of the 90,000 photographs that have been captured. This situation has both strengths

and weaknesses: the advantage is that as an approach it ensures continuity and familiarity with the material, the country, the techniques and so on; the weakness lies in depending largely on one set of eyes and perspectives to create a national dataset (though, of course, staff do fly together on occasion and photographs are passed round for peer review, which offsets some of this emphasis). There is no criticism implicit in this observation, but it does highlight the impact the individual can have, and the need for reflective practice to keep institutional (e.g. RCAHMS) and individual approaches to survey under constant review (Cowley 2005). It also highlights the difficulties of retrospective analysis of approaches and results, in that any critique immediately becomes personal. Finding the language to deal with this will remain one of the challenges of exploring these issues, the success of which will be a reflection of the maturity of the discipline.

Cursus monuments and the archaeological context
The archaeological record is constructed by archaeologists, and patterns within that record will inevitably reflect the activities and interests of archaeologists as much as any reality in the past. This is particularly apparent in the ongoing process of the interpretation and re-interpretation of cropmarks. An initial interpretation of a cropmark will be dependent on the experience and skill of the individual(s) involved, but this primary interpretation will have a significant impact on subsequent interpretations. The earlier classification or descriptive material becomes part of the intellectual baggage or 'pre-understanding' (see Rączkowski this volume) of subsequent work. This tendency can be illustrated (3) through

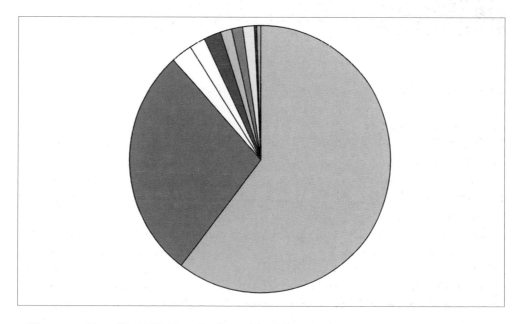

2 The proportions of RCAHMS sorties directed by different flight directors over the period since 1976. *Crown Copyright: RCAHMS*

the pattern of discovery and interpretation of Neolithic cursus monuments in Scotland. These patterns can, in turn, be linked to contemporary events, labelled A–D on the illustration (see Brophy & RCAHMS forthcoming for more detail). The chart is generated from 44 cursus monuments (with the assistance of Gordon Barclay and Roy Loveday), all wholly, or partially, cropmark sites.

Underpinning this illustration is the simple premise that a cropmark site may be photographed (and re-photographed) and interpreted (and re-interpreted) on any number of occasions, perhaps decades apart by any number of different parties. So for instance, a site classified as 'linear cropmarks' at East Linton, East Lothian, was photographed by RCAHMS in the 1970s and 1980s, but not interpreted as a cursus monument until the 1990s (Armit 1993; Brophy & RCAHMS forthcoming); and there are any number of other examples of such time lags between recording and interpretation.

The context within which reconnaissance was taking place, and interpretations being made, is crucial. Until 1976, there was no known cursus 'tradition' in Scotland, despite these sites being well known in lowland England since the 1930s. The four earliest cursus monuments recorded from the air in Scotland, in the late 1940s (A on *3*), were the fruits of the earliest CUCAP sorties into Scotland, and reflect perfectly the 'bias' of CUCAP flyers at that time, namely towards Roman sites (see Jones this volume). Of the four, the Cleaven Dyke was thought to be a Roman 'vallum' until the 1980s, Westfield forms part of a cropmark complex of Roman sites and field-systems at Inveresk and was not identified as Neolithic until small-scale excavation in 1984, and Fourmerkland sits in the middle of a Roman temporary camp and was

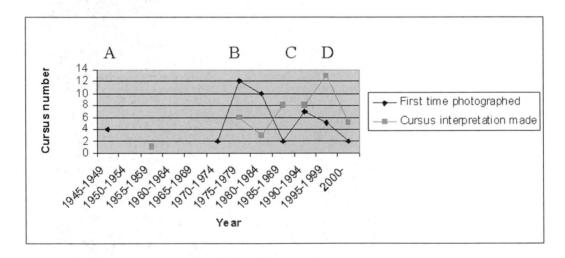

3 Cursus monuments of Scotland: discovery and interpretation
A: First CUCAP flights into Scotland
B: RCAHMS aerial survey programme commenced
C: Loveday/Barclay
D: Brophy/RCAHMS

not identified at the date of photography, but was recognised from the early images in the 1980s. Only one, Gallaberry, was thought to be a cursus by St Joseph, who did the flying (noted in his flight log written in 1959), and even then the site was only spotted because a Roman Fort overlies it.

The peak in new discoveries (B on *3*) relates to the establishment of the RCAHMS aerial survey programme in 1976, when large areas were flown intensively for the first time ever, with a subsequent explosion (*4*) in the recording of new cropmark sites (Maxwell 1978; 1983). The peak in positive interpretations spans the mid-1980s and the early 1990s (C on *3*), and this is closely linked to two researchers, Loveday (1985) and Barclay, who compiled lists of known cursus monuments in 1985 and 1994 respectively (Brophy & RCAHMS forthcoming). The key period for the identification of cursus monuments (D on *3*) was in the late 1990s, when specific research was done on these monuments towards a RCAHMS publication (RCAHMS 1997) and a PhD (Brophy 2000). This 'boom' in cursus numbers was a combination of re-visiting the photography of older cropmark sites, and a heightened awareness among the aerial community in general. The realisation that there was a cursus tradition in Scotland in turn allowed its full extent to become apparent. Attitudes changed from not expecting to find cursus monuments, to actively looking for them.

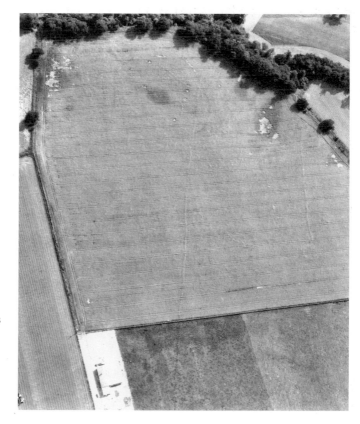

4 The widely-spaced ditches of this cursus monument at Broich in Strathearn were first photographed by RCAHMS in 1982. *Crown Copyright: RCAHMS, PT 10395*

The table (*3*) shows a certain stabilisation now, with fewer new sites being discovered (due in part to the law of diminishing returns, and also because of increasingly poor weather conditions for cropmarking), and fewer new interpretations of sites being made as intensive research on the corpus has now finished. However, armed with this specialist knowledge, rare new cursus sites are interpreted as such as soon as they are found (i.e. Cowley & Gilmour this volume). Perhaps the overall pattern reflects what we would expect when a new technique is introduced – chance discoveries with no context to make sense of them (A on *3*), followed by new methodology producing an explosion of partially understood data (B on *3*), leading to reflection on that data (C, D on *3*) and then a mature application of knowledge based on experience. This pattern illustrates the extent to which archaeological data and knowledge may be essentially serendipitous, the product of a complex interaction between technique, practitioner, and their context.

Seeing what you want to see
All interpretations are subject to bias due to preconceptions, 'seeing what you want to see', and a tendency to work within known and often inflexible typological classes. The cropmark site at Lagg, in Strathearn, Perthshire, illustrates the interplay of these factors (*5*). This site was being transcribed (i.e. computer mapped) as part of a block of work across three 1:10,000 map sheets containing large numbers of cropmark sites, and was initially interpreted and drawn out as a long barrow with some kind of mortuary structure at the lower, left end (in the picture). During the process of peer review of the mapping and accompanying text, it was suggested that what was recorded was in fact a square barrow, with a central grave-pit and two parallel lines of pits extending away from the burial. As this was pointed out by a colleague my (DCC) perception of the monument changed and I found myself unable to rationalise why I had not seen the site in this way before – it was by this stage obvious that it was indeed a square barrow and rows of pits! Some of this can be put down to a lack of experience, but the unexpected morphology of the site will also have played a role; most square barrows in Scotland do not have linear features, lines of pits or otherwise, extending from them. Furthermore, in working the area I had been conscious of 'looking for the Neolithic', in part informed by two nearby cursus monuments (e.g. *4*) included in the project, and in part by a cropmark long barrow (*6*) seen at an earlier date in an adjacent area. Comparing the cropmarks of the long barrow (*6*) and the Lagg site (*5*), the differences in morphology are evident, but the latter may at the time have fitted a memory of the long barrow seen earlier as wished for.

Whatever the interplay of inexperience, 'pre-understanding', the constraints of typologies and the desire to pull something Neolithic out of the survey, it is clear that these issues were exerting a considerable influence on my pattern of work. Now, a decade on, I would like to think that I would not make the same mistakes again, that I would look at the imagery more objectively and that my greater experience would be brought to bear to create a more persuasive classification and interpretative text. However, it is one of the recurring lessons

5 The square barrow and parallel lines of ditches at Lagg in Strathearn defy straightforward classification. *Crown Copyright: RCAHMS, A 72254*

6 The ploughed-down long barrow near Thorn in Strathearn has been recorded as cropmarks. *Crown Copyright: RCAHMS, B 79202*

of archaeological interpretation and one that is picked up by Maxwell, Palmer and Brophy in this volume, that while there is no substitute for experience, the interpretation of aerial photography is essentially subjective. The impact of this subjectivity can be offset by alertness to its presence and by structured peer review in which a consensus of view can create a robustness of interpretation.

Chance and discovery: which way to look
The vagaries of site discovery during aerial survey are explored elsewhere in this volume (Cowley & Gilmour), discussing the role that momentary lapses of concentration, other air traffic and so on can have on the survey process. This is a difficult area of working practice to illustrate, but one of the challenges of survey, that of directional cropmarks (i.e. only show from one direction) is illustrated here (7) to highlight the significant role that chance has on discovery. The four images were taken while circling round a field in Berwickshire, Southern Scotland, on a summer sortie looking for cropmarks. It is only in the fourth image (bottom right) that the arc of ditch of a promontory enclosure (A on 7) becomes visible. On the one hand this is a testament to the skill of the airborne surveyor and on the other hand shows how even a good look at the field from the wrong angle would not have revealed anything; fortunately, few cropmarks are as directional as this. These photographs also illustrate another facet of survey, that of keeping an open mind. The sortie was directed towards cropmarks, but the aerial surveyor must remain open to other targets such as the earthworks of a previously unrecorded promontory fort on the opposite side of the watercourse (B on 7). A summer search pattern will be conditioned by patterns of arable fields and in this focus earthworks, even when they are adjacent to features such as in this example, could easily be screened out.

Taking interpretation forward
A little-explored and very difficult area of cropmark interpretation to engage with is how far to take an interpretation. It is one of the problems with lone working and the consequent lack of peer review, a situation that can lead to both timidity of interpretation or equally wild excesses of interpretation (above). The following illustration is presented partly by way of a cautionary tale, highlighting the dangers of over-extending the interpretation of what are after all plough-damaged sites that have been revealed through the vagaries of crop growth against what may be a complex geological background, and also to place the cropmark in a wider context – that of an excavation – to remind us that aerial survey and photography is not an end in itself.

Inevitably, excavation can render some interpretations obsolete, often revealing a level of detail that cannot even be guessed at from the photography. In this instance, one of the editors (KB) was involved in the excavation of a cropmark site at Tinto Quarry in Lanarkshire. The site itself was first recorded as a cropmark in 1992, during flights both by Bill Hanson and RCAHMS, and has been visible intermittently since. Interpretations of the cropmark suggested that the site was a large enclosure

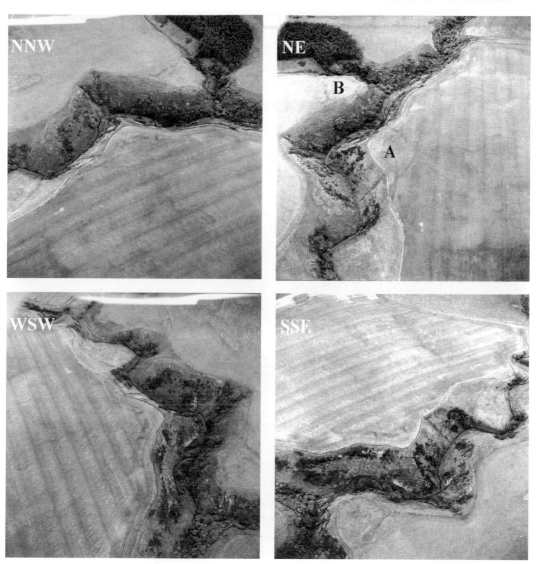

7 Few cropmarks are as directional as those of the promontory enclosure (A) visible on only one of these four images, each taken within a few seconds of each other. The earthworks (B) of a second promontory enclosure, probably a fort, was a new discovery during this sortie. *Crown Copyright: RCAHMS, D 76036-39*

of Neolithic or later prehistoric date (the photography was catalogued in the NMRS as such). However, excavation quickly established that the 'enclosure' was in fact a natural variation in the gravel subsoil. This disappointing conclusion lead to much head scratching and comments like, 'I can't believe it is not an enclosure!' Nonetheless, post-excavation, looking at the original aerial photos and those taken during the excavation (*8*) did reveal, in hindsight, that the 'enclosure' was not as coherent as I had previously believed, and that to an extent my eyes had deceived

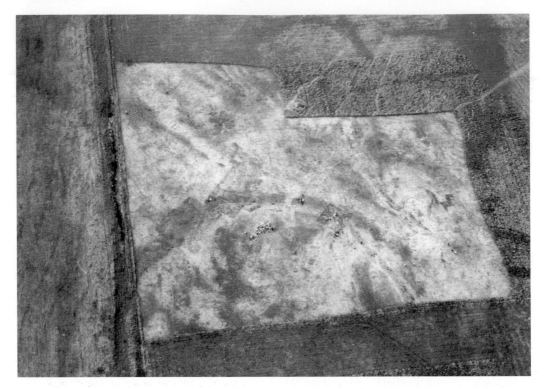

8 Excavations at Tinto Quarry, Annieston, Lanarkshire, in summer 2004, showing the lens of sand in the gravel that caused an enclosure-like cropmark. *Crown Copyright: RCAHMS, E 43943*

me, allowing me to see a complete enclosure where there was not really one. There is always a danger of 'over-interpreting' cropmarks; it is a reflection of the very personal perspective that any individual brings to a 'photo-reading'. However, this essential subjectivity and the dangers of being 'wrong' should not produce the opposite, where photo-interpreters are unwilling to explore the richness of their material. In this case, the recognition of the problem at Tinto Quarry should inform on the interpretation of other cropmark sites in that area, so in this sense the aerial photographs have still yielded useful information.

CONCLUSION

The case studies above are a small selection of aerial stories drawn from our personal experience, and there are many more in the following pages, which demonstrate that our practice is essentially subjective, driven by our experience and perception, and biased: all issues that need exploration and understanding in order to best work with the material. This volume engages with these issues in a frank way; fundamentally, it aims to demystify processes that are opaque to those out with a small aerial archaeological community.

BIBLIOGRAPHY

Armit, I. 1993 Drylawhill, East Lothian – cursus and associated features, *Discovery and Excavation in Scotland 1993,* Council for Scottish Archaeology, 57

Barker, P. 1993 *Techniques of archaeological excavation* (third edition), Batsford

Bender, B., Hamilton, S. & Tilley, C. 1997 Leskernick: stone worlds; alternative narratives; nested landscapes, *Proceedings of the Prehistoric Society* 63, 147-178

Bradley, R., Durden, T. & Spencer, N. 1994 The creative use of bias in field survey, *Antiquity* 68, 343-6

British Academy 2001 *Aerial survey for archaeology: a report of a British Academy working party,* http://www.britac.ac.uk/news/reports/archaeology/asfa.html

Brophy, K. 2000 *The cursus monuments of Scotland,* Unpublished PhD Thesis, University of Glasgow

Brophy, K. & RCAHMS, forthcoming *The Neolithic cursus monuments of Scotland,* RCAHMS/Society of Antiquaries of Scotland

Carter, G. 1990 Captain of the clouds, *The Independent Magazine,* 21 April 1990, 52-55

Cowley, D.C. 2002 A case-study in the analysis of patterns of aerial reconnaissance in a lowland area of southwest Scotland, *Archaeological Prospection* 9, 255-65

Cowley, D.C. 2005 Aerial Reconnaissance and Vertical Photography in Upland Scotland: Integrating the Resources, in: Bourgeois, J. & Meganck, M. (eds) *Aerial Photography and Archaeology 2003. A century of information,* Archaeological Reports Ghent University 5, Academia Press

Hodder, I. 1999 *The archaeological process: an introduction,* Blackwell

Jones, A. 2001 *Archaeological theory and scientific practice,* Cambridge University Press

Loveday, R. 1985 *Cursuses and related monuments of Britain and Ireland,* Unpublished PhD, Leicester University

Lucas, G. 2001 *Critical approaches to fieldwork,* Routledge

Maxwell, G.S. 1978 Air photography and the works of the Royal Commission on the Ancient and Historical Monuments of Scotland. *Aerial Archaeology* Vol.2, 37-44

Maxwell, G.S. 1983 Recent aerial survey in Scotland, in: Maxwell, G.S. (ed.) *The impact of aerial reconnaissance on archaeology,* CBA Research Report No. 49, 27-40

RCAHMS 1997 *Eastern Dumfriesshire: an archaeological landscape,* TSO

THE PREGNANT JEWEL: ON THE TRACK OF THE PAST

Gordon S. Maxwell

You speak of my gift for minute details. What I do I have no idea, but I know what I want to do; the fact is that I *omit* every detail … and fasten on whatever seems to me to reveal some general law … in no sense minutely observed, it's a whole theory of memory and perception.

Marcel Proust, letter of 12 July 1913, to Louis de Robert on the publication of the first volume of *A la Recherche du Temps Perdu*.

INTRODUCTION: LITERARY PARALLELS AND COGNITIVE PROCESSES

Retirement gives one the opportunity, if not the leisure, to appreciate the truth of the observation that everyone's experience of life runs parallel to that of many another. And the instances of shared experience frequently find their most vivid expression when they spring from widely differing contexts. In the field of aerial reconnaissance, many of us must have found, like Proust in creative writing, that though we knew what required to be done, we had only the vaguest conception how we went about it – a feeling that perhaps deepened the longer we plied our trade and no matter how successful we might have been in its pursuit! This seems to me particularly true of the process of discovery, whether it is the recognition of a new example of some well-known category of monument, or the 'silent upon a peak in Darien' moment when the previously undreamt-of image not only springs into being, but also resolves itself into a totally new field of exploration. How had we not seen it before? Was it simply because the evidence had never been physically visible, or had similar traces been previously available but ignored? Whatever the

circumstances, the underlying mechanism of recognition depended, in various ways, upon memory and perception.

Yet both memory and perceptions can be illusory or fragmentary, not to mention elusive. In Combray, the French country town where Proust's fictitious narrator recalled the scenes of his boyhood, it was an event almost beyond belief to meet someone whom one did not at first recognise; 'strangeness' was a quality to be rigorously interrogated, until at last banished by the establishment of some relationship with the known, no matter how tenuous. Indeed the entire world of Combray owed its literary recognition to something as insubstantial as the taste of a *madeleine* dipped in tea, which evoked in the narrator's recollection, but only after much heart-searching, the complex family life of his youth. In these two instances of memory and perception – the first indicating the propensity of the mind to override the evidence of the eyes, the second the subtle and apparently limitless data-retrieval powers of the unconscious mind – we may recognise two of the most significant forces operating for and against the aerial surveyor. Two contrasting instances of site discovery in Scotland may serve to illustrate just a few of the ways in which these forces influence the outcomes of reconnaissance.

THE ROMAN CONNECTION IN AERIAL ARCHAEOLOGY

That both examples are Roman military sites is neither fortuitous nor an expression of self-indulgence on the part of the author. Despite what some may think, the category as a whole offers the best opportunity for appreciating the peculiar advantages to be derived from aerial evidence. The reasons are not far to seek: in addition to being the beneficiary of a most intensive and long-running programme of aerial scrutiny (from O.G.S. Crawford to J.K.S. St Joseph and his successors; see Frere & St Joseph 1983, xi-xii and Jones this volume), our extensive knowledge of Roman military structures derives, in great part, from their predictable character as survey targets, whether it be in respect of their shape – mostly regular geometrical forms – or their location in the landscape, being disposed at relatively uniform intervals and in the pursuit of readily deducible tactical objectives. Not least important is our ability to presume not only the probable function of each site, but also the capacity of its constructors to impose their will on the physical landscape, stopping little short of domination. The further consequences for the aerial surveyor are at least twofold: in the first place, the complicated process of site-recognition is both accelerated and simplified, and in the second, the general circumstances of the discovery become more readily disentangled from the niceties of the individual interpretation. It was for these reasons, to give a graphic illustration, that it was appropriate, soon after capturing a Roman site on camera twenty years ago (*9*), to anticipate the eventually rectified plot with a freehand sketch of the oblique photography (*10*). Even so, the significance of both this and a companion site, first recorded from the air only days apart, lies in their wider relevance.

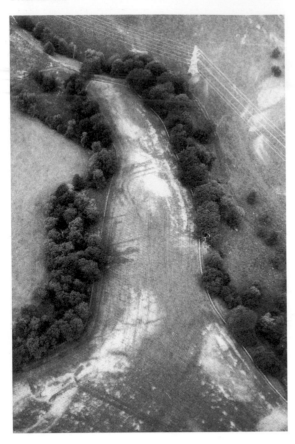

9 The first sighting of the small Roman fort, from the SE, at Inverquharity left little room for doubt about its character or date. *Crown Copyright: RCAHMS, AN 6632*

CASE STUDY I

The small Roman fort of Inverquharity is situated on the right bank of the Prosen Water, where the river South Esk emerges from Glen Clova and enters the broad valley of Strathmore, about 7.5km north–north–west of Forfar in Angus. It was found during survey by the RCAHMS in August 1983, in the course of a specific search, which was embedded in a routine sortie over central Strathmore; the objective of the search was to locate the late first-century frontier–post presumed for several years (see St Joseph 1976, 27) to lie intermediate between the large forts of Cardean and Stracathro, probably near the modern crossing of the South Esk, at Finavon, some 7km north-east of Forfar. The target had previously been sought by RCAHMS in a general way, but the discovery in 1981 of a Roman clay lamp at Kingsbridge Farm (DES 1981, 41), 5.5km upstream from the Finavon crossing, suggested to the author that it might be profitable to concentrate aerial scrutiny on the upper reaches of the river.

Hence, from 1982, whenever the survey aircraft was operating in the Brechin – Forfar neighbourhood, it became a standard procedure, if conditions were appropriate, to spend five or ten minutes of the sortie closely inspecting the

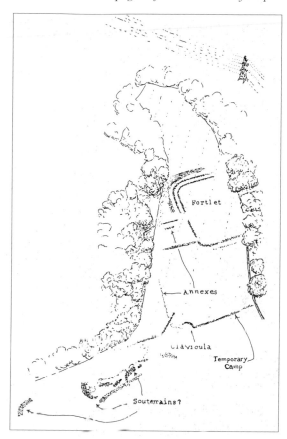

Labels within figure: Fortlet, Annexes, Clavicula, Temporary Camp, Souterrains?

10 Inverquharity, as seen in a pre-digital perspective sketch plot of 1983; the manual approach afforded not only alternative illustration, but also a commentary on the cognitive processes of the aerial observer. *Copyright: Gordon Maxwell*

ground on either side of the South Esk within the 6km stretch to the north of Kingsbridge. The RCAHMS flight records show that the area was flown over on at least three occasions in 1982, leading to the identification of a number of enclosures and traces of later prehistoric unenclosed settlements. But this was a summer in which eastern Scotland to the north of the Forth produced a profusion of cropmark evidence relating to such categories; and, more significantly, it revealed, for the first time and in amazingly complex detail, the ubiquity of that 'trademark' of the local Iron Age settlement pattern, the souterrain. Wherever one looked, starting with the epiphanous example at Glencarse to the south-east of Perth (Maxwell 1987, 36-42; see now RCAHMS 1994, 64-68), the presence of native habitation was manifest! It would not have been surprising, therefore, if this sudden efflorescence of material had distracted the observer from another, more specific task; such information overload is a frequently-encountered, but not much discussed, hazard of operations in a target-rich environment. However, when discovered in the following year, the Roman fort was seen to adjoin a group of comparably conspicuous souterrains, which were themselves unlikely to have been missed if the fields in question had then been in cereal cultivation.

Accordingly, when the fort, its annexes, and the accompanying temporary camp, were revealed in cropmark form on 5 August 1983 (9), only a few minutes after diversion from the overall flight-plan of sortie 1983/30, it was difficult to determine what was the most outstanding feature of the discovery: was it the completeness of the picture it provided, or the swiftness with which the sighting followed initiation of the dedicated search tactics? Or was it that the presence of the Stracathro-type *clavicula* at the north-west gate of the temporary camp allowed the whole complex to be assigned not just to the Roman period, but with reasonable certainty, to the late first century AD? The answer is probably that all are equally remarkable, but that the central message enunciated so clearly more than two decades ago has been lost sight of. What it was possible to achieve with Roman material is not presented here in a spirit of vainglory, but rather as a plea to extend its applicability to *all* classes of structure. In other words, to so sharpen our focus on any category of monument that its accessibility to our physical powers of perception may be exploited to the full.

CASE STUDY 2

The second case study concerns the discovery of the Roman bridgehead fort of Doune (Maxwell 1984) at the crossing of the River Teith, about 8km north-west of Stirling. Like Inverquharity, it was found in the course of an aerial search for a 'missing' site, the garrison-post that was presumed to guard the ford or bridge by which the main road to the north crossed the River Teith or Forth. In 1982 the identification of a possible Roman marching-camp at Ochtertyre (DES 1982, 36) on the right bank of the Teith, opposite the site of a large third-century camp and at a known fording point, appeared to narrow down the possibilities for closer inspection. At this stage the balance of probability lay in favour of a position somewhere in the grounds of Keir House, to the south of Dunblane, but the area was densely wooded or maintained as parkland, and though several RCAHMS sorties in the earlier summer of 1983 permitted its inspection *en route* for more distant targets, no significant finds were reported.

And then, ten days after the success at Inverquharity, a sortie planned as a long-range reconnaissance swept north-west from Edinburgh along the headwaters of the Forth and thence south to Nithsdale and Galloway; it commenced its survey-work by revisiting the lower Teith, initially following the left, or northern, bank of the river. Within a short time the aircraft overflew the burgh of Doune, holding Doune Castle and the riverside fields under its port wing. Initially the fields seemed to contain nothing remarkable; much of the land was in permanent pasture, and though the later summer held promise of a deepening drought, no conspicuous parching could at first be descried. However, when the aircraft had flown on past Doune for a minute or so, it was decided to turn back for a second circuit of the burgh. To this day the author, who was on board, does

not know precisely what had made him request this manoeuvre, except that he was unhappy to proceed further upriver. Yet as they once more approached the pastures beside the castle, the conviction grew that the site around which they would be flying was a Roman fort. And so it proved (*11*).

As the accompanying illustration shows, the traces were truly vestigial: doubtless, the eye had been first drawn by the sharp dividing-line between the still-verdant grass that covered most of the field and the parched slopes delimiting its eastern edge (later enquiries revealed that the pasture had been improved over the years by imports of richer soil and composting, which had roughly doubled the topsoil depth). Yet this did not satisfactorily explain the certainty with which the discovery of a Roman structure was increasingly expected on the second approach. Close inspection of the 1983 photograph (*11*) reveals part of the explanation: the boundary-zone between the green and yellowing pasture (dark and light respectively on the photograph) straddles an intermittent triple-ditched feature, which represents the outer defences of a Roman fort as they swing round from the north-west angle and sweep down the east front. However, more tellingly, just before they disappear on the south, the ditches begin to unite. It was surely this tiny fragment of evidence presented subliminally, that convinced the subconscious eye not only that there was something demanding attention, but even impressed upon it the character (and date) of the discovery. In time,

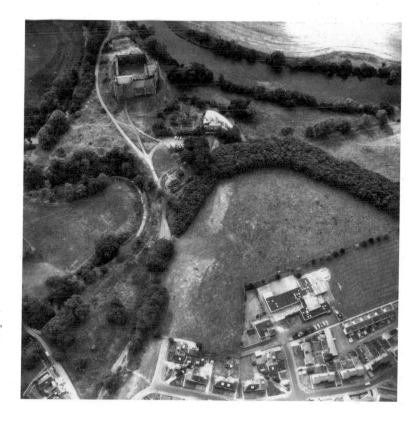

11 The Roman fort at Doune, as first recognised from the air in 1983. The target lies in the lower right-hand third of the photograph, between the castle and the town. *Crown Copyright: RCAHMS, PT 14118*

excavation and ground survey, allied with a later year's photography, confirmed the correctness of these early impressions (see rectified plot and 1984 print, *12*, *13*). The incurving ditches at the fort's south-east entrance unmistakably form one half of a 'parrot's beak' type of gateway, now associated with one of the legions which accompanied the Roman governor Julius Agricola on his campaigns in north Britain in the late first century AD (Maxwell 1998). The faintly-visible bands of parched grass (indicating the metalled road that ran along the inner edge of the enclosing rampart) revealed themselves in later photo-interpretation; while it is possible that their relative positions, suggesting the typical square ground-plan of a Roman fort, were also perceived from the air, the first visual trigger seems more likely to have been the gateway, the structural element with the greatest diagnostic weight. In reconnaissance, size may well matter, but significance apparently outweighs it.

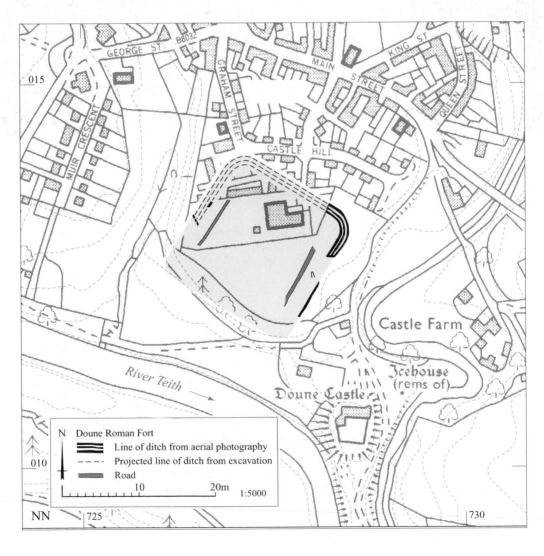

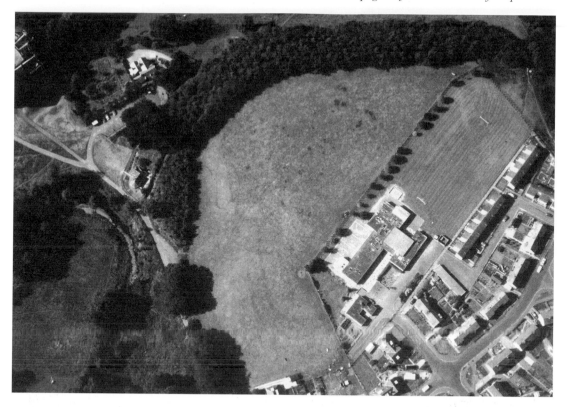

13 Above: Doune, as it appeared in the year after its discovery, with a clarity not equalled, or even approached, in the next two decades. *Crown Copyright: RCAHMS, A 69554CN/PO*

12 Opposite: Doune: a digitally rectified plan of the fort's defences and intervallum road, using 1983-4 photography; excavation in 1999 (Moloney 1999) confirmed the position of the western side. *Crown Copyright: RCAHMS*

CONCLUSIONS

Several lessons may be learned from these experiences – not least the need to acquaint oneself with the dislocated anatomy of archaeological structures by frequent observational practice in the air and the library or archive. But even that, conscientiously applied, would merely graze the surface of a vast and little considered subject, the study of the cognitive, evaluative and retrieval processes by which reconnaissance builds the structure of new knowledge. To return to the beginning, it is clear that Proust, pursuing a literary objective, was searching along a parallel path. Aerial observers on the track of archaeology need to be as aware as he that, in their field too, memory and perception are inextricably intertwined; and the more aware we are, as Pasteur remarked of scientific observation, the more handsomely fortune will favour us!

TAILPIECE

None of the foregoing observations is essentially new. The truth that they embody has been observed in many fields of endeavour, but its application in aerial archaeology has yet to be fully appreciated. For its pithiest description, as for other words of aerial wisdom, one must turn to Shakespeare...

'Tis very pregnant,
The jewel that we find, we stoop and take't,
Because we see it; but what we do not see
We tread upon, and never think of it.
(*Measure for Measure*, II, I, 23)

ACKNOWLEDGEMENT

My thanks to Kevin MacLeod for producing the plan of the fort at Doune (*12*).

BIBLIOGRAPHY

DES = *Discovery and Excavation Scotland*, Council for Scottish Archaeology

Frere, S.S. & St Joseph, J.K.S. 1983 *Roman Britain from the Air*, Cambridge University Press

Maxwell, G.S. 1984 New Frontiers: the Roman fort at Doune and its possible significance, *Britannia* 15, 217-23

Maxwell, G.S. 1987 Settlement in Southern Pictland – a New Overview, in: Small, A. (ed.) *The Picts: a New Look at Old Problems*, Dundee, 31-44

Maxwell, G.S. 1998 Agricola and Roman Scotland: some structural evidence, in: Bird, J. (ed.) *Form and Fabric: studies in Rome's material past in honour of B.R.* Hartley, Oxbow Monograph 80, 13-20

Moloney, C. 1999 *An archaeological excavation of the playing fields of Doune Primary School, Doune, Stirling*, Data Structure Report, Headland Archaeology Ltd

RCAHMS 1994 *South-east Perth: an archaeological landscape*, HMSO

St Joseph, J.K.S. 1976 Air reconnaissance of Roman Scotland, 1939-75, *Glasgow Archaeological Journal* 4, 1-28

SUBJECTIVITY, BIAS AND PERCEPTION IN AERIAL ARCHAEOLOGY

Kenneth Brophy

INTRODUCTION

Aerial reconnaissance makes an appearance in John Wyndham's book, *The Day of the Triffids* (1999). In an England left blind by mysterious green comets, leaving the population helpless and prey to the genetically modified and deadly triffid plants, the sense of sight is rare and with it comes power (the triffids are also sightless). The narrator spends much of the book searching for his girlfriend, and in one scene, a group of sighted people find a helicopter at a deserted RAF base and use it for reconnaissance over a wide area of country, searching for her and other survivors. This involved flying around looking for stragglers, then landing and trying to help them.

At several further points in the book, the appearance of a helicopter brings with it at least brief hope. As groups of survivors see one, they have 'hopeful excitement' (*ibid.*, 201). Later, the narrator spots one as he drives off, alone, from a group he had been sheltering with: 'even the sight of it seemed to give me some support' (*ibid.*, 209). Finally, after his search is successful, he and his girlfriend see a passing helicopter. 'The sight of the machine had changed our day for us. It destroyed quite a lot of resignation we had carefully built up ... it suggested that someone somewhere was making out better than we were ...' (*ibid.*, 250). Another helicopter arrival much earlier in the book caused cameras to be rushed out excitedly as it passed over the British Museum.

The appearance of helicopters at times of despair seems to me to be a kind of symbol of the human spirit, the positive use of technology and machines; in short, a metaphor for what is good about people, as opposed to the inherent

madness of messing with nature and weapons of mass destruction (both themes of Wyndham's book and recurring social issues then and now). Helicopters and flight are common and safe means of human travel in other contemporary science fiction novels where the land and/or sea is rendered increasingly dangerous, from Wyndham's *The Kraken Wakes*, to J.G. Ballard's *The Drowned World*. The hope offered by these flying machines is often fleeting, but by taking to the air, humans seem able to rise above their hopeless state.

This book is a collection of papers by practitioners of aerial photography and other archaeologists who use aerial photographs (see Palmer's distinction between these categories, this volume). It is intended as an insight into a world most archaeologists know little about, the processes behind the amazing discoveries of aerial photography, the experiences that lie behind the apparently objective process. It is also about the emotional and subjective significance of aerial reconnaissance as a process, providing a glimpse of the very human processes behind the technical façade (*14*). In short, the contributors to this volume were asked to reflect on their experience and years of practice to see the strengths and weaknesses of the technique, from taking to the air, to interpretation of the images captured and the social context within which all of this takes place. Reflection on practice and the conditions within which archaeological results occur in turn has implications for how we interpret those results, and future practice.

This is not to suggest that non-reflective practice should be equated with the stumbling blindness suffered by humans in *The Day of the Triffids*; nor that our over-emphasis on trying to make the process uniform and objective through technology is consistent with tinkering with cabbages to make triffids. Rather, that by addressing the role that personal experience, intuition, bias and emotion has in shaping the results that we crave as archaeologists, we can begin to have a clearer understanding of the what the results really mean, and how we shape them.

14 The tool of choice of the aerial archaeologist is often known affectionately by the unmodified registration code, or nicknames based on this code. *Crown Copyright: RCAHMS, XS 877*

15 Re-fuelling: one of the many rituals of the procedure. *Crown Copyright: RCAHMS*

The major themes of this volume are issues of subjectivity, bias and perception, rather than planes, cameras and methodology (*15*). Before going any further, it is vital to clarify exactly what these terms mean in this context, and why they should be considered as a positive part of the process of doing all kinds of archaeology. Firstly, all archaeological field survey is inherently subjective, has elements of bias and depends almost wholly on perception of one kind or another. This is non-negotiable (although is commonly denied) because we are human beings, not robots, and because field survey is a decision making process. Secondly, there is *nothing wrong* with any of these main themes. To suggest that archaeological records, flight plans, the choice of sites to be recorded (or ignored) have been influenced by things like 'personal interest' and 'bias' are not in any way a criticism. This would be like criticising someone for selecting their favourite from a box of chocolates. Aerial reconnaissance is a process where people inevitably have ideas, choices, decisions to make, and this usually (albeit sometimes subconsciously) overrides or limits any attempt (externally or self-imposed) to impose orders or rules (*16*). There is nothing wrong with this. There is nothing wrong with subjectivity: indeed, what is wrong and potentially misleading is trying to deny its constant presence within archaeological practice.

In this general paper, I want to consider in a bit more detail the role of subjectivity, bias and perception in aerial archaeology, as well as making some other, more general, observations about the practice and practitioners. I offer no dictionary definitions here, only personal ones. Despite a lack of explicit comments on such issues previously, I suspect aerial archaeologists have long been aware of the nature of their discipline.

16 Dialogue in the air. Routes, targets, permissions and weather may be discussed more than the archaeology itself. Photographer, Robert Adam, on the left, and pilot Ronnie Cowan discuss tactics with Simon Gilmour, the archaeological flight director, who took the photograph. *Crown Copyright: RCAHMS*

BIAS

The word 'bias' has negative connotations. For inanimate objects, it may mean a slight lopsidedness or unevenness, like a ship tilting to the side. In lawn bowls, it is the slight weighting of the bowl itself that causes its parabolic pathway, understood and harnessed by the bowler to tactical effect. In both of these senses, bias is something that has to be controlled, not ignored, either through elimination or mastery. And so it usually is with human relationships – bias is decried as a very bad thing in politics, the employment process, education, football refereeing and so on. It is readily associated with other 'negative' words such as favouritism and nepotism. In most areas of life, bias is indeed negative and inadvisable, a bad thing.

Bias also occurs in archaeological survey. This is adequately illustrated in various contributions to this volume (Hanson, Jones, Wilson). The question therefore should not be 'does bias exist?', but 'what should we do about it?'. If we agree to define bias as something like, 'a tendency towards certain things through preference or intuition' (Collins Dictionary), should we as archaeologists

eliminate it or master it? At best, it must be accepted and certainly not ignored.

The elimination of bias is, some would argue, already part of the aerial reconnaissance process. When out flying, one simply records (a) everything they see; or (b) everything they see that fulfils certain carefully pre-selected criteria (the objectives of the flight). This inclusive approach would seem on the face of it to leave little room for bias, which is eliminated by the flight strategy before it has time to creep in. However, nothing is that simple. It is always difficult to draw such clear lines in the air, and all too often decision points are reached that were not anticipated. Questions like 'is that worth recording?', 'is that the kind of site I need to record today?' and so on are commonplace, and the answer is frequently a matter for personal choice. As Wilson (2000) has observed, interpretation begins in the air (*17*).

Rączkowski (2002, 321) has argued that, 'during the time of observation [from the plane] there is a process of the picture's interpretation, in [the] aerial archae-ologist's mind. In this interpretation, there is a process of excluding (decision not to take a photograph) of such structures which are not recognised to be archaeological.' Cowley (2002) has persuasively argued that many factors of bias influence the routes, targets and outcomes of reconnaissance, and there are well-documented lists of external factors that affect what happens in the air (for instance Aston & Rowley 1974, 75-89; Palmer 1978; Riley 1987; Wilson 2000); all of these factors will effect different observers differently (Brophy 2002). The

17 The point of fusion between camera, photographer and the target on the ground. For this moment to be reached, interpretation has already taken place. *Crown Copyright: RCAHMS, SC 369925*

choices made in the air, to take certain routes, to include or exclude certain sites and views, are choices predicated upon any number of reasons: gut feelings, tiredness, indecision, boredom, alertness, time pressure and so on (e.g. Cowley & Gilmour this volume). Attempts to eliminate bias founder at these moments of decision.

If we cannot eliminate bias, then we can certainly try to judge the impact it has on archaeological survey, perhaps allowing a methodology for the mitigation of some forms of bias to be developed. Bradley and his collaborators (Bradley *et al.* 1994) outlined attempts to monitor bias amongst participants in a field survey looking for rock art in Northumberland. It was found that a certain expectation that rock art was found mostly in certain parts of the landscape developed among surveyors, and teams tended to focus attention in these places with a greater hope of success. To militate against this bias, once recognised, strategies based around raising awareness and swapping survey teams around were adopted. There was a high awareness of the dangers of becoming 'prisoners of our own expectations' (*ibid.*, 343).

I take this to mean that when we start to discover certain characteristics of sites in a recurring pattern, whether it is a topographical location for rock art or a particularly productive cropmark area, we may start (subconsciously or otherwise) to concentrate on this particular location rather than neutrally everywhere. Bradley *et al.* (*ibid.*) call this, amongst other things, 'preconception', 'judgement sampling' and 'bias'. Strategies employed on this particular project were designed to eliminate this bias, averaging out the results. Cowley's (2002) recognition of 'honeypot' locations in south-west Scotland, cropmark hotspots so to speak, is not just an idle observation but a first step in trying to establish aerial survey strategies that look at the landscape as a whole rather than 'cherry pick'.

Whether we regard bias as a necessary part of the archaeological process, or a real problem, experiences like Bradley's and those of other archaeologists (e.g. Plog *et al.* 1978; Shennan 1985) suggest that by understanding the impact of bias, it could be ironed out statistically. Specially designed methodologies, heightened awareness and statistics, are all strategies employed by Bradley *et al.* (1994) that could be attempted within archaeological aerial survey. To apply this rigorously, however, we would have to get a number of observers to fly the same route under the same type of conditions and see what each recorded. The results could be collected together and averaged; also, the individual biases, strengths and weaknesses of each observer could be calculated for future surveys. The cost effectiveness, value and feasibility of such an experiment is dubious (see Palmer this volume). Practically speaking, conditions and light vary too much during the day to allow a flight to be a repeatable experiment. In terms of cost and logistics, it simply could not happen once, never mind dozens of times a year.

There may well be no methodological way that we can develop to avoid bias in what is recorded and what is not, although being aware of bias and the forms it takes for each individual flyer and photographer is welcome. So perhaps we

must acknowledge and accept bias as an inevitable part of the archaeological process, perhaps try to quantify and understand the nature of it, and leave it at that (see Mills, and Oakey, both this volume). It is certainly true that if we got a number of different observers to fly the same route that they would come home with different results. The biases inherent in all that we do are due to the human element of the process, existing *despite* the surrounding technology that offers only the façade of hi-tech objectivity. Bias is 'an inescapable feature of human perception' (Bradley *et al.* 1994, 344).

PERCEPTION

This leads me to the second theme of this book, perception. Inevitably this is tied in with what aerial photography is all about, and that is seeing (*17*). It is perhaps the most vision-dominated of all archaeological field survey, without the textual subtleties of excavation (Bradley 2003), or the bodily engagement with landscape of field survey (Bowden 1999). The acts of reconnaissance, of photography, of looking at photographs, are all dependent on the level of light and the human eye. In the world of the blind predicted in *The Day of the Triffids*, the act of flight and looking around the landscape was an impossible dream. Flight equals sight.

But perception is much more than just a biological process involving the optical nerves picking up light signals via the eye and transmitting them to the brain. Perception is not simply looking at something. What we see is not necessarily a neutral and objective reproduction of the object we are looking at. Recognition, identification and interpretation are all part of the seeing process and are subjective qualities based on our own life experience, our levels of knowledge, our memory and of course our biases. The cliché, 'to see what we want to see', is apposite here in the context of aerial archaeology (not of course that the opposite is true: that what we see is a creation of the mind alone and has no existence without us bringing our gaze upon it). Archaeological perception is also a cumulative, learned skill; Bradley (2003, 154-5) has argued that archaeologists 'learn to see' through successive excavations, which in turn has an impact on what they actually see.

Perception is a subtle relationship between the perceiver and the perceived, a relationship that allows us as human beings to see beyond the empirical dimensions and physical form of an object and instead assign it a name, purpose and role. To give a prosaic example, when we look at a chair, we do not 'see' its basic physical or atomic form; rather we see a functional object with a preconceived function (Merleau-Ponty 1962). Indeed it is only when we see something that we have no name or function for (*18*), something wholly out with our experience, that we are forced into describing the form, colour and context of that object (see Palmer this volume, for an explicit example).

In aerial archaeology, much the same relationship is played out. If someone with

18 Ambiguity 1: Unusual effects visible from the air are not always archaeological in origin, like this swirling pattern created by agricultural activity or the reconstitution of quarrying. *Crown Copyright: RCAHMS, C 29617*

no knowledge of archaeology or the existence of cropmarks were to be flown over a cropmark, they would have no knowledge to fall back upon to understand what they were seeing, and would be forced to describe the shape and colour of the vegetational variation. This subtle subjective element to seeing means that practitioners of aerial archaeology see through the shape of a cropmark and immediately assign that object a label. That label in turn may carry connotations of function and date. This simple contrast indicates that perception depends as much on the perceiver as it does on the object or thing being perceived. One has only to think of colour-blindness as another example of how even simple visual constructs depend on the viewer as much as the properties of what they see. Rączkowski (2002) has argued recently that the perception of an object from the air is an act of 'categorisation' and 'verbalisation' where 'each observed feature is constantly named and characterised' (*ibid.,* 321). This is true of all archaeological fieldwork, whether it be the sherd of pottery at the end of the trowel or the cropmark of an enclosure viewed from the air. Being an archaeologist allows us to enter into a peculiar and

specialised visual relationship with the objects of our study. Inevitably this has an outcome on the results and the interpretation of those results.

Therefore, our perceptions are physical images but at the same time verbal constructs and ideas. We create the archaeological record in words as well as pictorial images. Different archaeologists with varying levels of experience and under different conditions may well see physically exactly the same thing from the air or on an air photo, but what they think they are seeing and how they label and describe it may well vary (*19, 20*). Only a complex series of leaps of understanding and/or faith allows certain professionals to see the almost ghostly outcome of a sub-surface variation affecting crop growth, as viewed from a certain angle and in a certain light, to be a henge monument or Bronze Age barrow.

So perception is important to aerial archaeologists because it is neither a wholly biological phenomenon, nor is it an entirely subjective process in the mind of the beholder. The act of perceiving pre-supposes that (a) there is somebody who will see, (b) that there is something to see, and (c) that this is a meaningful relationship. This is why the same cropmark could be a settlement to a later prehistorian, a henge monument to a Neolithic specialist, and a funny pattern in the crop to a non archaeologist (*18-20*). This relationship can only become part of meaningful discourse if it is (a) recognised as a relationship at

19 Ambiguity 2: Crop circles are not the same as cropmarks (a response to a common question from students). *Crown Copyright: RCAHMS, SC 928609*

all (not regarded as a one-way visual process), and (b) understood to a certain degree. It is us that allow something as abstract as cropmarks and the shapes caused by shadows to make any kind of sense at all, and so it is in a sense us that creates them by looking for them and photographing them (do cropmarks exist when nobody is looking at them?). In the context of bias, and subjectivity, this is a vital concept.

SUBJECTIVITY

The idea of subjectivity is one that is increasingly prevalent in current archaeological theory and thinking (e.g. Shanks 1992; Tilley 1994). Subjectivity can also be expressed in ideas such as bias, perception, judgement, motivation, knowledge, perspective and so on, and has its root in the thoughts of the subject (i.e. you and me). All of these ideas and many more are part of the archaeological

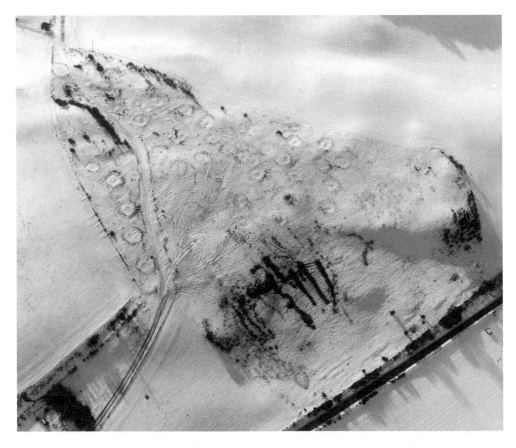

20 Ambiguity 3: Later prehistoric hut circle cluster or an animal feeder bin pattern? Experience and context is vital to differentiating the patterns of earthworks produced by animal feed bins from archaeological features. *Crown Copyright: RCAHMS, B 46641*

process, but various ways and means have long been used to iron out personal and un-quantifiable elements of description and interpretation through a general striving for objectivity (positivism). The argument runs that if archaeology is truly a science, as some believe, then there is a need for facts, not speculation and free interpretation. Yet I hope that I have already shown that certain subjective elements – bias and perception – are inherent and inescapable parts of archaeological practice. And I have gone further and suggested that this is an important part of practice.

Some archaeologists are now coming to accept that subjectivity has an important role to play in interpretations of the past. Personal insights, perspective views, judgements and anecdotal evidence have been applied to aspects of archaeological practice as diverse as excavation (Bender *et al.* 1997; Hodder 1997; Lucas 2001), field survey (Tilley 1994) and material culture studies (Cumberpatch 1997). This is not to say that archaeologists have free rein to concoct fictions about the past through their personal experiences in the present, but rather that within the constraints of the physical evidence and the physical world, meaningful non-objective statements can be made.

In aerial archaeology, there is clearly plenty of scope for subjective interpretations of the process, and the outcomes of the process. If some archaeologists can argue that the weather conditions and morale of excavators can affect efficiency, productivity, methodology and interpretation during excavations (e.g. Bender *et al.* 1997), then the same can be said for aerial archaeologists. As well as the inherent bias within the aerial process, there are also a number of external influences that will effect perception and the physical experience of observing from the air. States like boredom, excitement, tiredness, interest, distraction, illness and so on will effect what is recorded, and even how (*21*). Our own subjectivity somehow, and almost certainly unquantifiably, will shape the creation of the archaeological record. Archaeological survey is filled with periods of boredom and broken concentration where it is easy to miss something; and then there are the moments of exciting discoveries (Lucas 2001) that heighten perception amongst the whole team for a period of time.

Palmer (1978) noted the impact of subjectivity on aerial archaeology some time ago in a volume on statistical sampling in archaeology. As well as the external variables that Palmer lists as effecting the sampling strategies employed by aerial archaeologists are a number of personal (subjective) factors. The first of these was convincingly illustrated by Cowley (2002), namely that practitioners of aerial survey have a tendency to focus on productive cropmark areas. 'Aerial photographers like to photograph archaeological features therefore flying over supposed negative information zones is not a favoured practice' (Palmer 1978, 135), the implication being that efficiency and/or individual interest will effect the results dramatically and bias distributions (see Oakey this volume). Palmer also listed other variables that depend on the subject (observer) in the

21 Landing at Stornoway, 2004. Returning to the airfield can bring frustration or relief, and an eagerness to see what has been photographed. *Crown Copyright: RCAHMS*

plane, including 'experience', 'perception and recognition' and the 'interest of the interpreter'. He concludes with this important observation:

> Objectivity: *this is impossible to achieve* since the air photo interpreter is subjectively assessing all of the various indications on all the photographs and selecting what his experience tells him is likely to be archaeologically significant. It is subjectivity that leads interpreters to differ, sometimes quite extensively, over depiction of points of detail. (1978, 136, my emphasis).

REVEALING METAPHORS

> The fine weather of 1983 and 1984 yielded exciting discoveries, although of course the team members never use words like 'thrilling' or exciting'. They keep their feelings strictly to themselves ... the flying archaeologist doesn't take kindly to being earthbound (Gibbens 1987).

Bias, perception and subjectivity are all parts of the process of undertaking aerial archaeology. Yet there is little indication of the effect that any of these actually has had in the development of the method or the explosion of results produced from it. It is rare, for instance, to read any accounts of specific sorties, or the conditions under which certain cropmarks were achieved (see Cowley & Gilmour this volume). Such accounts, where they exist, remain anecdotal and do not even

make a suitable subject for inclusion in an autobiography (e.g. Crawford 1955). There exists something of a gap between the actual practice of aerial survey and the reporting of that practice, a gap where reflection on practice, bias, mistakes, excitement and disappointment fall. In light of the discussion above, this type of reflective detail may in fact shed light on how and why certain results came about. The true nature of the discipline of aerial archaeology may better be revealed not by the publication of the results of flights, but through a series of dominant metaphors that are commonly used to describe the practice and participants. These could be crudely summarised as soldier/spy, adventurer/explorer, and the 'anorak'. On the surface these metaphors seem to re-enforce the objective image of aerial archaeology suggesting discipline, technology and rigour. But they also draw out some of the themes that this introduction has focused upon, as well as hinting at heroism, obsession, power relationships and masculinity.

Very often aerial photography in archaeology is written of in terms of military metaphors – sorties, campaigns, season, reconnaissance, mission, shooting, targets and so on. Keillor wanted more 'accurate marksmanship' (cited in MacGregor 2000, 93), while Atkinson (1946, 28) described aerial photography as a new 'weapon' for the archaeologist. The technique and much of the technology was developed for military purposes (reconnaissance, mapping and spying), and war allowed the development of better and more efficient technology. 'Wars, because of the need for survival, always gave technology a shot in the arm …' (Heiman 1972, 35). The literature of aerial archaeology is full of pilots, observers and photographers with military titles (Squadron Leader, Major, Flight Lieutenant, Air Commodores and so on); or with RAF backgrounds (Allen, Crawford, Keillor and St Joseph amongst them).

Early flights had an element of the *Boy's Own* adventure, with the aerial archaeologist simultaneously an explorer (making new discoveries), adventurer (breaking new ground) and spy (with a privileged aerial view), a spirit personified in the eccentric O.G.S. Crawford (MacGregor 2000; Bowden 2001, 33-5) or Captain Alfred Buckham. Buckham, an artist as well as pilot, whose heady and ambiguous artwork combined aerial photos of cityscapes with dramatic clouds and paintings of his own plane, are as much factual record as they are fantasy (*1*). Equal parts 'adventurer, photographer and painter' he was the proverbial hero, flying in all weathers and conditions to fulfil his passion, serving in the First World War, crashing and flying again. He was the archetypal 'swashbuckling aviator' with a camera (Carter 1990). These masculine tasks were performed as if for King and Country. On Lindbergh's flights over Maya settlements, Deuel (1969, 170) imagines his thoughts – 'was not the flying machine ideally suited to scout across vast virginal areas of Central America, which had remained unmapped and most of which had never seen a white man?'

And, of course, the camera and the film, and the plane itself, are integral parts of the process and how they work and should best be used often becomes the concern of the archaeologist (*14, 15*). Many learn to fly (even I have dabbled in flying lessons), or develop their own photographs, or customise their kit in some way. Again these

are tasks usually associated with masculinity, involving gadgets, jargon and tinkering with technology. Papers have been published on the merits of types of plane (Gregory 1977) and the best lens (Pickering 1981). Davies (1984) recounted the passion of G.W.G. Allen for collecting and restoring early motorcars; Crawford was well known for his habit of riding his motorbike wearing flying gear (MacGregor 2000). Aerial archaeology can be an involving, multi-task process, typified by those such as Otto Braasch who fly, navigate and photograph on their own.

These metaphors may appear light-hearted but, as metaphors often do, they capture some truths, in this case about the process and practitioners of aerial photography in archaeology. They suggest that (as is traditionally regarded) the process is objective and technical, but that this is only a façade. Behind the process there can be a lot of excitement and emotion. They suggest that the participants are experienced, professional and dedicated individuals (all of which are true), but also that they get a thrill from this kind of archaeology. They suggest that high standards in recording and practice are demanded, but that there is room for improvisation and subjectivity. These apparent contradictions are two sides of the same coin. For me, the way that we record and report the results of reconnaissance only reflects the official, objective side of that coin; this leaves no room for bias, subjectivity and perception as I have outlined above. There is frequently no indication of the moments in the air when improvisation and choices occur, or how the personality and emotions of the archaeologist may shape the results of that particular flight.

CONCLUSION

In this paper, I have tried to outline three themes which for me connect the contributions in this volume – bias, perception and subjectivity – although of course I do not suggest that all contributors will either agree with my standpoint on these issues or what our reaction should be to them. For instance, I outlined three strategies for dealing with bias in aerial archaeology – to eliminate it; to quantify it; or to accept it. In taking the latter position as my preferred alternative, I accept the benefit of quantifying bias but feel that its elimination is both questionable and not cost-effective. Accepting bias as an inherent part of the archaeological process is a positive way of assessing how it shapes the archaeological record and may add an extra degree of caution to our interpretations, not just of individual sites, but also to patterns in the landscape.

In considering perception, I argued that what we 'perceive' from the air or indeed on the aerial photograph is partly a physical phenomenon, but one that is instantaneously assigned to a pre-conceived category of site. Cropmarks are as much ideas as things. Interpretation in the air and on the ground involves both the ability to recognise the photographic target as an archaeological site, but also depends on the (intellectual and physical) perspective of the aerial archaeologist. Finally, in considering subjectivity, I argued that we have an underplayed physical

and emotional engagement with the whole process that inevitably has a (perhaps relatively small) impact on what we see and record from the air. The practice of aerial photography is a physically demanding and rather detached process that calls for a certain way of recording and understanding archaeological traces, and this is very much a human, non-scientific, process.

As Plog and his co-workers have observed, '… it is virtually impossible to avoid introducing biases into our data and completely impossible to avoid making a variety of observational and recording errors in the field' (Plog *et al.* 1978, 384). It is perhaps only by honest self-reflection of our own practice that we can find the strengths and limitations of our working practice and the methods we use. This should not be, nor is this paper intended to be, a difficult and critical process. Rather, it is a call to acknowledge the inevitable subjective elements that form part of all archaeological practice (*22*), and so facilitate a more

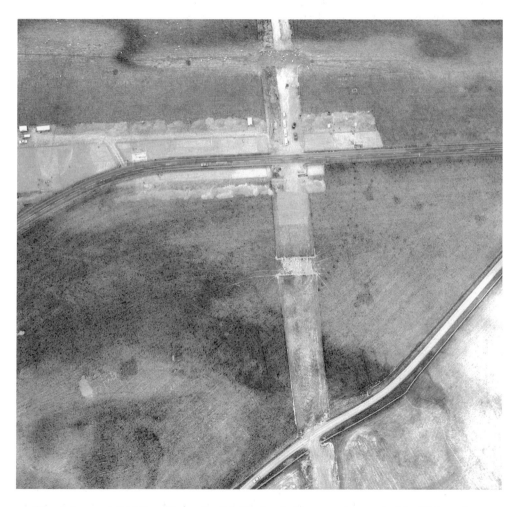

22 'The flying trowel' (*cf.* Pete Horne, English Heritage); the excavations at the Neolithic enclosure at Meldon Bridge, Scottish Borders. *Crown Copyright: RCAHMS, PB 1598*

realistic and potentially fruitful way of doing aerial archaeology. The following contributors in this volume have undergone such self-reflective journeys and should be commended for that.

If I have made aerial archaeology seem difficult, both physically demanding and emotionally draining, then *The Day of the Triffids* (Wyndham 1999, 202) offers one more insight:

> 'As a task, the flights were far from enjoyable, but at least they were to be preferred to lonely scouting in the ground.'

ACKNOWLEDGEMENTS

This paper is the culmination of many years of reflection and discussion on the nature of aerial archaeology. These thoughts have been explored through discussions with, amongst others, Mike Anderton, Andrew Baines, Dave Cowley, Rog Palmer and Wlodek Rączkowski. I doubt if any of them can be blamed for any of the thoughts expressed above. Parts of this paper were published in an article in *AARGnews* in 2002, while others were delivered in a paper at the AARG conference in 2002. Thanks to RCAHMS for permission to reproduce a number of photographic images.

BIBLIOGRAPHY

Aston, M. & Rowley, T. 1974 *Landscape archaeology: an introduction to fieldwork techniques on post-Roman landscapes*, David & Charles

Atkinson, R.J.C. 1946 *Field archaeology*, Methuen

Bender, B., Hamilton, S. & Tilley, C. 1997 Leskernick: stone worlds; alternative narratives; nested landscapes, *Proceedings of the Prehistoric Society* 63, 147-178

Bowden, M. (ed.) 1999 *Unravelling the landscape: inquisitive approaches to archaeology*, Tempus

Bowden, M. 2001 Mapping the past: OGS Crawford and the development of landscape studies, *Landscapes* 2, 29-45

Bradley, R., Durden, T. & Spencer, N. 1994 The creative use of bias in field survey, *Antiquity* 68, 343-6

Bradley, R. 2003 Seeing things. Perception, experience and the constraints of excavation, *Journal of Social Archaeology* 3.2, 151-68

Brophy, K. 2002 Thinking and doing aerial photography, *AARGnews* 24, 33-9

Carter, G. 1990 Captain of the clouds, *The Independent Magazine* 21 April 1990, 52-55

Cowley, D.C. 2002 A case-study in the analysis of patterns of aerial reconnaissance in a lowland area of southwest Scotland, *Archaeological Prospection* 9, 255-65

Crawford, O.G.S. 1955 *Said and done. The autobiography of an archaeologist*, Weidenfield and Nicholas

Cumberpatch, C.C. 1997 Towards a phenomenological approach to the study of medieval pottery, in: Cumberpatch, C.C. & Blinkhorn, P.W. (eds) *Not so much a pot, more a way of life: current approaches to artefact analysis in archaeology*, Oxbow, 125-51

Davies, J.D.R. 1984 George Allan – the man, *Aerial Archaeology* 10, 31

Deuel, L. 1969 *Flights into yesterday: the story of aerial archaeology*, MacDonald

Gibbens, H. 1987 Marilyn's eye in the sky, *The Scotsman Magazine* 8.1, April 1987

Gregory, R. G. 1977 Aircraft as a tool in archaeological surveying, *Aerial Archaeology* 1, 7

Heiman, G. 1972 *Aerial photography: the story of aerial mapping and reconnaissance*, Collier-MacMillan

Hodder, I. 1997 'Always momentary, fluid and flexible': towards a self-reflexive excavation methodology, *Antiquity* 71, 691-700

Lucas, G. 2001 *Critical approaches to fieldwork*, Routledge

MacGregor, A. 2000 An aerial relic of OGS Crawford, *Antiquity* 74, 87-100

Merleau-Ponty, M. 1962 *Phenomenology of perception*, Routledge

Palmer, R. 1978 Aerial archaeology and sampling, in: Cherry, J.F., Gamble, C. & Shennan, S. (eds) *Sampling in contemporary British archaeology*, British Archaeological Reports, 129-48

Pickering, J. 1981 Telephoto and zoom lens air photography for archaeology, *Aerial Archaeology* 7, 4-6

Plog, S., Plog, F. & Wait, W. 1978 Decision making in modern surveys, *Advances in Archaeological Method and Theory* 1, 383-421

Riley, D. 1987 *Air photography and archaeology*, Duckworth

Rączkowski, W. 2002 Beyond the technology: do we need 'meta-aerial archaeology'?, in: Bewley, R.H. & Rączkowski, W. (eds) *Aerial archaeology: developing future practice*, IOS Press

Shanks, M. 1992 *Experiencing the past*, Routledge

Shennan, S. 1985 *Experiments in the collection and analysis of archaeological survey data*, University of Sheffield, Department of Archaeology and Prehistory

Tilley, C. 1994 *A phenomenology of landscape*, Berg

Wilson, D.R. 2000 *Air photo interpretation for archaeologists* (second edition), Tempus

Wyndham, J. 1999 *The day of the Triffids*, Penguin (1999 edition)

SOME OBSERVATIONS ON THE NATURE OF AERIAL SURVEY

David C. Cowley & Simon M.D. Gilmour

INTRODUCTION

The processes involved in survey of any type are manifold and complex and range across the technical, intellectual and emotional. Where they have been articulated, discussion has tended to concentrate on the mechanics of the procedures and technical aspects of equipment. Much more difficult to express are the intertwined roles of perception, experience and cognition, which operate at an individual level and render the survey process an essentially subjective experience, driven by a cycle of decision making, both conscious and unconscious. This subjectivity is increasingly recognised and can be used as a facet of survey, both as a means of understanding what elements of the products of survey are a consequence of the individual(s) undertaking the work or the methodologies employed, and as a mechanism to engage in a reflective, or 'reflexive', way with these processes and the material under examination. In this context the assessment of subjectivity and bias in survey should begin to shrug off the negative connotations that these terms often evoke (*cf.* Brophy this volume), enabling survey practitioners and end-users to engage in dialogue about this sometimes vexed issue.

Aerial survey is no different in this respect, and there is a long-standing recognition of the pervasive subjectivity of the processes involved, from planning, through implementation, to analysis of aerial-derived material (e.g. Brophy 2002; Cowley 2002; Featherstone & Bewley 2000; Palmer 2001; Rączkowski 2002). However, despite this interest there is surprisingly little published material describing the detail of the survey process beyond the generalities of, for example, the circumstances that lead to cropmark formation; ranging across issues such as where to look and the screening and evaluation of patterns. This paper explores

some of these issues, highlighting the potential value of 'flight biographies' in conveying this type of information, and presenting a case study of the discovery during aerial survey of a pit-defined cursus monument in Fife during July 2003, which is placed in the wider context of RCAHMS's national summer flying programme. In this paper aerial survey is used to refer to 'observer-directed' reconnaissance and photography (a term coined by Rog Palmer), as opposed to block coverage (more usually referred to using the shorthand of 'verticals').

FLIGHT BIOGRAPHIES

The credit for the innovation of applying aerial reconnaissance to archaeological subjects in Scotland can be credited to O.G.S. Crawford, who undertook a groundbreaking series of flights in the 1930s, publishing his results and observations in *Antiquity* (1930; 1939). In each of these published contributions he adopts a personal style, describing the work as a narrative (a term he applied to his publication (1939, 289)). This narrative highlights the very personal decisions made and their impact on choices of target and route, the thought processes involved in recognition and interpretation of features, his emotional state, ranging from anxiety to elation, and the excitement of discovery.

Crawford's biographical approach to disseminating the results of his flights is interesting because it incorporates many details on the reasoning and practice of recording from the air that provide the context for the subsequent flights from which photographs were published. In fact, Crawford apologises for the, 'slight but inevitable intrusion of the personal element imposed by the character of the narrative' (1930, 273). Details such as the fact that the pilot and observer were able to sit side by side, and the advantages of this disposition in the plane, as well as the fact that sites were being spotted by both the pilot and the observer, and that the flight path followed Roman roads whenever possible, are useful and important observations. Descriptions include what was not recorded as well as what was, the emotional impact of the discoveries made and even admit that without a comparable ground survey much may have been missed even along such well-known features as Hadrian's Wall, or that features may need to be 'ground-truthed' as at Burnswark, Dumfriesshire (*ibid.*, 275-6). Discussion of the weather and its impact on the flights, and especially the combination of weather and topography in Scotland during flights undertaken to accompany the production of the Ordnance Survey Map of Roman Britain (Crawford 1939, 280), give flesh to the bare bones of flight routes. During these later flights it was again the pilot who is credited with discovering many of the new sites and in fact took all the photographs (*ibid.*, 281). The process of interpretation in-flight is briefly addressed in the context of recognising both Roman signal stations from relict sheepfolds (*ibid.*, 282) and the presence of Roman roads as revealed by the pattern of their quarry pits (*ibid.*, 283). Crawford also noted sites that would repay

further flights during different conditions and areas where, had more time been available, more sites than those recorded might be discovered (*ibid.*, 285).

The importance of this flight biography style of recording aerial reconnaissance is made clear when Crawford described the discovery of Cardean Roman fort (*23*) as partially accidental because they were looking for a different site at the time (*ibid.*, 287-8). He is also candid about his aims, observing that they had, 'tried not to neglect entirely the remains of other periods. Native forts were so numerous that is was difficult, and sometimes impossible, to check them on the map' (*ibid.*, 289; see also Jones this volume); how, one wonders, would such frankness be received today? These 'personalised' descriptions of flights allow us to understand and evaluate the context of the material discovered and recorded.

Incidentally, another pioneer of Scottish aerial reconnaissance, J.K. St Joseph, also compiled detailed (unpublished) flight logs and these are preserved in The Unit for Landscape Modeling at Cambridge (formerly CUCAP). These specify

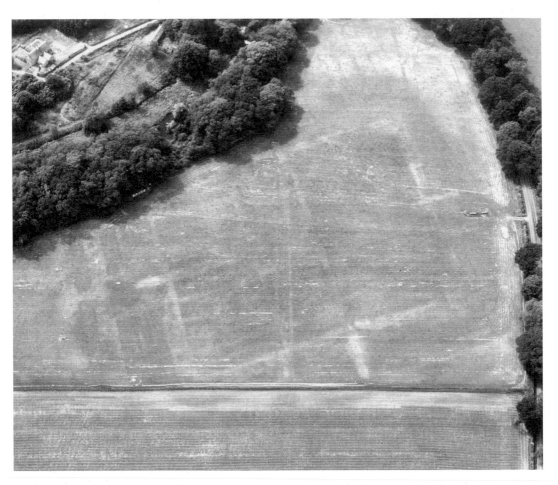

23 The Roman fort at Cardean as seen from the air in 1977. The site was discovered, partly by accident, from the air by O.G.S. Crawford. *Crown Copyright: RCAHMS, AN 3347*

the motivations of sorties and the circumstances surrounding the development of the flight, what was photographed or not photographed, and why. St Joseph's motivation in producing these logs included conveying what he did and why to workers using his material (D.R. Wilson pers. comm.).

Publication of aerial reconnaissance since Crawford has invariably concentrated on the interpretation of the imagery itself. Discussion focuses on various factors that influence the pictures and are what might be described as physical factors, generally out of the control of the photographer, such as geology and geography, weather, visibility and cloud cover, as well as physical factors much more within human control, such as the type of aircraft, camera and film. However, all of these are placed in a formal introduction to the interpretation and, more recently, mapping of the results, rather than a detailed analysis of the survey process itself, and the less tangible factors that impact on the results of any given sortie.

For example, the introduction (and these discussions are often limited to the introduction, preface or first chapter of any publication) to *The Uses of Air Photography* (second edition) concentrates on the various film types, the types of photographic cover available, including the various scales, and resolution of vertical versus oblique photography (St Joseph 1977, 13-14). There then follows information on the geology, geography, visibility and cloud cover that might affect aerial photographs (*ibid.*, 16). The closest this publication comes to discussing the process of the flights themselves is an analysis of the difference between targeted and general flying, the former the equivalent to oblique photography and the latter of vertical photography (*ibid.*, 14). Derek Riley covers some of the same issues in his *Early Landscapes from the Air* but also goes into much more detail about the mapping of the cropmarks from oblique photography and how this began to influence the patterns of later flights (1980, 2). In fact, Riley also highlights a point about the flight process itself, suggesting that due to the banking of the aircraft required to capture the cropmarks, 'much time was wasted while the aircraft was circling' (*ibid.*, 5; see also Palmer this volume). However, this single highlight of a possible retrospective analysis of the flight process was not picked up in either *The Emerging Past* (Whimster 1989) or *The Ancient Landscapes of the Yorkshire Wolds* (Stoertz 1997), which both epitomise the style of recent aerial photographic publications by concentrating entirely on the imagery, and the mapping of the material from those images, with very little, if any, critique of the processes that have influenced the images used. This tendency can be further illustrated in *Lincolnshire's Archaeology from the Air* (Bewley 1998), a volume that presents the results of a RCHME National Mapping Programme (NMP) project. In this publication those contributions dealing with the physical landscape and a series of period or class specific essays follow papers on the NMP. The paper entitled 'The contribution of Aerial Survey: Understanding the Results' (Carter 1998) is the final paper in the volume. It is something of a mantra in the aerial archaeological community that the results of aerial survey are routinely abused with little understanding of their character, and in this context the placement of

Ann Carter's paper at the end of the volume could be read as symptomatic of not placing the issues of bias and subjectivity that pervade all survey to the fore. These issues should be the vanguard; in our view explanation of the nature of the material should precede the more specific analysis (in this instance the editor placed the Carter paper at the back of the volume as a 'rounding-off' piece (R.H. Bewley pers. comm.)).

David Wilson's second edition of the bible of air photographic interpretation, *Air Photographic Interpretation for Archaeologists*, again only hints at the issues involved. 'When a specialist air photographer records an archaeological site in this way [oblique photography], the most important elements in the interpretation have taken place before he presses the button on the camera.' (2000, 33), suggesting that it has already been decided that the site is worthy of record, what angle it is to be viewed from etc., and that this leads to a very selective record. We would argue that this is entirely correct, but that there are other 'elements' involved in the pre-flight and in-flight interpretation process, and that, other than these statements by Wilson, little has been written about them.

In contrast, the *Aerial Archaeology E-mail Newsletter* (ISSN 1479-6481), edited by Derek Edwards and circulated to about 300 subscribers, the majority of whom are based in the United Kingdom and mainland Europe, provides a less formal forum for articulating exactly these issues (to subscribe to the newsletter, email: dae@air-arch.fsworld.co.uk). In fact, the various flight reports filed in this newsletter are often brief flight biographies, presented in an informal manner, but giving much more detail on those elements of the flight process that we wish to highlight. Here we find details of the various reasons for flights, why areas were chosen for inspection, what the original target(s) of the sorties was and whether this was successful or not. There are often descriptions of cropmarks viewed from the plane but not recorded for various reasons (e.g. weather closing in or controlled airspace), the use of 'touchstone' sites early in the cropmark season to try and predict the potential of areas to cropmark, and in many instances there are already interpretations of the cropmarks seen, such as whether something looks Roman or Neolithic depending on its character.

Retrospective analysis of survey methodologies is a valid and vital process in understanding how our datasets come about. Reflexive practice in archaeological excavation and its interpretation is increasingly commonplace (i.e. Andrews *et al.* 2000; Hodder 1999), and aerial survey is an aspect of archaeological operations where such approaches are entirely appropriate. Although there has been a distinct trend in the last decade for the teaching institutions to reduce the amount of fieldwork that forms part of the archaeological learning experience, the understanding of the origins of archaeological data is of fundamental importance. This becomes paramount when the form of data acquisition is one that has necessarily restricted access due to costs and availability of the material required (such as aircraft), but which so obviously has a considerable impact on the perception of any given archaeological landscape. The flight biography, or at

least a recognition of the various aspects of the flying process that contribute to the formation of the imagery that is interpreted and used in archaeology, should be a valid area for discussion and those who have no knowledge of this process need to be made aware so that they can make more informed interpretations of the data produced. What follows is a contribution to this facet of archaeological interpretation, where a specific flight is placed in the wider context of RCAHMS' annual programme of summer reconnaissance and photography.

RCAHMS AERIAL SURVEY

Since 1976, RCAHMS has pursued an annual programme of aerial reconnaissance during the summer, directed towards recording sites revealed by cropmarking, and less commonly, parchmarking. As a body of record, with responsibilities to provide national coverage, this survey has ranged across the cropmark-producing areas of Scotland, largely, but not exclusively, concentrated into the arable heartlands of the east coast running south from Aberdeen and the major river valleys of the south. This pattern of flying, during June, July and August is illustrated (*24*) by the GPS flight paths for the majority of the sorties from 1993 onwards. There is clearly an emphasis on the arable areas of Eastern Scotland, which even after nearly 30 years of reconnaissance are still producing new material. While there are issues regarding how representative is this focus on honeypot areas where high returns are guaranteed, as against working areas, such as pasture, where returns may be lower but which cumulatively serve to provide much more balanced site distributions (Cowley 2002), there is a clear need to continue working the arable areas. The strategy behind the annual cropmark survey season is conditioned by a number of factors, including the shared experience of over a quarter of a century of aerial survey, and soil moisture deficit data that has been shown to have an indicative value. In addition, there is a process of flying areas to evaluate conditions that begins at the start of June, and in a patchy year such as 2003, continues through the summer. There is also a set of performance targets for aerial survey that have to be met.

The aircraft used is a Cessna 172 (four-seat) aircraft, with a photographer occupying the front, left seat (with an opening window) beside the pilot, and the flight director (this can be an archaeologist or architectural historian on an RCAHMS flight) occupying the left rear seat behind the photographer (*25*). The flight director, sitting in the rather low rear seat, has no forward vision and has to do all observing out of the left side of the aircraft and, at a bit of a stretch, across the camera gear that usually occupies the fourth seat behind the pilot, out of the right side. Essentially, this set-up places a very strong emphasis on the left side, which has a significant impact on the placement of the aircraft relative to what is being seen. The fourth seat behind the pilot is usually occupied by photographic gear, but it is also used for an additional observer, usually to

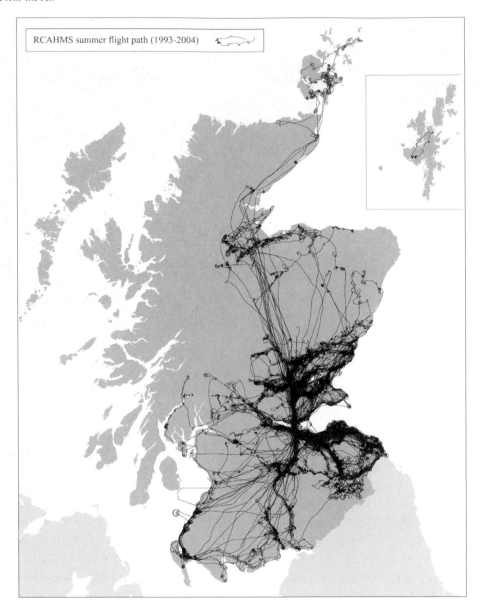

RCAHMS summer flight path (1993-2004)

24 Map of the majority of GPS flight paths for RCAHMS summer sorties (1993-2003). *Crown Copyright: RCAHMS*

provide training and experience. This practice also serves to offset some of the left-hand bias noted above, and there are examples of sites that would probably not have been found had this fourth seat not been occupied. As well as ensuring a wider view, two observers on the sortie provides for 'on-site' discussion and 'peer review', both processes that can help to offset the impact of lone-working where working practice may fossilise. However, this practice has implications for staff time and the weighting of the aircraft and its consequent fuel consumption.

25 In flight over the Western Isles, Scotland: this view of the inside of a Cessna 172 conveys something of its cramped interior. *Crown Copyright: RCAHMS*

This set-up pertains to RCAHMS and we find it an effective way of working, but there is some variation in (equally valid) working practice across Europe. It is, for example, quite common for the seat beside the pilot to be occupied by an individual fulfilling the tasks of observer, navigator and photographer.

A Cessna aircraft is not a large plane, and the working conditions for aerial surveyors are generally cramped, noisy and often cold when flying at 2,000ft with the window open. At the present time the flight director on an RCAHMS flight uses 1:50,000 scale OS Landranger maps and a Garmin GPS to locate the aircraft accurately and note the location of any sites photographed. Sites are plotted on the map in coloured pencil and a note is made on a separate list of its form or immediate on-the-spot classification, the name of the nearest mapped farm, and a six figure grid reference if possible (all necessary to produce a primary log in advance of developing and printing of film, and in case the GPS fails). The aircraft is usually already in a relatively close circular flight path, entailing the left wing pointing more-or-less towards the ground, and ensuring the entire recording exercise is done at an angle. At the same time the photographer will have opened the window and begun photographing the site, creating a considerable air stream in the rear of the aircraft where the flight director is trying to record as well as continue examining the present site and look for others nearby. The photographer meanwhile, because of the configuration of the camera used, can no longer use the microphone on the headset to talk to the pilot or flight director, and must communicate how and where he wants the plane located

using hand signals. When recording multiple sites, such as might occur during a particularly good cropmark season, the aircraft is constantly moving, swinging from side to side, changing from one close circle to another, and both the flight director and photographer have to concentrate on their tasks. This is not an environment conducive to careful consideration of the evidence being recorded, or even of the wider context of the individual photographed areas!

In line with Civil Aviation Authority (CAA) guidelines the duration of the flight is limited to three hours (which must include an allowance for time waiting to land), conducted under Visual Flight Rules (VFR) that require good all-round visibility. There are specific controlled airspace zones in Scotland, which require careful planning to work within, if possible at all, and cover reasonably large percentages of Scotland.

The summer of 2003 was warm and dry and a good cropmark year seemed likely. However, the patterns of the weather did not produce the crop stress required to induce widespread cropmarking. Indeed, the year was characterised by the patchiness of cropmark formation, varying from one river valley to another in a manner suggesting that very localised patterns of rainfall may have been

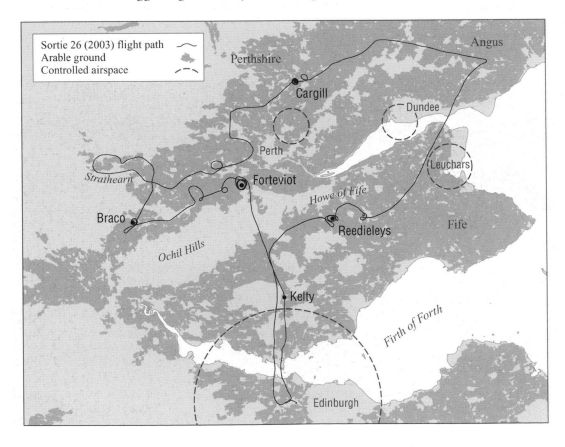

26 The GPS flight path for sortie 26 (2003) with the distribution of arable ground, controlled air space and sites mentioned in the text. *Crown Copyright: RCAHMS*

exerting a significant influence. In this context it proved very difficult to predict the occurrence of cropmarks in any given area, and the process of flying large areas to assess the state of crops came to the fore; one such flight is described here.

SORTIE 26, 14 JULY 2003 – A POTTED BIOGRAPHY

The general route of this sortie was preconditioned by discussions in the office before the flight, which were informed by the need to provide a national coverage and the shared experience of staff involved in the aerial survey programme. This sortie was directed into the Earn and southern Perthshire, taking in areas that had been productive in the past. A routing northwards out of Edinburgh airport will take a small plane out of the Controlled Airspace (CTA)/Aerodrome Traffic Zone (ATZ) at Kelty, to follow the line of the M90 to Kinross and thence across the east end of The Ochil Hills and into Strathearn (*26*). With this sort of route it is likely that you end up over or near the extensive prehistoric complex at Forteviot (*27*); the major elements of this, including the henges, were visible and were photographed as part of a trial of a digital camera. A westwards flight path was then chosen, placing the aircraft along the River Earn, more or less centered on the extent of the arable ground as marked in an indicative way (*26*). The emphasis

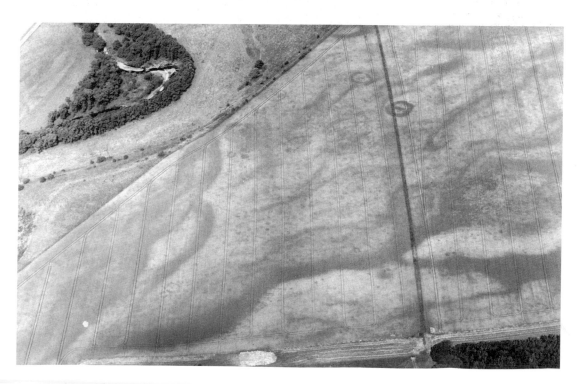

27 An aerial view of part of the complex of sites at Forteviot in Perthshire. *Crown Copyright: RCAHMS, E 36735*

at this stage of the flight lay in looking at the variations in tone in the arable fields, but it rapidly became clear that it was only the palaeochannels on the flood plain that were showing in anything like a consistent way. Leadketty, another familiar and reliable face in the cropmark record, was also showing, and while it has been captured under better conditions, the absence of other material prompted a series of images, again with the testing of the digital camera in mind. The extent of arable ground reduces further west in Strathearn (and has generally reduced significantly since the mapping of its extent in 1988) (*26*), and here the increasing areas of improved pasture were examined for parchmarks, a particular interest for the flight director (DCC) but, unsurprisingly given the lack of cropmarking, there was a monotone of green fields. Investigating the more broken patches of arable and improved ground confirmed the non-productivity of this patch of ground, leading in time to Braco and the Roman fort of Ardoch. This was photographed, partly to enhance the colour holdings of the NMRS, but also, in small part, to ensure that the flight did at least return with something!

The upper reaches of the Earn were examined, before returning along the north side of Strathearn towards Perth and then heading along the lower reaches

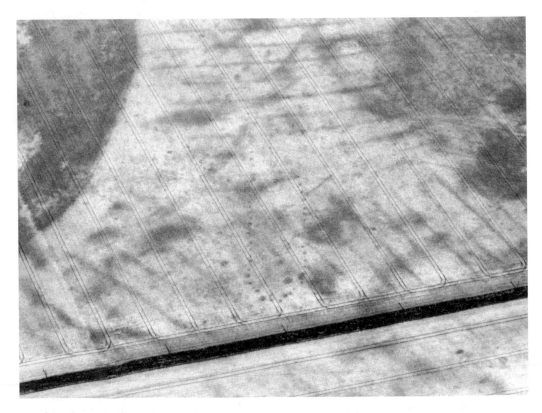

28 Aerial view of the pitted cursus monument and rig at Reedieleys, in the Howe of Fife. This image was captured on a subsequent sortie due to a camera malfunction during sortie 26. *Crown Copyright: RCAHMS, E 36753*

of Strathmore, often a productive cropmark area, all the while confirming the lack of cropmark formation, and by this time having given up any hope of extracting anything from the pasture areas and concentrating on the honeypot areas of arable. The Roman fortlet at Cargill was again photographed: a very familiar face that can be relied on to show in even the most inauspicious conditions. The eastwards progress of the flight was limited by a bank of low cloud built up along the coast of Angus, and having seen so little to excite attention it was decided to return to Edinburgh, taking a slightly eastern route over Fife. There was a lot of activity at RAF Leuchars so it was not possible to do anything other than fly through an area where there were, as is usual in most years, at least some cropmarks showing. This route took us near the Howe of Fife, a large basin of freely draining soils blanketed in arable. On the eastern edge of this area a small, rather innocuous ring ditch was observed by the flight director and photographed, prompting a slight diversion to the west to examine the rest of the area. During this diversion, and in a sea of otherwise unresponsive fields, the cropmarks of a pitted cursus monument were discovered (*28*). Neolithic cursus monuments are currently very much in the minds of the aerial survey team at RCAHMS because a volume on the Scottish examples is being prepared (Brophy & RCAHMS forthcoming), and at the instant of recognition of the features that made up this monument in the crop below, there was also a rush of excitement from the knowledge that this was a site that had not been previously recorded. This excitement was heightened by the fact that there was no ambiguity in the character of the monument although, as a pitted monument, the feature was not a bold one. Having photographed the site, a combination of time pressing and other flight activity around us sent us straight back to Edinburgh.

From the point of leaving the controlled airspace to the north of the Forth, within the overall structure of the flight, the areas examined in general and those looked at in detail are predicated on an ongoing series of value judgments that reflect the patterns that caught the eye of the flight crew and the decisions based on them. As such the flight was essentially a highly subjective process, but one that is informed by past experience and the ongoing stimulus of working a piece of ground, attempting to identify the patterns that produce a return, and minimising input to unproductive searches. In the context of the discovery of the 'new' pitted cursus at Reedieleys (Brophy & RCAHMS forthcoming; Cowley & Gilmour 2005), the fact that a small innocuous ring ditch caught the eye of the flight crew and resulted in a diversion into the area, highlights the accidental nature of many such discoveries, mirroring Crawford's experience nearly three-quarters of a century earlier. The changes in the state of mind during this sortie, ranging between an initial optimism, to a growing sense of disappointment, through to the surprise and excitement of discovery at the end of the flight, encapsulate aspects of many programmes of ongoing survey. The mundane and routine predominate, but every so often there is the rush of excitement in discovery and a heightened engagement in the process of interpretation and

analysis, something that is not limited to the survey process alone, but can occur during, for example, routine cataloguing.

The patterns illustrated in this sortie represent, in microcosm, many of the vagaries of discovery in summer flying as a whole. It also reinforces the importance of maintaining programmes of prospective flying, because major discrete monuments such as Reedieleys will continue to emerge, while the ongoing recording of other elements in the jigsaw will continue to enhance our understanding of patterns in the wider landscape.

CONCLUSION

In describing the context and circumstances of the discovery of a cursus monument in Fife, this paper has attempted to shed some light on aspects of the processes involved in producing a resource that is often used without questioning the impact that its methodologies, preconceptions and other inherent and unspoken biases, may have on the character of the data. Source criticism is vital to make proper use of data, and has a very significant role to play in the development of methodologies. In this process, survey practitioners must maintain a self-critical perspective, in which the reviewing of flights and the data produced, plays a central role in developing future practice, ensuring it does not stagnate, simply reinforcing known patterns in our data, but continues to expand the boundaries of our knowledge. The notion of biographies of flight, including pre-flight planning, the mechanisms of a sortie and the experience of the flight, may be a useful one for both presenting and explaining the survey process to non-fliers, but also for providing a mechanism for the self-critical assessment of our own procedures: an autobiography if you like. This process should also be extended to the critical assessment of the products and progress of the national bodies of survey (RCHME/English Heritage, RCAHMS and the RCAHMW), as well as regional fliers (see for example Oakey this volume). This type of analytical approach is vital to maintaining best practice and developing future practice that does not simply reinforce what we have already learnt. This is especially pertinent where the substantial and vitally important datasets that are the national collections of aerial photographs are being produced by a handful of individuals. These individuals need to maintain a self-critical approach that is open to the criticisms of end-users as part of a mature dialogue.

ACKNOWLEDGEMENTS

We are grateful to various colleagues at RCAHMS, Bob Bewley and Rog Palmer for comments on the text, and to Georgina Brown for producing the two maps (*24, 26*).

BIBLIOGRAPHY

Andrews, G., Barrett, J.C. & Lewis, J.S.C. 2000 Interpretation not record: the practice of archaeology, *Antiquity* 74, No. 285, 525-30

Bewley, R.H. (ed.) *Lincolnshire's Archaeology from the Air*, Occasional Papers in Lincolnshire History and Archaeology, Volume 11

Brophy, K. 2002 Thinking and doing aerial photography, *AARGnews* 24, 33-9

Brophy, K. & RCAHMS forthcoming *The Neolithic Cursus Monuments of Scotland*, RCAHMS/Society of Antiquaries of Scotland

Carter, A. 1998 The Contribution of Aerial Survey: Understanding the Results, in: Bewley, R.H. (ed.) *Lincolnshire's Archaeology from the Air*, Occasional Papers in Lincolnshire History and Archaeology, Volume 11, 96-104

Cowley, D.C. 2002 A Case Study in the Analysis of Patterns of Aerial Reconnaissance in a Lowland Area of Southwest Scotland, *Archaeological Prospection* 9, 255-65

Cowley, D.C. & Gilmour, S.M.D. 2005 Discovery from the air: a pit defined cursus monument in Fife, *Scottish Archaeological Journal* 25.2 (2003), 171-8

Crawford, O.G.S. 1930 Editorial Notes, *Antiquity* IV, 273-8

Crawford, O.G.S. 1939 Air Reconnaissance of Roman Scotland, *Antiquity* XIII, 280-92

Featherstone, R. & Bewley, R. 2000 Recent Aerial Reconnaissance in North Oxfordshire, *Oxoniensia* 65, 13-26

Hodder, I. 1999 *The Archaeological Process: an introduction*, Blackwell

Palmer, R. 2001 'The site was discovered on an aerial photograph.' Thoughts on the 'when' of discovery, *AARGnews* 23, 46-7

Rączkowski, W. 2002 Beyond the technology: so do we need 'meta-aerial archaeology'? in: Bewley, R.H. & Rączkowski, W. (eds) 2002 *Aerial Archaeology Developing Future Practice*, IOS Press, 311-27

Riley, D.N. 1980 *Early Landscapes from the Air*, Department of Prehistory and Archaeology, University of Sheffield

St Joseph, J.K.S. 1977 *The Uses of Air Photography* (second edition), John Baker

Stoertz, C. 1997 *Ancient Landscapes of the Yorkshire Wolds: aerial photographic transcription and analysis*, RCHME

Whimster, R. 1989 *The Emerging Past: air photography and the Buried Landscape*, RCHME

Wilson, D.R. 2000 *Air Photo Interpretation for Archaeologists* (second edition), Tempus

<center>5</center>

BIAS IN AERIAL RECONNAISSANCE

David R. Wilson

INTRODUCTION

Bias is an inevitable feature of all aerial reconnaissance. The important thing is for the practitioner to recognise it in her or his own work and to declare it wherever the reader or listener would otherwise be misled by the results obtained.

A properly designed scientific experiment will incorporate in its design procedures that specifically seek to eliminate (or at least confine within acceptable limits) possible bias in the data. Aerial reconnaissance obviously does not take place in laboratory conditions, and bias in the data is not something that can be avoided. The kinds of bias that occur are many and varied. At one end of the spectrum bias may be built into the policy of the sponsor and into the research programme being pursued. Often such bias is laudable or at least harmless – nevertheless every policy should be subject to periodic review. More insidiously, at the other end of the spectrum are the kinds of bias that pass unnoticed because they are unconscious. Here it is for the practitioner to undertake her or his own review, either by candid self-assessment or else by sometimes flying with experienced and critical colleagues.

Let us look at examples of different kinds of bias.

BIAS TOWARDS ARCHAEOLOGY

All aerial photography, if it is to be of much value and if it is to be cost-effective, must be selective in its extent or its subject matter or both. Whatever criteria inform the photographer's overall strategy in this respect, these also constitute a

first level of bias in the work undertaken. Most archaeological air-photographers, virtually by definition, do for the most part limit themselves to what they believe to be archaeological features. This may be part of their job description, or it may be what led them to take to the air in the first place; it is still one kind of bias.

The working of this kind of bias is most clearly seen when it affects a photographer who does not in fact limit himself just to archaeological work. When I was working for Cambridge University, our interests were multidisciplinary, comprising not only archaeology, but also agriculture, forestry, geology, land use and nature conservation. Thus, I have myself been known to spot a field of interesting-looking cropmarks, to have perceived on closer inspection that the marks are not archaeological, but geological in character, and to have then momentarily decided not to take photographs for that reason. This, I am happy to relate, is the very moment that I woke up to the fact that I was thinking like an archaeologist and immediately proceeded to take photographs precisely because the marks were geological!

BIAS TOWARDS 'HONEYPOT' AREAS

Selectivity or bias in reconnaissance strategy takes a good many different forms. A particularly vexed question concerns those areas that are generally unrewarding for summer photography because their soils are not favourable to the production of cropmarks. How much time should be spent in scanning such areas, normally without significant benefit? After all, if you never look, you will never see cropmarks when they do occur, but experience shows that this does not happen often. The most effective strategy is probably to make frequent visits to monitor local conditions, but not to spend much time there except on those rare occasions when archaeological features do become widely visible. If that happens, it will be justified to spend a good deal of time in the area, even if the results obtained are still meagre by normal standards. Whatever strategy is adopted, it is inevitable that many more photographs will be taken on those soils (like river gravels) that readily produce archaeological cropmarks than on those (like clays) that do not do so.

From time to time retrospective analysis is applied to past flying programmes in a particular region, plotting the distribution both of photographs in general and of repeat photography in particular, and unsurprisingly these are usually found to be concentrated in so-called 'honeypot' areas on river gravels, chalk and limestone, while the less responsive areas contain few photographs and are therefore characterised as 'neglected'. Such studies are nevertheless flawed unless the investigator has included the flight logs of the respective photographers within the study, to establish how much time they actually spent in the relevant areas looking for archaeological features, but without success. A lack of photographs does not necessarily mean a lack of reconnaissance.

The bias in such a case is indeed often not that exhibited by the photographer, but that of the subsequent investigator. Of course, the flight log may not be very

informative. If it is virtually limited to an account of areas where photographs were taken, it can add little to what is inferred from the photographs themselves. The recent use of GPS to record the total flight path of a photographic aircraft has done much to clarify for the uninitiated the ways that such aircraft are actually flown, as well as bringing credibility to subsequent analysis (*cf.* Cowley 2002).

Having said all that, it is certainly true that there are some areas that, because of their position in relation to active airfields and other controlled airspace and because of largely unrewarding soils, have yielded little information until targeted by a local flier with the knowledge and tenacity to fathom their secrets. Such an area is the Cheshire Plain: much of it poorly drained; close enough to Manchester Airport to be constrained by many flying restrictions; and remote enough from Cambridge and Biggin Hill to make it unlikely that flying teams from either Cambridge University or English Heritage will find it convenient to devote more than passing attention to it. This is where a local flier has many advantages. The home airfield probably lies inside controlled airspace, so she or he is forced to learn how to get about. A relationship is built up over time with the air-traffic controllers, who get to know the photographic aircraft, the way that it flies on its mysterious missions and the fact that it can be relied on to behave with good sense and consideration. Pre-flight briefings become more helpful. Little time is needed to reach the areas of immediate interest, so not too much is lost when a flight is unproductive, but eventually you get to know the limited areas of more favourable geology and can also take advantage of extreme weather conditions when they occur. Most important, by pursuing a strongly local interest you can be better informed about the local archaeology than anyone whose interest is spread across one or more countries and thus more readily perceive the significance of what you do find.

BIAS TOWARDS THE FAMILIAR

I will readily admit that there can be a tendency for certain routes to become habitual. If you take off from Cambridge with the intention of going to Essex, you are bound to start by skirting the London Terminal Movement Area until you reach Haverhill. From Haverhill there is a natural route down the Stour valley, which forms the county boundary with Suffolk and is a 'honeypot' area with many varied and unusual potential cropmarks. There are nevertheless a number of factors that ensure that in practice you do not always go that way. If, for example, your flight plan is to cross the Thames at Tilbury and continue south into Kent, you have little reason to make an excursion eastwards to Colchester. And in any case it would be normal practice to take a different route on each succeeding flight, simply in order to see as much of the ground as possible.

A useful way to ensure that flying patterns do not become too well established is to pursue more than one programme of photography simultaneously. Even

if you do not have a Buildings Section claiming your services, you may still choose to develop an interest in country houses, parks and gardens that will take you in directions that are unconnected with your understanding of the distribution of prehistoric settlement or of supposed Roman lines of march. What is more, such targets may take you into controlled airspace that you would not normally penetrate (you will, however, need a transponder with mode C, which automatically transmits height information). Air traffic controllers are not responsive to requests to enter their airspace 'to have a look around'. If you don't have any specific targets for photography, you have to give them a story they can agree to, asking (for example) to enter the zone at point A and then route via B and C. If you are wise, you mention that you are a photographic aircraft and that they may from time to time see you make a 360° turn for photography. This gives you quite a lot of freedom, but, even so, you really will have to take a direct course through B and C, unless you negotiate a change of route along the way. Despite these limitations, you will see a good deal more than you ever could by staying out of their zone altogether.

A good example of serendipitous archaeological discovery when engaged in non-archaeological photography is provided by the Roman fort of Malling. The Cambridge University aircraft was operating west of Stirling, engaged on a

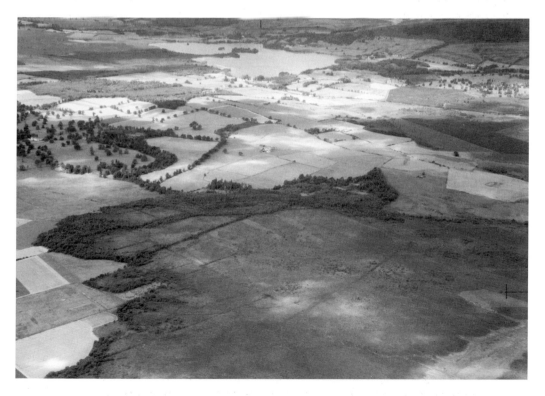

29 Looking over part of Flanders Moss to the Lake of Menteith (Stirling Council, Scotland), 4 August 1974. *Copyright reserved: Cambridge University Collection of Air Photographs, BRI 15*

vertical survey of Flanders Moss for what was then called the Nature Conservancy. Professor St Joseph was operating the vertical camera, and he and the pilot were navigating the aircraft on parallel tracks across the moss. I was sitting in the back, making notes from which to write up the day's log that evening. I had the leisure to look around (*29*) and I saw some striking cropmarks at the west end of the Lake of Menteith. The survey came to an end at the north-east edge of the moss, and I then remarked to St Joseph that there was something I thought he would wish to look at the other end of the lake. Oh, what did I think that it was? Well, it looked to me like a Roman fort. 'Oh, that is most unlikely!' But it was (*30*).

30 Cropmarks of Roman fort, Malling (Stirling Council, Scotland), at the time of discovery, 28 July 1968. *Copyright reserved: Cambridge University Collection of Air Photographs, AWC 66*

BIAS TOWARDS OUR PRECONCEPTIONS

This, of course, is an example of another kind of bias. On the basis of the evidence available up to that time (which he had most carefully evaluated) St Joseph had no reason to suspect that Roman garrisons had been established in this part of Scotland any further south-west than Bochastle; so he had made no effort to seek them. After the discovery of Malling, however, much time was spent in subsequent seasons exploring the ground between Lake of Menteith and Loch Lomond in search of at least one other fort that could now be expected there. This led eventually to identification of the fort at Drumquhassle, beside the Endrick Water near Drymen (Maxwell & Wilson 1987, 17).

BIAS TOWARDS THE FIELD OF PERSONAL EXPERTISE

Many archaeological aerial photographers will have special interests that make them especially sensitive to archaeological features relevant to these. Thus, a Romanist will never see cropmarks of a straight length of ditch without considering whether it might form part of a Roman camp, and will make sure that photographs are taken looking along its length in both directions, as this will be vital for plotting it in any subsequent mapping.

The other side to this particular coin is that we tend only to see the things we are looking for, or at any rate the kind of features that we have learnt to recognise in the past. We should take care to be aware of alternative explanations.

What seems to be a small henge may actually be the ditch of a large medieval windmill. Such is my preferred, but unconfirmed, interpretation of an eye-catching feature in a cropmark complex at Little Bromley, Essex (*31*). An apparent prehistoric field-system may turn out to be one of several different kinds of geological patterning; for example, the periglacial pattern widely seen in glacial sands in west Jutland (*32*). Conversely, an intriguing linear ditch may, when viewed in context, fall into place as part of the post-medieval field-system. Whatever your own expertise, you should seek to understand all components of the visible landscape, whether archaeological, geological, agricultural, military or industrial. Unless you can do this in some detail, your work is certainly going to be biased by frequent misunderstanding.

It is no quick or simple matter to learn to recognise and identify archaeological markings when these are of a kind that you have never knowingly encountered before. The first sightings of the crescent-shaped marks made by circular house platforms when these are terraced into a slope, for example, or of the slug like shapes of filled-in souterrains, did not immediately evoke a convincing explanation. It was only when the crescents were repeatedly found in association with undoubted houses (*33*) that I and others felt confident enough to claim them as similar houses; and it was only when a souterrain of very characteristic shape was seen in a convincing context that someone had the insight to recognise it for what in fact it was (*34*).

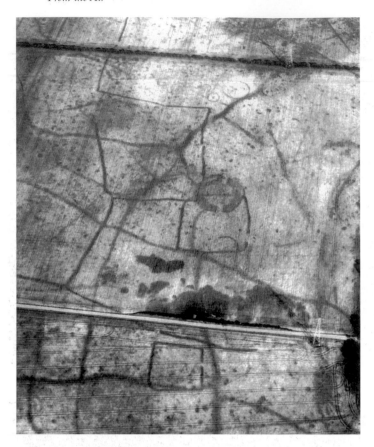

31 Cropmarks of geological
and archaeological features,
including a possible henge
or windmill, Little Bromley
(Essex, England), 15 June 1976.
*Copyright reserved: Cambridge
University Collection of Air
Photographs, BXJ 30*

32 Periglacial crop patterns (not
Celtic fields) near Alslev, Jutland,
27 June 1967. *Copyright reserved:
Cambridge University Collection of
Air Photographs, ASF 35*

33 Various types
of cropmarks
of roundhouses
in the Lunan
Water valley
near Inverkeilor
(Angus Council,
Scotland), 19 July
1977. *Copyright
reserved: Cambridge
University Collection
of Air Photographs,
CDB* 5

34 Cropmarks
of a souterrain,
(bottom, centre)
near Stonehaven
(Aberdeenshire
Council,
Scotland), 20 July
1977. *Copyright
reserved: Cambridge
University
Collection of Air
Photographs,
CDE 9*

CONCLUSION

The upshot is that biases of a good many kinds are normal and mostly unavoidable features of aerial reconnaissance and photography in archaeological research. Practitioners should be sufficiently self-aware to see for themselves the biases in their own work and to declare them in contexts where this is relevant. They should adopt strategies that minimise needless bias of a kind that is counter-productive, but should not be afraid of the bias of skilled work concentrated on a rewarding area of study.

BIBLIOGRAPHY

Cowley, D.C. 2002 A case study in the analysis of patterns of aerial reconnaissance in a lowland area of southwest Scotland, *Archaeological Prospection*, 255-65

Maxwell, G.S. & Wilson, D.R. 1987 Air reconnaissance in Roman Britain 1977-84, *Britannia* 18, 1-48

6

SUN, SAND AND SEE: CREATING BIAS IN THE ARCHAEOLOGICAL RECORD

W.S. Hanson

INTRODUCTION

This paper sets out to consider some of the biases inherent in the nature of aerial reconnaissance and their impact on the use of the information retrieved in terms of understanding the nature of the archaeological record in different areas. In particular it will consider the geomorphological and meteorological factors that contribute to the formation of cropmarks, and the potential they provide for the establishment of cumulative and self-perpetuating biases within that archaeological record. To illustrate this proposition it will utilise case studies from two very different geographical regions: Lowland Scotland and western Transylvania, Romania.

LOWLAND SCOTLAND

The contribution of aerial photography to our understanding of the archaeology of the Scottish Lowlands is considerable, serving to offset to a large extent the relatively low level of archaeological visibility of extant remains in the plough zone. Though often insufficiently appreciated, it is no exaggeration to claim that aerial reconnaissance has made the single most important contribution to our improved appreciation of the density, diversity and widespread distribution of archaeological sites in recent decades. This is particularly the case for sites that survive only as cropmarks where nothing is visible above ground level (35). It is through aerial reconnaissance that we have come to recognise that these lowland fertile zones have always been, as they remain today, the core areas for settlement in Scotland.

35 Map of cropmark sites recorded by RCAHMS in Lowland Scotland. *Data courtesy of RCAHMS*

The contribution of air reconnaissance lies in the first instance in the discovery of new sites. This continues each year, though with varying levels of intensity according to fluctuating weather patterns. More than just increasing the density and extending the area of distribution of familiar types of site, however, aerial photography is also responsible for the discovery of classes of monument previously unknown in Scotland, such as square barrows or cursus monuments (Maxwell 1983a; Brophy 1999) and, indeed, the recognition of entirely new types, such as the semi-subterranean structures of later first millennium AD date at Easter Kinnear (Driscoll 1997, 78-9) and the Neolithic 'houses' at Balbridie and Claish (Fairweather & Ralston 1993; Barclay *et al.* 2002) (*36*). Finally, by providing evidence of patterns of field boundaries and land divisions, as for example with ditch systems in Fife or pit alignments in the Lothians, it can demonstrate graphically that archaeology is

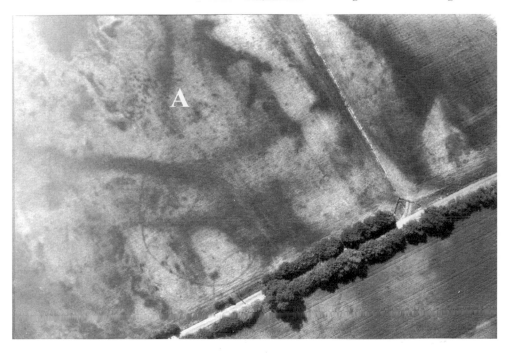

36 Aerial photograph of Neolithic 'house' (A) at Claish. *Crown Copyright: RCAHMS, PT 5524*

concerned with the history of the landscape, within which archaeological 'sites' are merely foci, or concentrations, of past human activity (e.g. Macinnes 1982; 1984).

But it must not be forgotten that aerial reconnaissance for cropmarks is not equally effective throughout the whole of the lowland zone. The factors that determine the appearance of cropmarks are complex, involving the availability of moisture and dissolved nutrients to the crop at crucial times of the growing season, the type of crop being grown, the type of soil in the field and the depth of that soil (*cf.* Evans & Jones 1977). Of these factors, the most important is the differential availability of soil moisture, which is most directly linked to levels of precipitation. The ideal conditions for the production of cropmarks would be provided by cereal crops on a well-drained, shallow soil in a growing season with low rainfall. At the opposite end of the spectrum, the least conducive conditions would be provided by permanent pasture on deep, poorly drained soils in a growing season with high levels of rainfall.

If we consider in turn these three main factors of weather, soils and agricultural regime in relation to Lowland Scotland, the inherent bias resulting from consistent differences across the country rapidly become apparent. Most importantly, meteorological records clearly indicate that the eastern half of the country is consistently drier and has marginally warmer summer temperatures than the west (Meteorological Office 1989, figs 2 and 6). Combining these two factors in relation to the potential for plant growth, the bulk of the eastern side of the country is made up of what has been defined as warm, or fairly warm, and dry, or rather dry,

lowland with some fairly warm, moist lowland and foothills; while the west has been categorised mainly as warm, or fairly warm, moist or rather wet lowland with fairly warm, wet lowland and foothills (Birse & Dry 1970). These meteorological differentials are further emphasised by soil differences, with a greater percentage of well-drained soils in the east. Combining these factors determines the capability of the land for agricultural use. Some 26 per cent of the land in south-east Scotland falls into grades 1-3, including some of the best arable land in the country, while only 15 per cent of land in the south-west falls into the same categories, and virtually all of that is grade 3 with no grade 1 land whatsoever (Coppock 1976; Brown *et al.* 1982, 19, 135-40 and map sheet 6; Brown & Shipley 1982, 24-5, 135-41 and map sheet 7). As a result of these various factors there is a predominance of ley or permanent pasture in the western Lowlands and high levels of cereal growth in the east. Deeply rooted crops are the most sensitive to the impact of the presence of archaeological remains below the surface, particularly cereals. Grass, which is shallow rooted, does produce cropmarks, but normally only in very dry conditions. Thus the already favourable factors in terms of soil type and levels of precipitation in the east are further enhanced by the greater emphasis on cereal production, while the equivalent unfavourable factors in the west are further reinforced by the emphasis there on permanent pasture. Furthermore, the pattern of land use change across Scotland has seen a fairly steady increase in the area of cultivable land laid down to pasture by a total of some 23 per cent since 1983 according to published government statistics (http://www.scotland.gov.uk/stats/bulletins/00317-05asp), a development which is likely to further exacerbate the problem of cropmark recovery.

As a result of these various factors, there is considerable bias in the discovery and, consequently, known distribution of archaeological sites revealed as cropmarks (*35*). In particular, there is a strong bias in favour of the drier eastern side of the country with its greater concentration of arable agriculture, as opposed to the west with its generally wetter climate and much higher proportion of grazing land. It was noticeable in the relatively poor summer of 1990, for example, that cropmarks were almost totally absent from the west side of the country whilst still visible in parts of the east (RCAHMS 1993b, 4). This inherent geographical bias is further accentuated, however, by a natural tendency to concentrate reconnaissance in areas where there is the most obvious and immediate return, focusing on what have been referred to as 'honeypots' (Cowley 2002, 257-62), an approach which is reinforced by the need to be seen to provide best value for money given the limited finances available for aerial photography (Hanson & Macinnes 1991, 155-57).

Thus, plots of flight paths undertaken by RCAHMS (*24*), the primary archaeological aerial survey body in Scotland, indicate a consistent heavy concentration in the south and east of the country, especially Lothian, Fife and Angus (e.g. British Academy 2001, fig. 4). Though this picture is slightly offset by the activity of regional fliers based in other institutions, their impact on this overall pattern is at best marginal because of limited budgets. Even in very dry summers, such as occurred in 1989 or 1992, when results from the less conducive areas in the

west were likely to have been better than normal, the bulk of flying has still tended to take place in the eastern regions (*cf.* RCAHMS 1993a, 4–5; 1996, 2–6). Accordingly, if we are to redress this balance in the recovery of aerial photographic data, there must be positive discrimination, in terms of both finances and the employment of personnel, in favour of less productive areas (Hanson & Macinnes 1991, 157). This is particularly the case in those rare, very dry years, occurring perhaps only once every decade, which may be the only occasions when some sites become visible in such areas. Indeed, the effect of the very dry summer of 1949 on the discovery of Roman sites in south-west Scotland has become almost a textbook example of the extreme circumstances sometimes necessary before sites become visible in the west (Evans & Jones 1977). More recently a survey of the cropmark evidence from the south-west has drawn attention to the dramatic impact aerial reconnaissance has had on our understanding of prehistoric occupation in the region, noting, however, the relative infrequency of the years in which cropmarks have appeared (Cowley & Brophy 2001).

Thus we have a pattern of bias resulting from the impact of geomorphological and meteorological factors on cropmark production being exacerbated by patterns of agricultural production and further reinforced by patterns of aerial reconnaissance. The first three are not within the control of the archaeological community, but the last is. Perhaps it is time for aerial reconnaissance in Scotland to be given a higher priority than has been the case in the past with increased resources being made available, particularly in the occasional very dry years. This would enable reconnaissance to be extended more frequently into the less productive areas in the west. Currently, the annual budget of RCAHMS for aerial reconnaissance in Scotland, including subsidies to regional fliers but excluding salaries, is less than £23,000 (British Academy 2001, 44), which equates broadly with the cost of a single, medium-sized area excavation. In terms of information-return, this reconnaissance already provides the best value for money in Scottish archaeology. There ought, therefore, to be sufficient leeway to redress the balance of reconnaissance more in favour of the less productive areas. Though the returns, in terms of numbers of new discoveries, might be less in the west than in the east, the value of the archaeological information obtained would be potentially greater by virtue of its comparative scarcity.

WESTERN TRANSYLVANIA

The aerial reconnaissance conducted by the author in Western Transylvania between 1998 and 2004 was the first time any such programme had been undertaken in Romania. The geographical focus of the project was the middle and upper Mureş valley, the major east–west flowing river which runs through the central Transylvanian plateau, and the plain of Haţeg to the south (37). This area was important both in terms of settlement and lines of communication throughout Romanian prehistory, and lies at the heart of both the Iron Age

kingdom of Dacia and the subsequent Roman province of the same name. The potential for new archaeological discoveries was, therefore, extremely high, and some extremely important results have been forthcoming. These have included, for example, the discovery of three extensive Roman military *vici* at Cigmău, Micia and Războieni and a number of Roman villas (e.g. Hanson & Oltean 2002; 2003; Oltean & Hanson 2001) (*38-41*). But there is a clear bias in the pattern of remains recorded.

As noted above, most new aerial photographic discoveries in such lowland areas tend to be cropmarks, since the sites involved are likely to be entirely buried beneath the ground surface as a result of ongoing arable cultivation and, therefore, not readily visible by other means. This is even more apparent in Romania when compared to Scotland, for the humid continental climate of the former, with its hot summers and cold winters, and the extensive black-earth or brown-forest soils make the plateaus and tablelands extremely attractive to agriculture. Indeed, cultivation can be shown to have extended in the past up steeply-terraced hillsides

to the flat tops of the lower mountain ranges, giving the impression that no suitable cultivable land was ignored regardless of its altitude (Moraru *et al.* 1966, 25; Matley 1970, 21-2). Though the first two seasons of reconnaissance in Romania in 1998 and 1999 produced very limited results, since the weather was particularly wet, with relatively high rainfall during the crucial part of the growing season in late spring and early summer, the third and final season of the pilot project in 2000 was extremely dry. Indeed, according to local farmers, it was one of the driest summers in Romania for some 20 years. Not surprisingly, therefore, relatively large numbers of cropmarks were recorded. The first and second seasons of the second phase of the project in 2002 and 2003 were also dry, and again a number of cropmarks were recorded. What was unexpected in all three good seasons, however, was the high proportion of negative cropmarks and parchmarks recorded. These are lines of restricted crop growth over buried stone-walled buildings or roads. Positive cropmarks, lines of enhanced growth reflecting the existence of buried pits or ditches, are by far the most common form of cropmarks in Britain and most other parts of western Europe where aerial reconnaissance is undertaken (e.g. Braasch 1983). They tend to appear earlier and in less extreme dry weather conditions

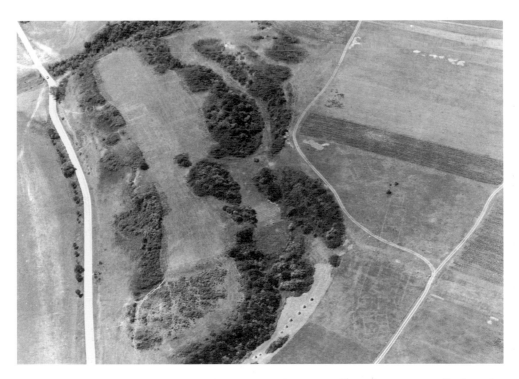

38 Above: Negative cropmarks of the buildings within the Roman fort and *vicus* at Cigmău from the air, June 2000. *Copyright: W.S. Hanson*

37 Opposite: Western Transylvania: the survey area and sites mentioned in the text. *Copyright:*
I.A. Oltean

than negative marks (Wilson 2000, 68-9). Their paucity in the Mureş valley was particularly striking and requires some explanation.

Some 160 hours of reconnaissance have been flown, over 95 of them in the three driest seasons in 2000, 2002 and 2003. Flying times were varied during the day, though concentrating in the period from 10.00a.m., when the early morning haze had burnt off, to 6.30p.m. Each season the reconnaissance was spread over two separate weeks some three weeks apart to allow for differential crop development, the second week falling immediately before the onset of the main harvest period in mid-July. Accordingly, the reconnaissance has been sufficiently extensive and varied to confirm that the phenomenon is unlikely to be a reflection of the timing or mechanics of the observation process.

A further possibility is, of course, bias on the part of the observer/photographer. One of the primary academic foci of the project was the Roman period, when such stone-built remains are more common. But an equally important second focus was on the contemporary indigenous population. Pre-Roman Iron Age settlement sites, whose presence is surprisingly poorly recorded in the area, were specifically sought with high expectations of their discovery. Moreover, though some known Roman sites were targeted, the discovery of others came about through the process of systematic reconnaissance. Thus the auxiliary fort and extensive *vicus* buildings at

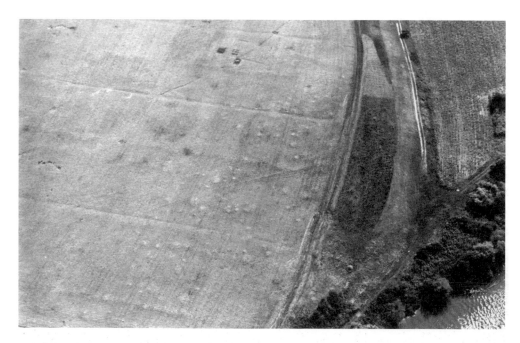

39 Above: Positive reversal cropmarks of a pit settlement and negative reversal cropmarks of a Roman villa at Vinţu de Jos, July 2000. *Copyright: W.S. Hanson*

40 Opposite: The site of the fort (towards the top of the photograph) and the eastern area of military *vicus* at Micia, July 2002. *Copyright: W.S. Hanson*

Cigmău (*38*) were recorded without reference to the potential existence of Roman remains there, whose supposed location was over a kilometre away (Gudea 1997, 101-102), and there was no prior indication of any such remains at the villa sites at Oarda, Hobiţa, Şibot, Vinţu de Jos 1 (*39*) or Vinţu de Jos 2. Furthermore, a number of other structures have been noted as negative cropmarks or parchmarks as part of the general reconnaissance of the area. Most of these are unlikely to represent Roman remains and include the outlines of buildings that clearly respect modern building alignments in the villages at Densuş, Mintia near Veţel, and Oarda. Nor is it probable that the aerial experience of the photographer/observer was more likely to favour the detection of rectangular buildings rather than curvilinear enclosures, despite his research interests in the Roman period. Indeed, the opposite is more likely to be the case since his other main area of reconnaissance has been in the western Lowlands of Scotland where such curvilinear enclosures predominate in the aerial photographic record.

It is also possible that enclosures were not a common feature of the prehistoric archaeology of this part of Romania and, therefore, that the explanation for their absence is cultural. But the excavation record from the region indicates that defensive enclosures are characteristic of large parts of later prehistory in the area (e.g. Vasiliev 1995; Zanoci 1998) and a number of extant examples are known on

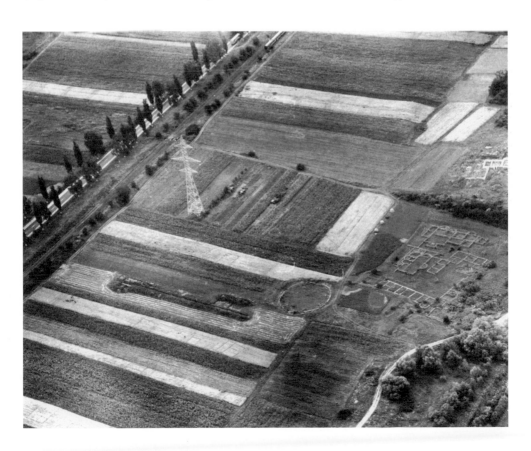

prominent hilltops (e.g. Hanson & Oltean 2000), so that the paucity of ditched enclosures in the cropmark record is not likely to be a true reflection of the full settlement pattern. There may, indeed, have been a greater preponderance of unenclosed sites in the area, but even the concentrations of pits that often characterise prehistoric settlement in other areas of central Europe, such as at Waidendorf, Drössing and Zwingendorf in Austria (Doneus 2000, figs 2a-b and 4a-b; 2002), which should also show as positive cropmarks, have been recorded only rarely from the air. The most obvious example from the reconnaissance in western Transylvania is at Vințu de Jos on the first terrace of the Mureș River, though even here the cluster of oval sunken houses and storage pits are located adjacent to the remains of two rectangular buildings showing as a faint negative cropmark towards the top of the photograph (*39*). That these are of Roman date, representing a villa, was confirmed by a site visit in 2002 which recorded quantities of distinctive Roman roof tile (*tegula*) in the plough soil.

Even at Roman military sites, which are known to have been enclosed, the ditches were not readily visible as cropmarks. At Vețel (Micia), where both the fort and most of its associated civilian settlement are under arable cultivation, there is little sign of the ditches (*40*). Similarly, at Războieni buildings of the civil settlement (*vicus*) have been traced across approximately 1km along the Roman roads immediately to the south and north-west of the fort. Its location

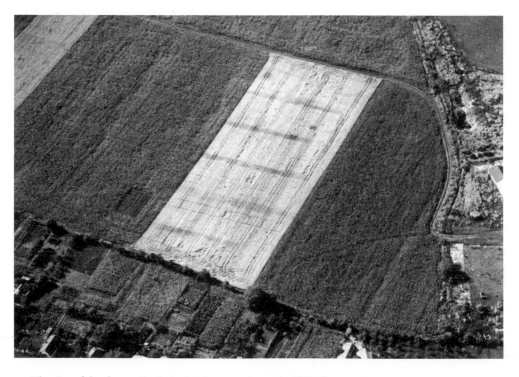

41 The site of the fort at Razboieni, July 2004. *Copyright: W.S. Hanson*

was apparent from the lines of roads and some buildings in the interior, but its ditches remained stubbornly invisible (*41*).

It seems likely, therefore, that some methodological explanation for the paucity of positive cropmarks should be sought. It is certainly attested in Britain that in pasture negative parchmarks appear first as the grass fails over roads or wall foundations, to be followed by positive marks if the drought conditions continue (Wilson 2000, 75). But the summer of 2000 was a period of extensive drought in western Transylvania, and occasional positive parchmarks were observed, as for example in the case of the roadside ditches (probably not of Roman date) located in pasture just outside the fort at Cigmău (*38*). However, there was no sign of the lines of timber barrack blocks which subsequent excavation indicates are to be expected on either side of the central range of stone buildings (information from Dr A. and Mr E. Pescaru).

An alternative hypothesis, that links the phenomenon to local soil conditions, may reasonably be put forward (e.g. Bradford 1957, 15, 23). The Mureş is known to be a highly active river, with extensive movement in the past attested both by borehole surveys (Information from Mr V. Bărbuţă and see also Diaconescu & Piso 1993, 70) and, indeed, by many aerial photographs which show older river courses as positive cropmarks or differential parchmarks. The river is also prone to flooding, as was experienced in the wet summer of 1998. Thus, the predominant soil type in the Mureş valley is alluvium. The appearance of positive cropmarks is dependent upon the increased moisture retention characteristics of buried ditches or pits with their infill of silts, as compared to the surrounding subsoil. Where depths of alluvium are recorded, the differential in terms of potential moisture retention capacity between the parent soil and the infill of a ditch is likely to be minimal. This mirrors the generally poor production of cropmarks in heavier soils with greater water retention attested in general surveys in Britain (e.g. Riley 1983). Negative marks, however, result from a reduction in the availability of moisture to the growing crop, which would contrast with the continued retention of moisture in the surrounding alluvial soil.

CONCLUSION

In two very different parts of Europe, an analysis of substantial programmes of aerial reconnaissance has indicated that local soil conditions and/or precipitation patterns can create a consistent bias in the recovery of archaeological data. This can be further exacerbated by agricultural patterns, which are themselves influenced by these same factors of soil and weather. In one case the bias could be redressed, at least in part, by positive discrimination in favour of less productive areas when conditions for the production of cropmarks are at their best. In the other the bias can be mitigated to

some extent by the experience of the observer. Both examples serve to remind us of the need to keep such potential biases in the recovery of archaeological data from the air in mind when those data are fed into wider interpretations of settlement patterns or are used to propose other generalisations about the nature of the past landscape.

ACKNOWLEDGEMENTS

The project in Western Transylvania was funded by the Leverhulme Trust (RF & G/10982), who paid for the preliminary flying programme and some research assistance, and the British Academy (SG-29800 and LG-29504), who met the costs of the computer hardware for post-reconnaissance analysis of the preliminary results and a second phase of reconnaissance. I am particularly grateful to Dr Ioana Oltean for her substantial contribution to the project.

BIBLIOGRAPHY

Barclay, G., Brophy, K. & MacGregor, G. 2002 Claish, Stirling: an early Neolithic structure and it context, *Proceedings of the Society of Antiquaries of Scotland* 132, 65-137

Birse, E.L. & Dry, F.T. 1970 *Assessment of climatic conditions in Scotland 1: Based on accumulated temperature and potential water deficit*, Macaulay Institute for Soil Research

Braasch, O. 1983 *Luftbild archäologie in Süddeutschland*, Limesmuseum, Aalen

Bradford, J. 1957 *Ancient landscapes: studies in field archaeology*, Bell & Sons

British Academy 2001 *Aerial survey for archaeology: a report of a British Academy working party*, http:// www.britac.ac.uk/news/reports/archaeology/asfa.html

Brophy, K. 1999 The cursus monuments of Scotland, in: Barclay, A. & Harding, J. (eds) *Pathways and ceremonies: the cursus monuments of Britain and Ireland*, Oxbow, 120-29

Brown, C.J., & Shipley, B.M. 1982 *Soil and land capability for agriculture: south-east Scotland, vol 7/sheet 7*, Macaulay Institute for Soil Research

Brown, C.J., Shipley, B.M. & Bibby, J.S. 1982 *Soil and land capability for agriculture: south-west Scotland, volume 6/sheet 6*, Macaulay Institute for Soil Research

Coppock, J.T. 1976 *An agricultural atlas of Scotland*, John Donald

Cowley, D.C. 2002 A case study in the analysis of patterns of aerial reconnaissance in a Lowland area of Southwest Scotland, *Archaeological Prospection* 9, 255-65

Cowley, D.C. & Brophy, K. 2001 The impact of aerial photography across the Lowlands of south-west Scotland, *Transactions of the Dumfriesshire and Galloway Antiquarian and Archaeological Society* 75, 47-72

Diaconcscu, A. & Piso, I. 1993 Apulum, in: *Politique éditilaire dans les provinces de l'Empire Romain II éme –IV éme siécles aprés J.C.*, Cluj Napoca, 67-84

Doneus, M. 2000 Vertical and Oblique Photographs, *AARGnews* 20, 33-9

Doneus, N. 2002 *Die ur-und frühgeschictliche Fundstelle von Zwingendorf*, Mitteilungen der Prähistorischen Kommission Nr. 48, Österr. Akademie der Wissenschaften

Driscoll, S.T. 1997 A Pictish settlement in north-east Fife: the Scottish Field School of Archaeology excavations at Easter Kinnear, *Tayside and Fife Archaeological Journal* 3, 74-118

Evans, R. & Jones, R.J.A. 1977 Cropmarks at two archaeological sites in Britain, *Journal of Archaeological Science* 4, 63-76

Fairweather, A. & Ralston, I.B.M. 1993 The Neolithic timber hall at Balbridie, Grampian Region, Scotland: the building, the date, the plant macrofossils, *Antiquity* 67, 313-23

Gudea, N. 1997 Der Dakische Limes: Materialen zu seiner Geschicte, *Jahrbuch des Römisch-Germanischen Zentralmuseums Mainz* 44, 1-113

Hanson, W.S. & Macinnes, L. 1991 The archaeology of the Scottish lowlands: problems and potential, in: Hanson, W.S. & Slater, E.A. (eds) 1991 *Scottish Archaeology: new perceptions*, Aberdeen University Press, 153-66

Hanson, W.S. & Oltean, I.A. 2000 A multiperiod site on Uroi Hill, Hunedoara: an aerial perspective, *Acta Musei Napocensis* 37.1, 43-9

Hanson, W.S. & Oltean, I.A. 2002 Recent aerial survey in Western Transylvania: problems and potential, in: Bewley, R.H. & Rączkowski, W. (eds) *Aerial archaeology – developing future practice,* IOS Press, 109-115 & 353-5

Hanson, W.S. & Oltean, I.A. 2003 The identification of Roman buildings from the air: recent discoveries in Western Transylvania, *Archaeological Prospection* 10, 101-17

Oltean, I.A. & Hanson, W.S. 2001 Military *vici* in Roman Dacia: an aerial perspective, *Acta Musei Napocensis* 38.1, 123-34

Macinnes, L. 1982 Pattern and purpose: the settlement evidence, in: Harding, D.W. (ed.) *Later prehistoric settlement in south-east Scotland*, University of Edinburgh, Department of Archaeology, 57-73

Macinnes, L. 1984 Settlement and economy: East Lothian and the Tyne-Forth province, in: Burgess, C. & Miket, R. (eds) *Between and beyond the Walls: essays on the prehistory and history of north Britain in honour of George Jobey*, John Donald, 176-198

Matley, I.A. 1970 *Romania: a profile*, Pall Mall Press

Maxwell, G.S. 1983a Recent aerial survey in Scotland, in: Maxwell, G.S. (ed.) 1983b, 27-40

Maxwell, G.S. (ed.) 1983b *The impact of aerial reconnaissance on archaeology*, Council for British Archaeology

Meteorological Office 1989 *The climate of Scotland: some facts and figures*, HMSO

Moraru, T., Cucu, V. & Velcea, I. 1966 *The geography of Romania*, Meridiane Publishing House

RCAHMS 1993a *Catalogue of Aerial Photographs 1989*, RCAHMS

RCAHMS 1993b *Catalogue of Aerial Photographs 1990*, RCAHMS

RCAHMS 1996 *Catalogue of Aerial Photographs 1992*, RCAHMS

Riley, D.R. 1983 The frequency of occurrence of cropmarks in relation to soils, in: Maxwell, G.S. (ed.) 1983b, 59-73

Vasiliev, V. 1995 *Fortifications de refuge et établisements fortifiées de premier age de fer en Transylvanie*, S.C. Caro Trading (Bucureşti)

Wilson, D.R. 2000 *Air photo interpretation for archaeologists* (second edition), Tempus

Zanoci, A. 1998 *Fortificaţiile geto-dacice din spaţiul extracarpatic în secolele VI-III a. Ch.*, Vavila Edinf (Bucureşti)

7

THE ADVANTAGES OF BIAS IN ROMAN STUDIES

Rebecca H. Jones

INTRODUCTION

The purpose of this paper is to examine the advantages that bias by individual aerial photographers has had on the archaeology of Roman Britain, taking the discovery and distribution of Roman temporary camps in Wales and Scotland as case studies. The impact of aerial reconnaissance in this subject area will be scrutinised, but the work undertaken by notable individuals on the study of the various air photographs collections will not be subjected to comparable analysis. This paper will also concentrate on those few individuals who have had an impact in the discipline of aerial archaeology and Roman studies, and the impact that their interests have had on both subjects. More general issues such as topography, climate and so on have, of course, played a considerable role in site recovery, but these are well known in Britain and will not be explored here.

AERIAL SURVEY AND ROMAN ARCHAEOLOGY

The history of the development of aerial survey is well known (e.g. Wilson 2000), but it is important for Roman archaeology to start with O.G.S. Crawford, quite rightly regarded as a pioneer and founding father of the application of aerial survey to archaeology. In recent mini-biographies and papers on his work, one aspect is surprisingly frequently ignored, and that is his contribution to furthering Roman studies. Those in Scotland will be familiar with his *Topography of Roman Scotland North of the Antonine Wall*, published in 1949, but his interest began far earlier. It was Crawford's idea to publish a map of Roman Britain, first mooted in 1910, that came to fruition in 1924 (Ordnance Survey).

Furthermore, Crawford's interest in tracing the campaigns of the Roman army, is explicitly stated in *Wessex from the Air*.

> Perhaps the aeroplane will reveal the early marching camps of Caesar's troops in Kent, and the later ones of the real conquerors of Britain, before they are obliterated by the march of progress. Archaeology can now circumvent annihilation by the plough, but even air photography cannot recover what is hidden beneath coal-tips and garden cities.
> (Crawford & Keiller 1928, 8)

Concentrating for the time being on the north and west of Britain, Crawford's first flight in Scotland was undertaken in a Puss Moth in June 1930 where he followed the route of the Roman road through Annandale and Clydesdale, did some exploration of Roman sites in Perthshire and returned, via Dere Street, to north-east England (Crawford 1930, 276-7). In this exploration he was following many of the routes known from the work undertaken by General William Roy in the eighteenth century (Roy 1793). It is unfortunate for the archaeological record that no photographs appear to have been taken on this flight, and it was a further nine years before Crawford was able to continue reconnaissance in Scotland, this time with Geoffrey Alington in June 1939.

The purpose of Crawford's flights was to carry out an investigation of the Roman roads and sites in Scotland from the air, partly in order to publish a third edition of the map of Roman Britain (finally published in 1956). During this reconnaissance, Crawford (1939, 284-5) discovered the missing corner of the Torwood camp earlier identified by Roy, and found a new camp at Gallaberry, both in Dumfries and Galloway (*42*). He also photographed the camp of Grassy Walls near Perth, which he had noted on his flights nine years previously (*43*).

The camp at Grassy Walls provides an interesting case study of patterns of recording of Roman camps in Scotland. It was first noted in 1771 by Roy who recorded the north, east and west sides, and was also recorded and planned, not as accurately, by the Rector of Perth Grammar School, J. McOmie, a few years later (Callender 1919, 141). However, by the 1850s, the Ordnance Survey were able to record only the site location on the first edition map as the surrounding landscape had changed quite dramatically and the farm of Grassy Wells had vanished. Although J. Graham Callender noted it on the ground in 1917 (Callender 1919, 138ff), Crawford (1949, 64) later claimed that while none 'would … think of claiming to have discovered Grassy Wells; but … I do claim to have put it on the map.'

One of the features of Crawford's work was the rapid publication of his survey results in *Antiquity*. His report of his 1939 flight is particularly telling when looking at bias in the recovery of archaeological sites from the air (see Cowley & Gilmour this volume). Bias is sometimes seen as a negative approach to what could be termed 'focussed recording', but whatever terminology is applied, Crawford deliberately applied a predisposition to the recording of Roman remains in these flights, evidenced by a remark in *Antiquity*:

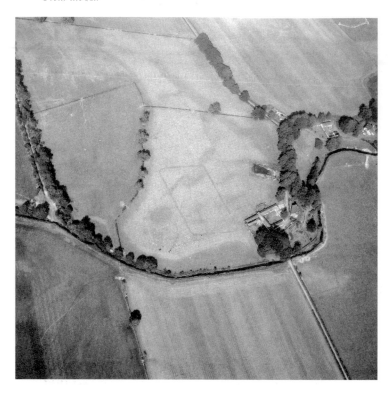

42 Aerial view of the camp at Gallaberry, Dumfries and Galloway. *Crown Copyright: RCAHMS, SC 360851*

43 Aerial view of the east side and *titulus* (gate defence) of the camp at Grassy Walls, Perthshire. *Crown Copyright: RCAHMS, SC 777927*

Although we had concentrated our attention upon Roman roads and sites, we had tried not to neglect entirely the remains of other periods. Native forts were so numerous that it was difficult, and sometimes impossible, to check them upon the map ...
(Crawford 1939, 289)

The rapid publication of Roman sites discovered from the air has remained an exemplary feature of Roman studies in Britain, with St Joseph continuing the tradition with his regular summaries in *Antiquity* for non-Roman sites, and in the *Journal of Roman Studies* (*JRS*). Nowadays, individual site summaries tend to appear in the 'Roman Britain in xxxx' section of *Britannia*.

J.K.S. ST JOSEPH AND CAMBRIDGE

Crawford's effective successor in the field, J.K.S. St Joseph brought the subject on in leaps and bounds. The archive of St Joseph, now held at the NMRS in Edinburgh, contains a wealth of correspondence, including numerous letters between Crawford and St Joseph; these demonstrate a good working relationship, particularly in the preparation work for the Ordnance Survey (OS) maps of Roman Britain. It is curious, however, that Crawford does not mention the young St Joseph in his autobiography, but perhaps this is unsurprising given the wide range of activities covered in that volume (Crawford 1955).

St Joseph's contribution to recording Roman Britain has been noted elsewhere (e.g. St Joseph 1976; Frere & St Joseph 1983), beginning with a small amount of flying in 1939 in Scotland using Crawford's Puss Moth, and later during the war in 1944 if not earlier, generally based at Scone, near Perth. Regular annual reconnaissance, initially within the training programme of the RAF, continued until 1948, when Cambridge appointed him Curator of Aerial Photography. St Joseph continued his regular reconnaissance of Scotland at this time, with flying in Wales commencing in the mid-1950s. Attention was focussed in these early years by Crawford and later by St Joseph on flying around some of the comparatively few sites then known, and flying along Roman roads.

PATTERNS OF DISCOVERY IN SCOTLAND AND WALES

This attention has produced remarkable results: some 46 per cent of the temporary camps known in Wales and Scotland today were discovered by St Joseph, usually from the air but occasionally using collections of vertical air photographs. This bold statistic ignores the 'rediscovery' of some camps from the air that had been known from ground survey in earlier centuries, such as Grassy Walls (above). In reality, St Joseph's contribution to camp studies is probably closer to 50 per cent of the total now known in the two countries, an immense achievement.

However, there are additional specific foci apparent in the work undertaken by St Joseph on Roman sites. A glance at his published papers indicates his preoccupation with the pursuit of the campaigns of the Roman army in Northern Britain, and in Wales and the Marches. Having started reconnaissance in the latter area in the 1950s, St Joseph included significant sections on these in various 'Air Reconnaissance in Roman Britain' papers (e.g. St Joseph 1961). However, of the camps now known in Wales, only a third are marching camps, the remaining two-thirds representing the likely remains of practice camps. St Joseph's papers make it readily apparent that he was far more interested in those archaeological remains that represented the active passage of troops on the march and the garrison of areas (through permanent military installations), rather than those units merely engaged in training exercises. His 1973 paper in *JRS* is his most significant treatise on the Roman advance into Wales, although his 1977 paper does represent an update based on new discoveries, particularly those of the exceptional summer of 1976, such as Llanfor in Gwynedd (the last marching camp and fort in Wales to be identified by St Joseph). In his mass of publications, St Joseph *never* wrote an article about a Roman practice camp, except for brief notes in the Council for British Archaeology annual summary *Archaeology in Wales* and passing remarks in his *JRS* papers. In the 1970s, it appears that his attention turned to the potentially richer Roman discoveries to be made in northern England and Scotland.

Yet practice camp studies have blossomed in recent years. To take the well-known example of Llandrindod Common (*44, 45*), south of Llandrindod Wells in Powys, mid-Wales, 18 practice camps were recorded by a local reverend in the early nineteenth century (Price 1814). These were rediscovered and published by Barri Jones and Charles Daniels in the 1960s (Daniels & Jones 1969), and this work was partly facilitated by the rerecording of many of the camps through aerial survey by St Joseph. However, in flying this area in 1977, David Wilson, St Joseph's colleague and successor at CUCAP, discovered a nineteenth camp (Maxwell & Wilson 1984, 11). This camp is clearly visible and can be traced on the ground as a low earthwork. There are now some 21 camps known on this common, lying to the south of the fort at Castell Collen, camp 20 being discovered during a re-assessment of one of St Joseph's *own* photographs in 1999 (Davies & Jones 2002, 836-7).

Turning our attention to Scotland, since Crawford's notable flight of 1939, over 180 camps have been discovered from the air, representing about 75 per cent of the total known camps in Scotland. In the early years most were detected by St Joseph but since 1976 his discoveries have been in tandem with those by Gordon Maxwell, who set up the aerial photographic programme for RCAHMS. The RCAHMS programme enabled Maxwell to prospect for the remains of Roman sites, whilst encompassing a far broader perspective of reconnaissance across Scotland. In the almost 30 years of flying by RCAHMS, over 60 new sites have been identified, two thirds of these by Maxwell and colleagues at RCAHMS; the others by Cambridge University and other flyers in Scotland. However, in the 13 years since the last bumper year of aerial survey in Scotland (1992), only two camps

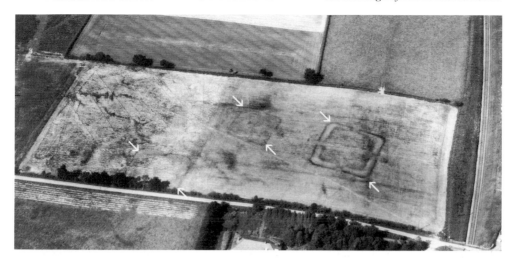

44 Above: Aerial view of three practice camps on Llandrindod Common (marked by arrows). *Copyright reserved: Cambridge University Collection of Air Photographs, AOU 76*

45 Right: Practice camps on Llandrindod Common, Powys, Wales. *Copyright: R.H. Jones*

have been discovered through this technique. Although this period has not been marked by ideal weather conditions, it also coincides with the reduction of focussed prospection for Roman sites by both Gordon Maxwell at RCAHMS and David Wilson at CUCAP. Indeed, the two sites discovered since 1992 were only recovered during targeted reconnaissance of Roman complexes and Roman roads.

Looking at the ways in which the camps have been recorded against their known condition, about a third of all known camps had an element of upstanding earthwork remains when they were first recorded (even if the cropmark element was recorded from the air and the earthwork only noted subsequently), whereas less than a quarter now have an upstanding element. Some 2 per cent of camps in Scotland have been discovered through excavation, whereas no camps in Wales have, as yet, been discovered through these means, although most of those in Scotland were discovered whilst undertaking excavations around known Roman complexes. Very few excavations have been undertaken on camps in Wales – the upstanding nature of much of the evidence precluding the need to test whether a site was Roman or not (unlike the numerous slot trenches placed through possible Roman ditches in Scotland, usually by St Joseph), and also the topographic setting of many of the Welsh camps. In the last decade, geophysical survey has played a role in discovery, but again around the area of known forts and camps, and it has been surprising in some instances that such camps have only been recorded through geophysics and have not been visible as cropmarks. In Wales, it is probably fair to say that serendipity has not played a major role in camp discoveries from the air in recent years, those discovered from such survey (about half) representing the pursuit of areas around known forts or chasing Roman roads, largely by Chris Musson or Toby Driver at RCAHMW, and also recently by Hugh Toller. The remaining half has been discovered from existing air photographic coverage as part of RCAHMW's air photograph mapping programme or a specific research programme looking at camps and roads.

CONCLUSION

There are almost three times as many camps known in Scotland compared to Wales, and it may seem misleading to compare their discovery rates, but the biases in the differing emphasis and focus on the discovery and recording of Roman camps in the two countries remain.

However, to start my conclusion with a comment from David Wilson:

> … after you have flown with St Joseph for a few years, you never forget that virtually any straight-line cropmark might belong to one of the ditches of a Roman camp; and, if so, where might the rest of it be? However uninteresting it looks, it is worth taking a record photograph, because it might join up with something else that you photograph in another year.
> (David R. Wilson, pers. comm.)

There are probably photographs of linear cropmarks that represent the remains of Roman camps 'lurking' in the collections of aerial photography in Britain. But if these have not been critically evaluated by an eye trained in interpreting and understanding Roman sites, then they may well retain this ambiguous morphological rather than an interpretative classification. Conversely, there are almost certainly some sites in these archives believed by various archaeologists to be camps when undoubtedly they are not.

Aerial survey in Britain has had a very strong tradition in Roman archaeology – such subjectivity in the discipline has clearly benefited productivity, and the product from a Roman perspective is invaluable. As with all trends though, there has been less of a bias towards the recording of Roman sites in recent years, which can ultimately only benefit the broader discipline and landscape studies in general. Paradoxically, in Scotland, this broadening of approach has contributed to the increase in the numbers of Roman sites whose distribution was less predictable than previously thought. However, none of these serendipitous sites were temporary camps, and it remains to be seen if wider prospecting survey has a longer-term effect on the discovery of this class of Roman monument.

BIBLIOGRAPHY

Callander, J.G. 1919 Notes on the Roman remains at Grassy Walls, and Bertha near Perth, *Proceedings of the Society of Antiquaries of Scotland* 53, 137-52
Crawford, O.G.S. 1930 Editorial Notes, *Antiquity* IV, 273-8
Crawford, O.G.S. 1939 Air Reconnaissance of Roman Scotland, *Antiquity* XIII, 280-292
Crawford, O.G.S. 1949 *Topography of Roman Scotland North of the Antonine Wall*, Cambridge University Press
Crawford, O.G.S. 1955 *Said and Done*, Weidenfield and Nicolson
Crawford, O.G.S. & Keiller, A. 1928 *Wessex from the Air*, Oxford University Press
Daniels, C.M. & Jones, G.D.B. 1969 The Roman camps on Llandrindod Common, *Archaeologia Cambrensis* 118, 124-134
Davies, J.L. & Jones, R.H. 2002 Recent research on Roman camps in Wales, in: Freeman, P., Bennett, J., Fiema, Z.T., & Hoffman, B. (eds) *Limes XVIII: Proceedings of the XVIIIth International Congress of Roman Frontier Studies held in Amman, Jordan (September 2000)*, British Archaeological Reports International Series 1084, 835-41
Frere, S.S. & St Joseph, J.K.S. 1983 *Roman Britain from the Air*, Cambridge University Press
Maxwell, G.S. & Wilson, D.R. 1987 Air Reconnaissance in Roman Britain 1977-84, *Britannia* XVIII, 1-48
Price, T. 1814 An Account of some Roman Remains near Llandrindod, *Archaeologia* XVII, 168-172
Roy, W. 1793 *The Military Antiquities of the Romans in Britain*, Society of Antiquaries of London
St Joseph, J.K.S. 1961 Air Reconnaissance in Britain 1958-1960, *Journal of Roman Studies* LI, 119-135
St Joseph, J.K.S. 1973 Air Reconnaissance in Roman Britain 1969-72, *Journal of Roman Studies* LXIII, 214-46
St Joseph, J.K.S. 1976 Air reconnaissance of Roman Scotland 1939-75, *Glasgow Archaeological Journal* 4, 1-28
St Joseph, J.K.S. 1977 Air Reconnaissance in Roman Britain 1973-76, *Journal of Roman Studies* LXVII, 125-161
Wilson, D.R. 2000 *Air Photo Interpretation for Archaeologists* (second edition), Tempus

'IF THEY USED THEIR OWN PHOTOGRAPHS THEY WOULDN'T TAKE THEM LIKE THAT'

Rog Palmer

INTRODUCTION

Archaeological air photographers and photo interpreters form two almost mutually-exclusive groups of people who actively take and use air photos for archaeological purposes. This contribution comes from a photo interpreter who, during the past 35 years, has worked with aerial photographs taken by many people. Some years ago I listed names of people involved in aerial work and divided them into 'photographers' and 'users'. At that time (1979) I could think of only two people, Crawford and Riley, who had been active in both fields. There is a slightly larger number now but personalities, and perhaps opportunities, tend to retain the division of data collectors and data analysts. My aim is to show the differences in approach and how these may be combined, and to suggest that it is time to change the ways in which we gather our basic data, aerial photographs, to meet the needs of current archaeological practices. My concern is with those photographs taken of past features that now often are levelled and produce the soil- and cropmarked evidence of our pasts.

THE THINGS WE DO: AERIAL PHOTOGRAPHY

From early in the twentieth century aerial photographers (with notable exceptions) have seemed often to assume that the photograph was the end

product of aerial survey. This was, and still is, marked by the abundance of published photographs accompanied by a description (Capper 1907; St Joseph 1966; Planck *et al.* 1994; Wilson 2000; plus the myriad *Somewhere from the Air* books). The reader will be reminded by other contributors to this volume that the majority of these photographs are oblique views that have been taken after an observer's 80mph decision that the ground 1500ft below holds something of archaeological merit or will make an otherwise pleasing view. I pose the question whether this brain in the air is what we really require to guide the principal means of data collection, and will expand this point below.

Archaeological aerial survey has been led by such observers, a statement that may seem self-apparent until it is explained that this phase of the work, the data collecting phase, may often be undertaken with no real research design and with little consideration about how those photographs will be used. It seems that these aerial photographers – who include aviators with no formal archaeological training – take their photographs, may project a few as lecture slides, and expect that we users should be grateful for their efforts. Often this is not the case, yet those photographers often deign not to hear any criticism and continue to work in their chosen way. By so doing, and by collecting inappropriate or inadequate data, they miss many opportunities to further archaeological research. Often their need for artistic satisfaction and the 'hit' of discovery appears to take precedence over the needs of ground users who are presented with photographs that cannot accurately be placed in context and thus are the aerial equivalent of artefacts collected by treasure hunters using metal detectors. The very nature of the standard orbiting photographic technique leads to a record of site-specific pictures, although this is often inevitable given that cropmarked information may only show in single-field pieces rather than as a conjoined landscape. Runs of oblique photographs were taken under John Hampton's direction in the 1970s which did allow linear features to be followed and enabled continuous and stereoscopic photography of several fields at one time. However, that practice was banned by the Civil Aviation Authority because the photographer, lying prone in the back of the aircraft with his head and camera out of the luggage hatch, put the centre of gravity too far to the rear.

This leads to an explanation of what I'll call 'working photographs' and 'illustrations'. John Hampton, founder of what is now English Heritage's Aerial Survey, began the tradition of taking working photographs and assumed that all of his photographs would be one day interpreted and used for mapping. Aircraft operating height was sufficient for photographs to include appropriate modern information (control points) to enable them to be used for mapping and he would photograph virtually any small trace of information on the understanding that this may later be combined with other fragments to make a comprehensible whole. This attitude is rare among photographers whose oblique orbiting technique allows them to identify and select the viewpoint from which features show best with, sometimes, scant consideration of needs other than artistic appreciation.

My understanding of how English Heritage's Aerial Survey currently works provides a good model of a best approach using the current orbiting method [yes I did write that]. All of their current air photographers are, or have been, photo interpreters and are thus aware of the main users' requirements and can take photographs appropriate to that use as well as occasional illustrative shots. The photographers know (as now do all photographers in England) that pictures of archaeological sites may provide data for the National Mapping Programme and that appropriate information to link them accurately to 1:10,000 maps needs to be included in each frame. There is also the policy that 1:50,000 flying maps show sketched impressions of all known sites and that these are kept updated. In other words, the airborne observer/photographer is considerate of the uses to be made of the photographs and is able to work from knowledge of previously recorded features.

Oblique photographs are ideal for illustrations. They show a view that can easily be understood and are usually taken from a sufficiently low height to show the relevant feature without need of a part-enlargement. Yet the photographs used for illustration are a tiny percentage of those used for interpretation. David Wilson's book (2000), one of the most comprehensively illustrated in Britain, contains about 150 figures; Cathy Stoertz's mapping of the Yorkshire Wolds was completed after examination of some 35,000 photographs and contains four illustrative plates (Stoertz 1997). On a smaller scale, one of my own developer-funded assessments of a few square kilometres may require examination of several hundred photographs taken between 1942 and the present. Clearly illustration, while a useful way of conveying the advantages of an aerial viewpoint, is a relatively minor part of the sum of uses to which aerial photographs may be put. Yet many photographers think mainly of illustrations, of framing 'good views', when they are airborne. This may be one aspect that encourages them to fly lower than is sufficient to include good control and is one of the reasons for the title of this contribution. We are now unsure who first coined the phrase, 'If they used their own photographs they wouldn't take them like that.' It was one of the experienced interpreters, Cathy Stoertz, Chris Cox or myself, but it sums up some of the frustration we have when trying to make use of photographs taken by low-flying illustrators. Our argument was that if they used their own photographs for interpretation and mapping they would fly higher and take obliques from a more vertical viewpoint. These are called 'low obliques' because they have low obliquity.

Oblique aerial photography was pioneered by amateur archaeologists in the 1920s and 1930s (e.g. Poidebard in Syria and Allen in England). The resulting photographs, usually of single sites, suited the archaeology of the time which was dominated by excavation and was primarily site-centred with little consideration of environmental factors or of the relationships of those sites to their surrounding natural and cultural landscapes. Oblique photographs, taken after human decision that the land below holds something worth recording, continue to be the principal means of recording archaeological sites from the air. It is claimed to be

a cost-effective way of recording the sites selected by the airborne observers and can produce rapid results in terms of, for example, counting the number of sites photographed per year to satisfy management requirements. Yet it remains site-centred data collection and, except by accident, is unlikely to record features that were not noticed in the air (e.g. Cowley 2002) nor those features not yet accepted as archaeological in origin. All aerial observers will fly with a compendium of known sites in their mind and will use this, plus a bit of common sense, as a way of deciding whether a site on the ground is archaeological or not. I suggest that the human brain in the air is the weakest part of the process of aerial survey and that to continue to use this as a means of filtering information is bound to leave archaeologists with a selective and partial record of sub-surface features.

THE THINGS WE DO: PHOTO INTERPRETATION

In alphabetical order, archaeological uses of air photographs include: conservation, excavation, fieldwork, illustration, management, research and teaching. Different people place these in different orders depending on their own vision of usage. David Wilson (2000, 23-28), for example, places illustration first because that is perhaps the principal way that he uses aerial photographs and those in his book provide a valuable compendium of examples showing a wide range of features, archaeological and non-archaeological, that have been recorded in Britain. In my opinion the title, *Air Photo Interpretation for Archaeologists*, is misleading as his photos-plus-description approach is more correctly at a 'photo-reading' level. Photo interpretation, to follow its uses in other disciplines, requires consideration of all available photos to be used in preparation of a map (expanded in Palmer 1989). This is another area of misunderstanding between aerial photographers and photo interpreters. The former may consider their job is done if they display a picture and tell us that it shows a Bronze Age fort. The latter want to place that fort in context and study it in relationship to adjacent features, perhaps including a field system, burial ground and settlement enclosures. To do this usually requires the extraction and combination of information photographed over many years.

An interpreter, who we will assume is making a map or plan of a landscape or specific site, will gather together as many photos as possible of the area under study. These will be sifted to find those that best show the detail to be mapped and have adequate control information, although these factors may be considered in the opposite order. Photos will be examined stereoscopically if possible – a simple requirement that tends to go unheeded by many oblique photographers despite its importance to interpreters – and relevant details, archaeological or not, will be identified. Interpreters, like aerial photographers, will store a compendium of types in their brain and these help to identify the more obvious features. However, unlike the airborne observer with one chance

to see and identify relevant material, all information on the photographs remains there to be re-examined at any future date. Given that interpretation is a subjective art this means that data can be reassessed in the light of changing knowledge, to suit differing paradigms in the discipline, or even to discuss differences noticed by more than one interpreter.

The ability to identify features correctly depends on the experience of the interpreter and his/her powers of perception. Both increase with experience, and perception especially is aided by knowledge of more than just the subject in question. An example comes from a demonstration at the annual Aerial Archaeology Research Group meeting in 1989 at which I produced an object of mine (*46*) and asked that members tell me as much about it as possible. After a day or so to examine the object I asked a series of questions that increased in difficulty:

What is it made of?
The answer, brass, was correctly given by those with knowledge of metals.

What is the purpose of the large screw?
After some discussion it was agreed that this was to enable the object to be fitted into a space between two fixed pieces.

46 The mystery item shown to the Aerial Archaeology Research Group conference participants in 1989 asking, what is it? The long screw on the right changes the overall length of the item and has a lock nut to hold it in position. The short screw on the left has an insulated central core. *Copyright: Rog Palmer*

What is the function of the smaller screw?
This required slightly more specialised knowledge, but it was agreed that it was to hold an electrical contact of some kind.

These three questions could be answered with a little thought by anyone familiar with basic technology and household appliances who had taken the time to examine the object. To answer the final question almost certainly required knowledge of my interests and activities other than archaeology. What is it? Answers to this ranged from the ridiculous to the inventive until John Hampton, who I used to work for and knew what I did in my spare time, asked if I still played my double bass. This was just the demonstration I hoped to provide as it required knowledge to be extended from physical descriptions by reasoning that the function of the object – a pickup for amplification that was fitted between the legs of the bridge – may be related to activities of its owner.

This may seem a far step from photo interpretation but the point is that there are limits to what can be said about features identified on photographs and that these will vary with the knowledge of the viewer. If the experience of the interpreter includes information gleaned from careful examination of ground features then further clues may come from that knowledge that help elucidate puzzling information on photographs. An example could be that posts with metal 'hats' on that are placed in hedgerows are markers for pipelines. Notices to that effect may be nailed to those posts and can be read by anyone on the ground who stops to investigate. Similar posts seen on air photographs along the line of a suspected Roman road will immediately identify it as a modern pipeline and may save any embarrassing announcements.

Just as airborne observers will not see everything on the ground, so too do interpreters not always see the obvious on aerial photographs. Many years ago I was mapping an area of Wessex at 1:10,560 and making regular trips to RCHME to examine photos. On one of these visits Grahame Soffe showed me some colour prints of a site that had recently been photographed at South Wonston, Hampshire, and which I had previously mapped from earlier photographs. The new prints showed a curvilinear ditched enclosure of fairly typical Wessex dimensions that was enclosed within a large rectangle. The large rectangle was new to me and my first step was to check other photographs to see what they showed. All of them recorded the rectangular enclosure as well as the smaller internal one but I had not seen it before. The reason for this is probably that I had tuned my mind to look for standard-size features and had not seen or understood objects that were out with that range. Another explanation may be that Graham held the photo at arm's length to show me and I was thus able to perceive at a different scale to my usual nose-to-the-stereoscope distance. This is one example that shows the need to examine photographs from more than one distance with, if possible, an open mind that is able to question all features, compare them with the user's compendium, and argue the pros and cons of those that are not immediately comprehended.

This indicates the level of subjectivity that goes into photo interpretations and explains why different people will make different interpretations of the same photograph and why the same person is likely to produce different results from the same photograph studied at different times. It also emphasises the need to have unbiased photographs from which to work rather than, or as well as, those selected and taken by airborne observers. The brain in the air will never see and understand everything on the ground below; the interpreter at the desk stands a higher chance of identifying and recording more information.

SEEKING THE MENTALITY OF THE PHOTOGRAPHER AND INTERPRETER

Such thoughts lead us to consider the mentality, and perhaps also the personality, of the fliers and the ground people, which is relevant to how different aspects of aerial survey are able to mesh together. The limited amount of flying I have done means that my understanding of the airborne personality comes from talking to colleagues and from examination of their photographs. When I have flown locally I have done so with a 1:50,000 map that shows roughly the known archaeological features recorded previously. This allows me to examine gaps in the known pattern and to pursue specific questions arising from previous interpretation, mapping and thought. Use of such maps to guide survey is common practice among the more rigorous aerial surveyors in Britain.

Without maps of this kind one wonders how any sensible survey can be undertaken. There are, claim the aerial photographers, different level of survey and they suggest that a preliminary selective flight, often just picking off the 'best' sites, is an accepted practice. Is it? In view of the many variables that affect whether a sub-surface site will be visible in any one year I submit that *all* aerial recording should be done in a way that creates records that can be used and reused for interpretation. Thus I would expect all photography to include stereoscopic cover of all targets and be of a quality that is suitable for mapping – i.e. that has been taken from a sufficient height to include control points. Unfortunately, the need for the airborne observer to identify features may be the main factor that affects their flying height and encourages them to fly close to the ground. Sites photographed from such low heights will not necessarily include adequate modern information to enable them to be fixed accurately to a map. One method practised in parts of Europe is to obtain a single GPS reading from (hopefully) above the site photographed and then to follow that by field visits. This may be adequate when there are few sites recorded, but when a single summer's photography records hundreds of sites then ground visits to all targets within a sensible timescale are out of the question.

While aerial photographers continue to work to their own agenda these criteria are likely to remain absent from our record. Many aerial photographers confess that they enjoy the sense of discovery that comes from identifying new

sites but few admit that they are content to do what they are requested by an interpreter on the ground. Among those who do were two who collaborated with my own photo interpretation and fieldwork in Wessex. John Boyden, a farmer who has been taking aerial photographs since the late 1950s, was happy to photograph a series of locations that I had identified when I was undertaking field survey on and around Hambledon Hill in Dorset and when mapping the Danebury environs in the early 1980s. John Hampton also flew and photographed specific targets for my Danebury area survey and both expressed some delight in being able to help in such specific ways.

Until mapping has been undertaken it is not easy to reach a 'research level' of flying and photography. Aviator-photographers such as Jim Pickering in England and Otto Braasch in Germany (and elsewhere in Europe) who work without maps are unlikely to break away from a site-specific method and mentality and, without mapping, are unable to comment seriously on the features they have recorded. Their usual style of photographs are far from the types needed by interpreters and, after years of work, it is depressing to think of their efforts as producing only illustrations. However, this comment is based on seeing only a handful of the turnover produced by Braasch who may use the illustrations as slides to show in lectures or for plates in books. The remainder of his output may all have control points and be near-vertical stereo pairs, but I doubt it following his comment to me once that he does not like his beautiful photographs turned into maps.

This attitude in which discovery seems to be a main criteria is far from the working of photo interpreters who have the minds to pick away at pieces of puzzle in the hope of creating a broader picture. In their own ways both are discoverers of new information as Pete Horne, now head of Aerial Survey for English Heritage, has said: 'aerial observers discover sites by flying over them while interpreters discover sites and landscapes by analysis of aerial photographs'. But whereas an airborne observer has one relatively rapid chance to observe, decide and record; an interpreter is able to sit down with a pile of photographs that may have been taken over 50 or more years, and sift through those. For a small area or single site these are likely first to be divided into their individual modern fields (mapping units) and then to be sorted on the basis of whether they have good control for mapping or not. After that may come the preliminary reading of the archaeological content and decisions about which of the (probably few) remaining photographs should be interpreted and transformed and in which order. Note the progression in sorting photographs. Where is it? Am I able to use it? What's on it? At this stage (and usually at any later stage) an interpreter is not interested in any descriptions recorded by a photographer, as each of the photographer's sites will become small components of a greater landscape and later described and analysed in the context of their surroundings.

The selected photographs will then be carefully examined and the information on them compared with that on other prints. This stage of the work will most

likely be done using at least 2x magnification and with stereoscopic pairs whenever possible. An end product of this examination may be a transparent overlay showing the features interpreted plus the control points. An increasing amount of current interpretation is done directly on screen to mark detail over transformed plans of scanned photographs. Work using this method is, of course, only possible when permission has been given to make digital copies of photographs. Regardless of the method used, the end product is likely to be a map showing an interpretation of archaeological, and possibly other, features within the chosen area. Our archaeological interpretations, or our understanding of the past, then use that map as their principal data. On this assumption – that we move from aerial photographs to map to understanding – photographs that are purely illustrative and cannot be used for mapping are reduced in value. We agree that some illustrative photographs are necessary, but these should be special cases rather than the main output of a photographer.

EFFICIENT AERIAL SURVEY?

As long as these two different approaches to aerial survey exist both parties may remain dissatisfied. Aerial photographers may feel outcast because only other aerial photographers appreciate their artistry (this is not strictly true, as we all admire a good dramatic photograph) and photo interpreters may find it difficult to work because many of the photographs are unsuitable. A view that has been developing over recent years is to have teamed pairs of interpreter and photographer in which the former controls the activities of the latter. In this way the bulk of photographs taken should satisfy the needs of interpretation and mapping with only occasional diversions to take possible illustrative shots. Satisfaction of the photographer should come from their part in filling in gaps in the map and answering questions that the teamwork has made possible. This, however, assumes that we continue to operate and promote airborne observation and oblique photography as the normal and accepted way of undertaking archaeological aerial survey. But is this the correct method to employ when surveying an area? How does the cost of a normal survey flight to take obliques, with all the orbiting that is required to place the aircraft in the 'best' position, compare with flying a similar area in regular-spaced strips with the camera in continuous operation? And how does the reliability of observer-directed photographic cover compare with that from block recording?

When I was a student in the 1970s David Clarke used to tell us that archaeologists deal with a sample of a sample of a sample…. We were taught that it was necessary to understand how our data were related to their collection methods before we could optimise our uses of those data. Since then we have been passing through a time of adaptation and development of archaeological practices to try and improve the reliability and content of those samples.

Excavation techniques were developed to collect macro- and micro-contents. Analytical techniques allowed us to find (and use) beetles, fish bones and DNA. Geophysical and geochemical methods were honed to aid prospection of localised areas and increased use is being made of satellite imagery to find archaeological sites and examine their environments. Among all this change in archaeological practice aerial photography for archaeology stands out as one of the few methods that continues, with very little change, to use techniques that were developed, and perhaps perfected, in the 1930s.

At that time we were content to put a man in an aircraft and let him roam around to see what could be seen on the ground and to record it by taking hand-held oblique photographs if a subject seemed to be of interest. We can call this method 'observer-biased photography' or 'observer-directed photography' in which the information collected, our sample, is directly related to the perception, attentiveness and understanding of our aviator. Is this the best we can do? May it be possible to improve the sample we collect from the air?

Observer-directed photography may have suited archaeological practice in the 1930s but I question whether it fits our current archaeological directions. Between the 1930s and now, archaeology, at least in Britain, has moved from the study of single sites to examining those sites in a landscape context and in association with their contemporary features. Aerial survey has not kept up with that trend. It should be leading it.

Look ahead another 70 years to a time when – possibly – many cropmarked sites have been ploughed away and aerial photos are the only, or principal, means through which they may have been recorded. Are current observer-directed methods of prospection the best means of attaining the most complete record of our by-then-lost past? Will future generations of archaeologists thank our aerial photographers for taking nice illustrations or might they prefer an unbiased photographic record?

My theme is to suggest that observer-directed photography is an inadequate and expensive means of recording the past and that we need to concentrate on methods that preserve maximum areal information for archaeologists of the future. A comparison of two methods of collecting archaeological data, by observer-directed photography and unbiased area cover produced by taking vertical photographs, may help our planning of future surveys.

SCALE

The argument that low-level obliques show more detail can be refuted, or at least met by a positive response. Finding post-holes in hut corners on 1:10,000 vertical photographs allowed Michael Doneus to demonstrate the level of detail that can be identified by an experienced interpreter (Doneus 1997). This should come as no surprise because the contact scale of oblique negatives taken from

a normal working altitude (500-750m) will also be in the region of 1:10,000, a usual scale for vertical surveys in Britain. Thus we should expect the same level of information on both. If we took the trouble to make enlargements of verticals, or reprint those that are 60 years old and faded, it is probable that their value would be better appreciated. With interpretation on screen becoming the norm we may begin to see fewer differences in the quantity and quality of information on obliques and verticals as use of image enhancement and on-screen examination should increase perception above that gained by optical magnification. It follows that features do not need to be seen by an airborne observer to appear on their photographs. I suggest it is an unverified claim that an oblique always records more information than a vertical although I agree that the angle of view can affect the clarity of information on obliques. So we could ask if the observer-directed method really is best practice?

FLYING TIME

Measuring from GPS flight traces of observer-directed 'systematic survey' it is apparent that orbits to take obliques of a single modern field entail between 5 and more than 20km of flying. In a 5km flight vertical survey at 1:10,000 with 60 per cent overlap for stereo viewing can record about 10sq km in four pictures. In 20km it will record 40sq km.

INFORMATION

Results from observer-directed survey are reliant firstly on the observer seeing something from the air, and then on their perception and understanding so as to record what they know to be, or think likely to be, archaeological. Currently unknown types of feature may not be recognised and if we continue to use this method of prospection that information may never be recorded. Unbiased area-covering photographs can be examined retrospectively to identify examples of 'new' site types that may be recognised in, say, 2030. A good example of this is pits. They abound in central Europe but in the west and in England do not appear to be as prolific. Is this because the western observers' criteria for recognition is biased towards ditched features and, in the air, do not tune in to pit groups? Using these unbiased photographs an interpreter can return at any future date to examine them for pits. Unbiased photographs are also seen as most suitable for what people are calling 'primary reconnaissance' – a first look at a new area – as they will provide a collection that can be thoughtfully appraised and returned to time and time again. They are not the result of observer-selected targets that will themselves be biased by the knowledge that observer has gained from working in other

parts of the world. It would seem pertinent to ask what are we not recording using observer-directed methods of prospection.

Some experienced observers respond to my thrust for unbiased surveys with the response that they may be appropriate in areas of dense archaeology but are a waste of resources where there are [thought to be] only scattered sites. Chris Musson names the Welsh Marches as one such area, but do we really know where these dense and scattered areas are? Our definitions of them depend on the very thing I am trying to counteract, observer bias, and I suggest that we do not yet have a real definition of dense and scattered distribution. For example, before 1996 the Bedfordshire clays would not have been seen as (or imagined to be) a densely populated area (Palmer forthcoming; Mills this volume). Vertical survey that year showed the clays to be as densely occupied in the past as were the chalks and gravels that have always been claimed to be favoured land. Observers more often than not work above ground they 'know' to be responsive and this returns me to the question of observer effectiveness and our trust in their record. We need to ask whether observers can be sure that gaps between their sites really are gaps or may there be features that are not yet recognised (by them) and therefore not yet recorded? In such an area it would be interesting to see the results of experienced photo interpretation of unbiased photographs taken at sympathetic times.

DATA-COLLECTING STRATEGIES

1. Unbiased block cover. This strategy is illustrated through a 4 x 4km area that is covered by mosaic of 12 vertical photographs which are part of three parallel strips flown on 18 July 1996 (*47*). The area is north of Bedford and almost entirely lies on boulder clay with one small lens of Oxford clay running along a river in the north of area. The clock on the data strip shows the frames were photographed in 34 minutes between 12:24 and 12:58, but this time includes flying traverses over two complete north–south strips of the county totalling some 120km. The actual flying time over the target area was at most three minutes.

2. Observer-directed photography. As no airborne observer appears to have been active over Bedfordshire during the dry summer of 1996 what follows results from my own 'systematic flight' over the on-screen mosaic viewed at reasonable magnification (*48*). My fairly ungenerous flight line for this airborne observation totals 112km, which I calculate is roughly 45 minutes flight time in the Cessna. In that time I 'photographed' 21 groups of sites and checked five others. Five of the orbited sites were pits and not all were photographed. Let us assume I took four black and white frames of each (i.e. two stereo pairs) but more of the 'good' sites to make a total of 72 photos. Those, plus half that many colour slides and the same number of digital images gave me a total of 180 records. A rapid scan of

47 *Above*: A mosaic of 12 vertical photographs covering some 4 x 4km in Bedfordshire. Three vertical lines mark the track of the survey aircraft and represent some three minutes' flying time in which time the complete area was photographed in 12 overlapping and stereoscopic frames (see *53*). Grid lines are at 1km intervals. *The mosaic was made in AirPhoto and photographs in the illustration are reproduced with the kind permission of Simmons Aerofilms Ltd*

48 *Opposite, above*: The same mosaic as in (*47*) but showing the flight line resulting from a simulated observer-directed flight over the digital image at a scale at which archaeological and other information was clearly visible. *Photographs in the illustration are reproduced with the kind permission of Simmons Aerofilms Ltd*

49 *Opposite, below*: The simulated observer-directed flight line (*48*) against a schematic map showing the 41 ditch-defined sites, pit groups (P) and possible sites (?) identified after a rapid scan of the 4 x 4km mosaic. Flight time is an estimated 45 minutes and attempted to cover the area systematically but with orbits where features on the ground were examined and photographed (*52*). Of the 41-site total, 21 were targeted for photography and parts of perhaps 3 sites were accidentally included in the resulting oblique pictures giving a success rate slightly above 50 per cent from this observer-directed survey. *Copyright: Rog Palmer*

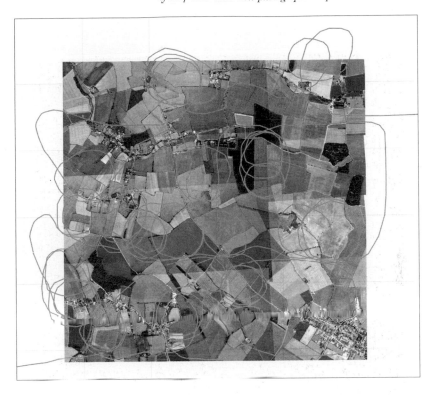

the vertical mosaic showed another eight sites that were not photographed plus 12 pit groups and 'query' features that – for a photo interpreter – would require checking with other photos (*49*). The summary for this game is that my observed sites totalled 21 out of 41 possible sites. To go back to the sampling theme, this method has allowed us to gather slightly more than 50 per cent of the visible sample. Put this down to my inexperience if you wish.

AIRCRAFT COSTS AND COMPARISONS

Operating costs per hour were provided by Cambridge Aero Club in June 2004 for hire of an aircraft and pilot (*50*). These costs obviously include a hidden element to cover maintenance and regular servicing. Performance figures were all taken from the same web site (www.flybernhard.de) in June 2004.

So, reasonably, a twin-engine aircraft costs twice as much to fly as a Cessna 172. To be cost effective we need the capacity to do at least twice as much work using the Aztec, so let's look at what we can do at those prices.

Even if searching for targets in a Cessna 152 or 172 is done at optimum cruising speed it is normal practice for an observer to slow the aircraft to about 80 knots for orbiting and photography. This is one aspect that makes this type of survey so extravagant with flying time. The other prime consideration is that observer-directed photography is intermittent, recording a handful of discrete targets per hour. If we use a fixed camera timed to take photographs at set intervals to cover an area of ground totally we are able to work the aircraft at its most economical flying speed. This will enable us to record that ground much faster, for a much shorter flying time and ultimately for a lower cost per photograph.

The cheapest way of achieving this block cover would be to use a detachable right door module as has been developed by Bryan Gulliver (http://www.thearco.co.uk/) for taking medium- or small-format vertical photographs using a Cessna 152 (*51*). Photographs from this are of sufficient quality for archaeological interpretations. A more expensive way, but one that opens wider commercial applications as well as the ability to carry a range of sensors, would be to use a twin-engine aircraft with at

Aircraft	Hire cost/hour	Cruising speed	Maximum range
Cessna 152	£110 + vat	110kt	1340km
Cessna 172	£130 + vat	120kt	1060km
Piper Aztec	£260 + vat	181kt	2309km

50 Operating costs for hire of aircraft and pilot, June 2004

51 The detachable right door module as developed by Bryan Gulliver for taking medium- or small-format vertical photographs using a Cessna 152. This is Civil Aviation Authority certified and can be exchanged with a normal door in a few minutes. *Copyright: Bryan Gulliver*

least one full-format vertical camera for acquiring digital or film photographs.

Block oblique cover may also be a practical solution. One method, still observer-directed, is outlined by Gates in this volume. Another would be to properly mount a medium- or large-format camera so that consecutive obliques could be taken with appropriate stereo overlap. A recent press release announced that Simmons Aerofilms were about to commence an oblique survey of the whole of the UK (*GEO: connexion* UK, September 2004, 50) which, if done at appropriate times of year, may record useful archaeological information. Gulliver's door could also be adapted to hold an oblique camera and Andrew Sayers, a pilot operating in Scotland, already uses a fixed oblique camera in his canard aircraft.

A practical means of becoming effective would need one of our larger (?civil service) institutions to buy its own twin-engine aircraft and co-opt a countrywide team of observers (flying instructors) to note and report on local ground conditions. Survey flying at appropriate times of year is then based on those reports.

Aerial photographers, be they archaeologists or aviators, currently favour observer-directed photography for a number of reasons: it is what they have always done, they claim it to be cost-effective, it enables them to take good illustrations, it satisfies their hunting instinct and it is good fun to do. They have convinced themselves and their paymasters that this is the right way to undertake 'aerial survey'. Archaeologists have allowed themselves to get stuck in the situation where in most cases a data collector provides data analysts with what the collector has

decided is what they want rather than what the analysts have asked for. This is one fault in the present system of 'aerial survey' that follows from the belief that the brain in the sky is the key to our data collecting. I think this is an antiquated idea and that aerial survey should grow up and begin to use modern methods of data collecting while the data are still there to be collected. In any area – new or supposedly well-examined – ground-based archaeologists need to decide whether they prefer their main source of data to comprise selected views of individual modern fields (*52*) or unbiased cover of the complete area of interest (*53*).

EXAMPLES

Within the writer's experience there are at least three large areas of lowland England where vertical photographs have recorded significantly more information than obliques. Some of the post-war RAF verticals of Hampshire and Wiltshire show extensive areas of Celtic fields and some associated features with clarity and at a scale that assists their understanding. On the silt fens of East Anglia verticals of similar date record the Roman landscape, archaeological and natural, with details and extent that has never been approached in the subsequent 60 years of observer-directed reconnaissance. This was demonstrated by the maps drawn by Sylvia Hallam for *The Fenland in Roman Times* (Phillips 1970) and is illustrated here by recent mapping of a few hectares at Thorney, Cambridgeshire in advance of development (*54*). Both Wessex and the Fens have continuous archaeological features that are most effectively recorded by blanket photography rather than selective targeting. They are ideal examples of real landscape archaeology and have long been known as such. Bedfordshire, on the other hand, has a high percentage of clay that is 'known' to be either unsettled in pre-medieval times or just does not allow crop growth to indicate buried features. So this makes the county an ideal testing ground for comparing the efficacy of oblique and vertical cover.

Bedfordshire County Council has acquired vertical cover initially at 1:12,000, and more recently at 1:10,000, at five-yearly intervals since 1976. Many of the photographs are archaeologically uninformative as would be expected from their

52 Opposite above: Polygons of possible oblique photographs showing an indication of cover that may result from an observer-directed flight over the 4 x 4km area. This set of photographs were those 'taken' when orbiting during the simulated flight (*48, 49*) and show which sites were recorded and which were missed. Many stereo pairs have been taken along with single frames of, perhaps, the less distinct features. *Copyright: Rog Palmer*

53 Opposite below: Outlines of 12 vertical prints at 1:10000 scale that provide total cover of the 4 x 4km area in frames that overlap by 60 per cent along the flight lines and by 10-15 per cent laterally. Each site will appear on at least two photographs providing a range of slightly oblique views. *Copyright: Rog Palmer*

dates of flying, although they do hold information relevant to the landscape. However, in 1996 a combination of the right date and a dry summer resulted in the recording of a completely unexpected archaeological landscape, much of which was on clay soils. This writer made a rapid survey of some 300sq km of the Bedfordshire–Cambridgeshire borders and identified slightly more than 300 sites. Comparing that distribution with that recorded by 45 years of observer-biased survey showed two mutually exclusive distributions (Palmer forthcoming). That aside, the new density of sites allows some comparative figures to be aired to contrast the effectiveness of vertical and observer-directed survey.

54 Both parts of this figure show mapping undertaken at 1:10,000 scale on the silt fens at Thorney, Cambridgeshire. The left figure maps information from all observer-directed photographs taken of archaeological targets that were available to me in the late 1980s. The right figure shows the same area as mapped from the national survey verticals taken by the RAF in 1946 and 1948. It is obvious that the observers' attention has focused on 'sites' and ignored, not seen, or not understood, the relevance of the larger ditch-defined system of which they are components. Might it be possible that our traditional observer-directed photographs are missing this quantity of information elsewhere? Is this why observers claim to record 20 per cent of new information on each flight? The grid is at 1km intervals. *Copyright: Rog Palmer, with additional Ordnance Survey map detail reproduced by kind permission, OS Licence number AL 100028850*

MATHEMATICAL INTERLUDE

The 300sq km of Bedfordshire that was examined from the 1996 verticals contained slightly over 300 sites. The flying time to record this with stereoscopic photographs at 1:10,000 scale was 90 minutes. Apart from one additional strip flown the next day the whole county was flown within a single day.

The 300sq km is roughly one quarter of the area of Bedfordshire, thus, as the density of archaeological features appeared consistent county-wide, we can estimate there to be about 1200 sites, probably mostly new, on that set of photographs. We also know that there will be virtually nothing that was visible on the ground during the flights that will not be recorded on those photographs and can later be viewed stereoscopically. Information comprises archaeological and various natural features that often have relevance to one another. The actual costs are confidential, but Cambridge University's Unit for Landscape Modelling quoted an approximate £20,000 for undertaking the same survey in 2004 (1:10,000 contact scale, colour negative, 60 per cent overlap) and providing prints or digital images. The flying time for the survey is estimated to be in the region of four hours and the whole county would be covered by almost 1000 photographs.

Measurements of flight paths on GPS flight trace of observer-directed surveys show that orbiting a single target requires between 5 and 20+ km of flying. A low estimate of two orbits to allow observation, decision and photography requires about 8km of flying.

Assuming that our airborne observer finds all 1,200 sites and flying 8km to record each makes a total flying distance of 9600km. At a speed of 80 knots (150kph) it requires 64 hours flying to cover that distance. Taking a working flight duration of a Cessna 172 at three hours, and flying once a day, it would need about 22 days to photograph those sites during which time crop conditions and possibly weather will change. This calculation falsely assumes there to be no transit time and that all sites are adjacent and identified immediately by the airborne observer.

An estimated cost per hour for a Cessna 172, as is commonly used in the UK and Europe, will be in the vicinity of £130 per hour. Cost for 64 hours flying is £8,300.

And the photographs? If four photographs are taken of each site that provides a total of 4,800 frames. It is usual to use medium format for best-quality aerial photographs and my old Bronica 645 camera took 15 frames per 120 film. Using this our oblique photographer would need 320 films which, from a current (January 2004) catalogue cost about £250 for bulk purchase of FP4 (£560 for Fuji colour film). It is realistic to use professional prices to compare with the professional vertical service and the excellent lab I use in Cambridge will process black and white at £5.28 per film, making a total of almost £1,700 (colour would be £1,450). And the price for 4,800 8 x 10-inch machine prints on resin-coated

paper would be £11,000 (colour at just under £10,000). It may be possible to negotiate reductions for bulk but from the above the working total for black and white film, processing and prints is £12,950 (colour £12,000). Hand printing to archival standards would almost double the cost of the black and whites. My own cost, based on work done in 2003, would be £19,200. Others may do it for less.

Our oblique survey, relying on observation and understanding before recording, may thus provide us with photographs of 1,200 discrete targets for a total cost of about £21,000 in either black and white or colour. To that figure must be added 20 days salary for the observer, perhaps another £3,000. We can assume that the time taken for interpretation (for mapping, not photo reading to describe and classify the pictures) is equal for both types of photograph.

THOUGHTS

Is the above an unlikely scenario? What would happen with observer-directed survey if one year a similar-sized area showed a prolific archaeological content? My guess is that the best looking sites (for illustration) would be picked off, the others ignored and quite possibly small fragments of sites would be un-noticed because of the wealth of other information to be seen. I suggest that there is no realistic way in which our normal methods of observer-directed photography would record anything approaching the total number of sites that were visible in 1996. Yes, 1996 was an exceptional year and yes, we are fortunate that the survey was taken at an appropriate time. So for a much lower cost than an oblique record that would never be achieved we are able to use, now and in the future, a total record of archaeological and natural features that were visible in a 24-hour period.

If obliques are taken from a sensible height to include mapping control information they are likely to have a contact scale in the order of 1:10,000 but it is more usual to enlarge oblique photographs than verticals. A similar contact scale suggests it is likely that an oblique and vertical of the same site will hold very similar archaeological information as was demonstrated by Michael Doneus (1997). Now that interpretation of photographs on screen is becoming routine, there is no reason why a vertical frame taken on an appropriate date at a contact scale of 1:10,000 should be any less informative than an oblique. In fact I suggest it will be *more* informative as it may record fragments of information that have been discarded or were unseen by an airborne observer.

If the mathematical interlude above is correct, or even approximately so, it appears to show that costs are lower if we aim to record blocks of land effectively. As an interpreter, as long as similar degrees of enlargement were available, I would prefer to work with unbiased photographs than those taken after a fast-moving human brain has decided to do so. Block photography taken at appropriate times would, I suggest, even add to our knowledge in supposedly well-recorded areas. It could be argued that this would entail repeat photography

of a lot of previously-known sites and this is true, but it may also record fragments of information that have not been noticed by an airborne observer that can be combined by mapping to show past landscapes. Do we know, for example, that ground between discrete sites in the Welsh Marches really is empty or is this due to the site-centred mentality of our photographers? And thorough 'off site' cover of even Wessex and the Fenland would seem likely, in places, to add information that may be relevant to inter-site behaviour. Block cover does not have to be county-wide but will be equally effective in smaller areas if it is sensibly planned to keep transit distances to a minimum. It could be argued that many other prospection methods are observer-biased with surface collection of artefacts perhaps being the closest to aerial survey. Agreed, but how much more revealing may be such a survey if the collector could vacuum up a whole field and analyse it in the comfort of a laboratory with comparative material to hand. Aerial survey has the terrific advantage that this is just what block photography allows the interpreter to do.

This leads to a number of other proposals. Whichever type of recording is undertaken, be it observer-biased or block cover, it would seem essential to use GPS to record the full track of the surveying aircraft. While this would not show any moments of inattention by an airborne observer it can be considered to indicate a swathe of ground that has been examined from the air on a particular date. More radical perhaps is the suggestion that one of the larger heritage bodies purchase a suitable aircraft and employ a specialist pilot and camera operator and use them to obtain block cover of selected areas at suitable times of the year. This would put an instant stop to complaints that verticals are not taken at times best suited for archaeological recording and would begin a collection of data that may be sold on to other interested parties. Furthermore, such an aircraft could undertake less time-sensitive photography for paying customers throughout the year and so bring in revenue to help support archaeological surveys. Frequent flying would also enable us to monitor changing crop conditions in different parts of the country and so undertake archaeological surveys at optimum times. Such a leap forward in the way in which we undertake archaeological aerial survey would move us from the level of amateur observers to a professionalism that serves the complete range of survey, from data collection to its analysis. This change in practice and attitude would bring an end to the heroic age of aerial prospection, in which we have seen the bold aviator battling with cropmarks to bring home a successful kill, and help to provide aerial survey with a higher level of credibility.

This note is not intending to play off one type of photography with another but more to question the philosophy and appropriateness of our aerial survey methods. Archaeological theory and practice has moved from the site-centred study that was in vogue when the technique of oblique aerial photography was perfected. Landscape archaeology demands investigation of blocks of ground, something that aerial survey can provide more effectively than any other form of prospection. But, by adhering to targeted observer-directed photography,

aerial survey has remained firmly in a single-site mode and may therefore be left behind, or seen as ineffective, by mainstream archaeology. The archaeological content of the majority of our aerial record has been obtained by observer-directed photography quite often taken by people who are not archaeologists, even though they are able to identify a range of archaeological sites. It is that method of data collecting, as an efficient form of survey, which is questioned by this contribution. Surely the main aim of archaeological aerial survey should be to record as much information as may be visible before it is all ploughed away. I would like future generations of archaeologists to be grateful for the thoroughness of the legacy we leave rather than scoffing at a collection of illustrations showing only a handful of lost gems.

I use the above to present a case in favour of unbiased block cover as a means of reliable and effective and *real* aerial survey. In case we ever again get cropmarked summers I hope that people involved in the flying side of aerial survey will plan ahead and decide that unbiased data collecting will provide a better sample of archaeological evidence than will be seen and brought back to us by the brain in the sky. I ask whether continued use of the 1930s method of aerial observation is:

... providing the best sample of visible archaeological (and other) evidence?
... as effective and cost-efficient as it is claimed to be?
... what twenty-first century archaeology wants and needs?

BIBLIOGRAPHY

Capper, J.E. 1907 Photographs of Stonehenge as seen from a War Balloon, *Archaeologia* 60, 571
Cowley, D.C. 2002 A case study in the analysis of patterns of aerial reconnaissance in a lowland area of Southwest Scotland, *Archaeological Prospection* 9, 255-265
Doneus, M. 1997 On the archaeological use of vertical photographs, *AARGnews* 15, 23-7
Palmer, R. 1989 Thoughts on some aspects of air photo-archaeology, in: Kennedy D. (ed.) *Into the Sun: essays in air photography in archaeology in honour of Derrick Riley*. J.R. Collis Publications, 53-60
Palmer, R. forthcoming 45 years – v – 90 minutes: effects of the 1996 Bedfordshire vertical survey on our perceptions of clayland archaeology, in: Mills, J. & Palmer, R. (eds) *Clayland Archaeology*
Phillips, C.W. 1970 *The Fenland in Roman Times*, Royal Geographical Society Research Series 5
Planck, D., Braasch, O., Oexle, J. & Schlichtherle, H. 1994 *Unterirdisches Baden-Württemberg: 250,000 Jahre Geschichte und Archäologie im Luftbild*, Theiss
St Joseph, J.K.S. (ed.) 1966 *The Uses of Air Photography*, J. Baker
Stoertz, C. 1997 *Ancient landscapes of the Yorkshire Wolds*, RCHME
Wilson, D.R. 2000 *Air Photo Interpretation for Archaeologists* (second edition), Tempus

BIAS AND THE WORLD OF THE VERTICAL AERIAL PHOTOGRAPH

Jessica Mills

INTRODUCTION

As a non-aerial archaeologist who has been involved with aerial photographic interpretation, this paper will demonstrate a different viewpoint on the current practice of aerial photography. Perceptions, experiences and knowledge generated through both the practice of archaeology and the interpretation of aerial photographs have given rise to this contribution which aims to highlight the merits of vertical aerial photography. I propose that the use of geographically unbiased vertical photographs is often a more appropriate and informative method for aerial photography than the highly selective and biased approach of oblique photography.

Oblique photographs, which usually concentrate upon a particular archaeological site, have long been the staple of archaeological aerial photographic techniques. Taken from an angle, and focusing closely on an archaeological feature, such photographs are reliant upon the photographer observing archaeological phenomena. Whether or not photographs are taken of features depends upon the research agenda, interests, targets and impulse of the photographer. Taking oblique photographs may involve considerable amounts of time in the air to record small areas of landscape as a result of the oblique angle and focus used in the technique. Conversely, vertical photography is commissioned by an individual and records areas of the landscape from a vertical viewpoint, usually covering a larger area than oblique photography. As the camera is mounted on to the aircraft and not held in the hand of the photographer the taking of photographs is automatic and does not rely on human judgement. The output comprises sets

of geographically unbiased photographs of large areas of the landscape, which may or may not contain archaeological evidence.

Since the advent of aerial photography, the oblique technique remains the most prevalent method of aerial survey, and it is this prevalence of an oblique view that has helped shape current thinking within aerial archaeology. It is my belief (as an archaeologist) that such channelled perceptions need to be opened up so as to embrace the wider opportunities of vertical aerial survey. Unlike the wider discipline of archaeology, aerial archaeology has yet to move away from the 'site-centred' approach which prevailed in the 1960s and 1970s. Current interpretive themes in archaeology emphasise the need to contextualise sites within their landscape settings thereby engendering more relevant interpretations and this is best enabled through the use of vertical aerial surveys.

Using the example of the 1996 vertical aerial survey of Bedfordshire, which revealed an unprecedented number of archaeological cropmarks upon clay geologies, it will be shown how geographically unbiased surveys enable greater insights into the past. Clayland areas in Bedfordshire, and at a greater scale in Britain, have traditionally been seen as areas of low potential for revealing cropmarks, and this view has been constantly reinforced throughout the decades by the direction of aerial reconnaissance and oblique aerial photography. The 1996 Bedfordshire survey shows how significant results can be obtained from vertical aerial photography if it is planned and directed by archaeological personnel to fulfil archaeological objectives.

THE STUDY AREA

Aerial photographic interpretation work was undertaken on a 90sq km study area of north and mid-Bedfordshire, south-east Midlands (55). The aim of this research (Mills 2002) was to rapidly determine the past settlement and land-use of this region. The 1996 Bedfordshire vertical survey was used as the primary data set (see Palmer, this volume), but alongside oblique photographs from the Unit for Landscape Modelling at Cambridge and local fliers.

The study area contains the river valleys of the Great Ouse and Ivel and their clayland environs. The geology comprises drift deposits of alluvium, river and glacial gravels along the floodplains and river terraces (Green 2000, 9-11). Outside the river valleys, the most widely occurring sub-drift deposit is the Jurassic Oxford Clay (Chatwin 1937; Edmonds & Dinham 1965, 11). Within the study area it is largely concealed by glacial and river deposits such as Boulder Clay and gravels. The Boulder Clay is a calcareous drift found in large zones to the north and south. It is not wholly impermeable and is characterised as a stiff grey clay, often with inclusions, and largely derived from Jurassic clays and Gault (King 1969, 6). Notably, there are significant drift-free tracts of Jurassic Oxford Clay in the east of the study area (56). The Oxford Clay is a very heavy dark brown formation, virtually impermeable and of low value for ground water

55 Location map illustrating the study area. *Copyright: Jessica Mills*

supplies. It is very finely grained and pure with little or no inclusions (Rigg 1916, 395; Edmonds & Dinham 1965, 79). This area is predominantly rural, supporting cereal production and a small number of market gardens. Due to the high percentage of land under the plough (there is little woodland, and limited pasture), the potential for archaeological cropmarks is good.

THE 1996 BEDFORDSHIRE VERTICAL SURVEY

The county of Bedfordshire is recorded by vertical surveys at five-yearly intervals. These vertical surveys have enabled an important picture to be built up of the whole county regarding archaeological and geological cropmarks, and other landscape phenomena. Significantly, the 1996 survey, undertaken by Aerofilms on behalf of Bedfordshire County Council, was commissioned by archaeological personnel. As a consequence, it was flown at a suitable time of the year (July), and completed rapidly in two days. Fortuitously, 1996 was a particularly dry summer and, as a result, the cropmarked ditches of many previously unknown clayland sites were visible and recorded (56).

518000/
256000

508000/
247000

0 1 2 3 4 5 **Kilometers**

N

Geology

|||| River Gravels · · · Oxford Clay ≡ Lower Greensand

Boulder Clay ▓ Glacial Gravels □ Alluvium

56 Plan illustrating the study area geology and archaeological cropmarks. *Copyright: Jessica Mills*

Prior to this 1996 survey, the clayland distribution of archaeological sites in Bedfordshire was deemed sporadic and small-scale (Simco 1973, 14). Previous research on the prehistoric archaeology of the area remarked upon the numerous and extensive cropmark complexes on the valley gravels and lack of similar evidence for the large areas of clay formations (Field 1973; Green 1973; Woodward 1978). However, this picture has developed over many years through the taking of oblique photographs that have focused primarily upon the bountiful river valley gravels. As the claylands have been seen as unfruitful for photographic purposes, relatively little was known about the past settlement of this area until the 1996 survey.

SURVEY RESULTS

Through studying all photographic sources, 301 archaeological cropmarked sites within the study area were determined (Mills 2002; 2003). The figures below indicate marked differences in the degree to which archaeological cropmarks are located on the different geologies (57). Importantly, the majority of sites located within the highly visible river valleys were already known within the Bedfordshire Historic Environment Record. However, the instances of sites upon the Boulder Clay and Oxford Clay of the region have increased considerably as a result of the 1996 vertical survey (58).

Significantly, the Boulder and Oxford Clays within the study area contain few sites despite the large areas that these geologies cover within the study area. Furthermore, despite the increased numbers of archaeological cropmarks upon clay geologies, it can be seen that the extent and distribution of past settlement differs according to the type of clay. Notably, the Boulder Clays of the area contain more archaeological cropmarks than the Oxford Clays. In addition, there are large areas of the Oxford Clay that contain no sites whatsoever, and sites that are located on the Oxford Clay appear to prefer locations around the boundaries of this clay with other geologies. These results suggest that quite different distributions of sites detectable from the air are occurring on each clay geology of the area. This has important implications for detecting sites upon clay geologies. Previously, aerial archaeologists have tended to treat all clays as being homogenously less favourable for revealing cropmarks, but it now can be proposed that important variations are occurring in their visibility according to the type of clay geology.

Geology	No. of Observed Sites	% of Total Study Area
Boulder Clay	61	36.15
Oxford Clay	33	21.86
Glacial Gravels	3	1.75
River Gravels	159	28.78
Alluvium	45	10.79
Lower Greensand	0	0.67
	301	**100**

57 Number of observed archaeological cropmarks and percentage of total study area categorised per geology

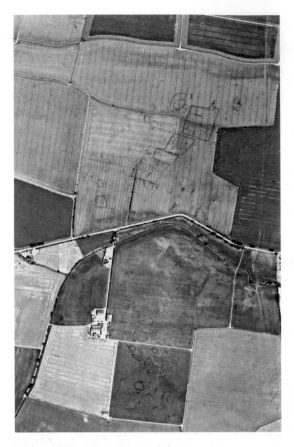

58 Vertical photograph taken from the 1996 Bedfordshire aerial survey. The geology of this area is Boulder Clay. Due to the favourable conditions when this photograph was taken a proliferation of archaeological cropmarks is visible. *Copyright: Aerofilms, AF 96C/563, run 16-1884, 18 July 1996*

Determining why this distinction between different clay types is occurring needs further investigation. It is possible that such distributions may be reflecting variations in the past settlement upon the two clays. Alternatively, the patterning of archaeological cropmarks on the Oxford Clays may be attributable to a less responsive nature of such clays to aerial survey. Whatever the reasons for the distinctions between the two clay types, more aerial reconnaissance over the claylands is urgently needed. This research is just one example of how vertical surveys can reveal new information which has important bearings for both archaeologists and aerial survey. Whether it is more informed site distributions and patterns, or discovering problems in the visibility of sites on certain geologies, these have come to the fore in this case through the utilisation of vertical aerial survey and not oblique photography.

CONTEXTUALISING SITES AND LANDSCAPES

From using the above example, it can be seen that through the use of geographically unbiased vertical survey the opening up of possibilities for observing new trends

within past landscapes becomes more of a reality. The feasibility of gaining new insights into past settlement, land-use, changes and continuities within large areas can be rapidly ascertained. Particularly, the vertical survey has facilitated a greater understanding of the settlement of this region as great swathes of the landscape have been recorded which are usually ignored by oblique photographers. This is more than just the aerial 'stamp-collecting' of sites as the features and sites visible on these vertical photographs are captured alongside their settings and landscapes (59). Intimate relationships between archaeological sites and geological and environmental data are placed to the fore, and the potential implications for studying whole landscapes from the air (including not only archaeology but woodland, hedgerows, boundaries, watercourses, geological features and so on) is enormous.

Archaeological sites are intimately bound up in their own settings, and relations with topographical features, geologies, soils and watercourses all contribute to a site's history and identity. By not recording these features fully we are missing a great chunk of the site's context and hence, our understanding of that site. Through the recording of such features in a geographically unbiased way, vertical photographs capture more information, and consequently may engender a greater range of interpretations and understandings of sites. In the majority of

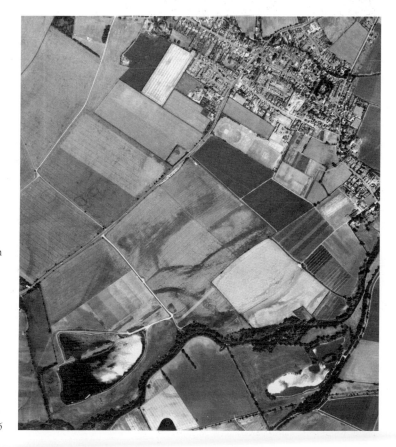

59 Vertical photograph taken from the 1996 Bedfordshire aerial survey. The relationships between archaeological sites, topographical, fluvial, and geological phenomena as well as modern features can be seen. *Copyright: Aerofilms, AF 96C/563, run 15-1946, 18 July 1996*

123

cases, the oblique view effectively divorces the site from its context leaving much of the story untold. Indeed, by seeking to record the maximum amount of detail in an aerial photograph, the limitation of interpretations, theories and ideas is reduced. Thus, by introducing an oblique view at the data-recording stage many possibilities are withdrawn immediately. In addition, vertical surveys allow for the recording of whole landscapes which may serve as important historical records. Changes through time of whole landscapes and, indeed, modern features which are not normally captured on oblique photographs are significant. What is today's modern feature is tomorrow's archaeology. Opportunities for future research from vertical photographs are not nearly as narrow as they are with oblique photographs which are the product of the photographer's selective perception.

Furthermore, we must not forget that it is through past human activities that these cropmarks, soilmarks and earthworks that are captured within aerial photographs are created. Through such tight focusing upon the very visual patterns, textures and phenomena that form such features, the archaeological site turns from being the place of dwelling, activity, relations, engagements and so on, to an abstract pattern of colour and textural changes which disassociates the very essence of the people that created them. On occasion, it appears that some aerial photography is more concerned with recording aesthetic, circumscribed patterns in the landscape and not the recording of locales of past human activity. People in the past were not constrained to their aerially visible sites, they would have moved around the surrounding landscape in a constant routine of everyday life, which makes it more imperative to record such wider landscapes in a geographically unbiased way.

OBLIQUE PHOTOGRAPHY AND THE CREATION OF MYTHS

The prevailing tradition of oblique photography has left a legacy of myth creation and perpetuation which may engender inappropriate or erroneous understandings. Moreover, because of the highly filtered and focused view, there is less opportunity for the aerial archaeologist and archaeologist to think of new interpretations. There is less room for manoeuvre. As is witnessed in the Bedfordshire region (and for that matter all over Britain and Europe), the discovery-led, selective view of the aerial photographer encourages the capture of more and more oblique photographs of the same productive locations in the landscape, and this is how myths are born. The action of placing the camera to the eye can be seen as a metaphor for the oblique *mentalité* of many aerial photographers.

Significantly, though, this is not to imply that the vertical aerial survey does not play any part in myth-making. Certainly, vertical photographs cannot speak for themselves, as they have to be commissioned by people, and interpreted to enable understandings and descriptions and to make sense of what is depicted in the photograph (see Brophy 2002). There can be a danger that we find what we want to find. Therefore, it must be borne in mind that vertical surveys are not an objective

map-like truth, as issues of bias and perception are introduced into the photograph at the commissioning and interpretation stage. Nevertheless, the strength of the vertical aerial photograph lies in that it negates the inherent bias, selectivity and pressures tied to combining flying, observation and oblique photography.

TAKING AERIAL SURVEY FORWARD

Whilst I have argued for vertical aerial photographs as the most appropriate form of rapid, landscape reconnaissance, there are a number of issues which need to be addressed if a more holistic and integrated regime of aerial survey can be achieved. So far, the prevailing technique of oblique photography has dominated photographic and interpretation methods and this needs to be changed. Certainly a more integrated regime of geographically unbiased vertical survey combined with focused oblique photography will help to provide a more balanced and informative view of past landscapes (e.g. Cowley 2005). Whilst vertical photographs provide a wider landscape view, the need for immediacy and detail are important also; this is where oblique photography can play an important role. By regularly recording areas of landscape in a geographically unbiased way oblique photography can be subsequently targeted to record areas and answer questions that have arisen as a result of the vertical survey.

Significantly, a barrier to this increased integration of both techniques has been the complaint that vertical survey is both costly financially and temporally. The extra flying time required to undertake additional vertical survey and the financial costs involved with this are often used as an excuse not to undertake such survey. Nevertheless, Rog Palmer (this volume), has shown how vertical survey can be a rapid, cost-effective exercise when carefully planned and commissioned. And costs of flying vertical surveys can prove to be just as efficient if not more so than the favoured oblique technique. Defining research questions and agendas prior to organising such survey will enable a more financially viable technique, and allow for the cost-effective targeting of archaeological phenomena.

CONCLUSIONS

In summary, the object of this paper is not to promote the use of vertical aerial survey as a panacea for aerial archaeology. From an archaeological point of view, I want to encourage a greater use of vertical aerial survey as a fundamental, yet reciprocal aerial photographic method. The increased flying of vertical surveys at suitable times of the year will engender a more balanced view of sites and their landscapes than can be obtained from the photographing of obliques alone. Importantly, vertical photographs do have their biases, which are introduced at the

commissioning and photo-interpretation stages, but as each stretch of landscape is captured in a geographically unbiased way for posterity, photographs can be revisited at any time to elicit different interpretations, information and ideas.

The 1996 Bedfordshire vertical aerial survey has opened up a whole new range of possibilities, not just for understanding the past settlement of this region, but for appreciating whole landscapes and their changes over time. It is difficult to predict what will form the archaeology of the future, but by not selecting particular features and phenomena during the data-recording stage, more possibilities are open to future research. Significantly, oblique photographs do hold an important place within aerial photography, but they should be seen as being complementary to vertical aerial surveys.

ACKNOWLEDGEMENTS

Thanks to Rog Palmer and Gary Jones for comments and discussions on the text, Anthony Crawshaw for advice, and Stephen Coleman at the Bedfordshire Historic Environment Record for his unfailing assistance at the data collection stage.

BIBLIOGRAPHY

Brophy, K. 2002 Thinking and doing aerial photography, *AARGnews* 24, 33-9

Chatwin, C.P. 1937 *British regional geology: East Anglia and adjoining* areas, HMSO

Cowley, D.C. 2005 Aerial reconnaissance and vertical photography in upland Scotland: integrating the resources, in: Bourgeois, J. & Meganck, M. (eds) *Aerial Photography and Archaeology 2003. A century of information*, Archaeological Reports Ghent University 5, Academia Press

Edmonds, E.A. & Dinham, C.H. 1965 *Memoirs of the Geological Survey of Great Britain: geology of the country around Huntingdon and Biggleswade*, HMSO

Field, K. 1973 Ring ditches of the upper and middle Great Ouse Valley, *Archaeological Journal* 131, 58-74

Green, C. 2000 Geology, relief, and Quaternary palaeoenvironments in the basin of the Ouse, in: Dawson, M. (ed.) *Prehistoric, Roman, and Post-Roman landscapes of the Great Ouse Valley,* Council for British Archaeology Research Report 119, 5-16

Green, H.S. 1973 Early Bronze Age burial, territory, and population in Milton Keynes, Buckinghamshire, and the Great Ouse Valley, *Archaeological Journal* 131, 75-139

King, D.W. 1969 *Soils of the Luton and Bedford district*, Special survey No. 1, Agricultural Research Council

Mills, J. 2002 *The aerial archaeology of north and mid Bedfordshire*, Unpublished MA thesis, University of Leicester

Mills, J. 2003 Aerial archaeology on clay geologies, *AARGnews* 27, 12-19

Rigg, T. 1916 *The soils and crops of the market garden district of Biggleswade.* Cambridge University Press

Simco, A. 1973 The Iron Age in the Bedford region, *Bedfordshire Archaeology* 8, 5-22

Woodward, P.J. 1978 Flint distribution, ring ditches and Bronze Age settlement patterns in the Great Ouse Valley, *Archaeological Journal* 135, 32-56

RECORDING UPLAND LANDSCAPES: A PERSONAL ACCOUNT FROM NORTHUMBERLAND

Tim Gates

INTRODUCTION

Since 1995 I have completed four fairly wide-ranging surveys of upland landscapes in Northumberland. In each case the survey area was first recorded by means of oblique air photography and then mapped by hand at 1:10,000 scale. Occasionally, pre-existing vertical photography was also used to create additional control in areas where the detail shown on published maps was inadequate for this purpose.

The four project areas are listed in the accompanying table (*60*) which sets out the size of the territory covered, the name of the commissioning body and the number of new sites recorded. As these figures show, around 1000 otherwise unrecognised sites have been added to the county Sites and Monuments Record (SMR) in the course of this work. In rough terms this represents an increase of approximately two thirds over and above the pre-existing total of known sites in each of the four territories – a startling figure particularly as all these areas have benefited from intensive fieldwork and ground survey in recent years. High though it may seem, this figure nevertheless represents only a small fraction of what has newly come to light, since it takes no account of the multitude of enclosure boundaries and rig cultivation systems which, for the sake of convenience, were not allocated SMR codes though they do in fact make up the bulk of what is

portrayed on the map overlays produced for each of the project areas.

For the purposes of this volume I have chosen to write about two different aspects of my work on upland landscapes: firstly describing some practical aspects of my approach to the photography of earthwork sites and secondly discussing some results of this work to show how the use of oblique photography in low-angled sunlight can add a new dimension to our understanding of upland landscapes.

SOME AIR PHOTOGRAPHIC TECHNIQUES APPLIED TO UPLAND LANDSCAPES

The first point to make is that the particular techniques that I use in the air are primarily geared towards making maps. While the maps that I produce are mostly controlled sketch plots drawn by hand from steeply oblique (i.e. near vertical) photographs, the same photographs are no less suitable for computer assisted mapping. Indeed the ones that I used to map the Hadrian's Wall corridor (*60*) are currently being employed by an English Heritage team to make a GIS-based map of the Wall landscape using Aerial software. But whatever mapping technique is involved, the first requirement of photography is that the whole territory should be covered. Where the survey area is relatively large, comprising, say, several tens of square kilometres, this requirement would normally be satisfied by resorting to vertical photography, specially taken for the purpose or obtained off the shelf from

Project area	Dates	Coverage sq. kms.	Commissioning body	New sites	Report
Otterburn Military Training Area	1995–1997	200	Northumberland National Park, MoD, English Heritage	444	Gates, 1997
Hadrian's Wall Corridor, from Chesters to Greenhead	1998–2000	115	Northumberland National Park, English Heritage	418	Gates, 1999 & 2004
College Valley, NW Cheviots	2000	50	Northumberland National Park	70	Gates, 2000
Wallington Estate	2001–2002	40	National Trust	85	Gates, 2002

60 Some upland landscapes in Northumberland that have recently been mapped from air photographs

some other source. However, experience shows that small or unobtrusive earthworks often fail to show up clearly on vertical photographs particularly if they were taken at an inappropriate time of day or the wrong season of the year, with the sun too high in the sky or vegetation obscuring the ground. Moreover, at photo scales smaller than 1:3,000, some archaeologically important details, including, for example, certain diagnostic features of ridge and furrow, may not readily be picked up.

This was certainly my experience on the Wallington Estate where vertical photographs at 1:10,000 scale, though of excellent photographic quality, proved quite inadequate for the detailed interpretation of certain kinds of earthwork site (including ridge and furrow) even when viewed in stereo and under magnification. For example, on outlying parts of the Estate, there are many hectares of low, curving rig which is all but invisible on the ground and can only be studied properly on

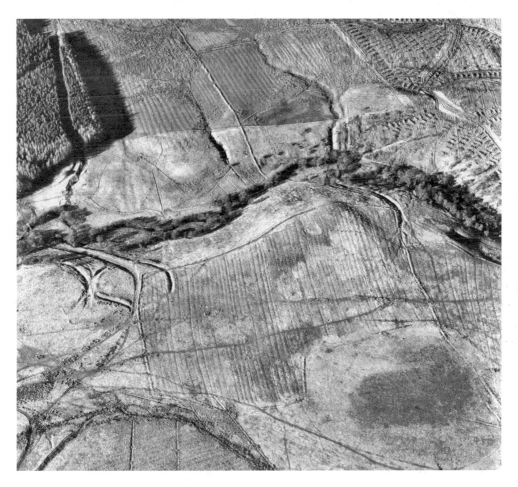

61 West Shank, Greenleighton Fell (NY 024 938). Low, curving rigs occupy an irregular shaped enclosure which probably dates from the seventeenth or eighteenth century, but could be earlier. They are much easier to see on the photograph than on the ground. *Copyright: Tim Gates, NT/02/ C/44, 13 March 2002*

high resolution photographs taken in low-angled sunlight (*61*). Surviving Estate maps suggest that these particular rigs are likely to date to the seventeenth or eighteenth century and, like certain 'low rigs' recently described at Menstrie Glen in Stirlingshire (RCAHMS 2001), probably represent short lived episodes of ploughing yielding a catch crop of barley or oats for one or two years followed by a return to permanent or semi-permanent pasture (Gates 2002).

One way of avoiding the disadvantages of off the shelf, non-archaeological, vertical photographs is to commission new surveys in which cameras equipped with a mechanism compensating for forward motion are used. By allowing longer exposure times, these enable satisfactory photographs to be taken late in the day with a more revealing amount of shadow than would otherwise be possible. Just such a camera (an LMK 15) is currently used by the Unit for Landscape Modelling at Cambridge (formerly CUCAP) and was successfully employed to record large swathes of Midland ridge and furrow for the Northamptonshire Open Fields Project (Hall 2001). However, even this refinement does not address the fact that some sites will only show to their best advantage on oblique photographs taken from one particular direction (usually against the light). This particularly applies to earthworks of notably low relief, such as, for example, timber-built prehistoric settlements and many field boundaries and cultivation systems, including poorly developed ridge and furrow of the type referred to above.

When recording earthworks from the air it is, of course, critically important that photography should take place in appropriate lighting conditions, good visibility and at times of the year when sites are not obscured by long grass or bracken. So far as lighting is concerned, best results are usually obtained by timing flights so that the plane is over the target area when the sun is at an angle between 10 and 25 degrees above the horizon. For any given latitude, the exact times of day when this condition will be met can be predicted by reference to a chart showing the movement of the sun above the horizon as it changes week by week through the year. Such a chart is not difficult to construct, for those who are mathematically minded, and shows that at latitude 53 degrees 57 minutes N (York) the sun will be in the required position almost continuously during daylight hours from late October until late February. In late March, on the other hand, its transit between these same angles is limited to a period of two hours in the morning (7-9am GMT) and two hours in the afternoon (3-5pm GMT). By the end of the third week in May the most appropriate times are between 5-7a.m. and 5-7p.m. GMT. In other words, in spring, when flying conditions are often best, the sun will be at the optimum angle for photographing earthworks during a period of not more than two hours on any given flight.

Since the exact angle at which the sun's light strikes a particular target also depends on the slope of the ground, in undulating terrain this too has to be taken account of in flight planning. Again, there may be circumstances when it would be better to have low sun in the south rather than, say, the west and to achieve this the flight might need to be made in February rather than May or June. Such a situation can, for example, arise with cord rig where one wants if possible

to have the light at right angles to the alignment of the rigs so as to produce the optimum degree of shadow or, better still, to have photographs taken with the sun at two different angles 90 degrees apart. However, this is a council of perfection and budgets will not normally run to luxuries of this kind.

For most kinds of air photography a minimum of 15km visibility as judged by an observer on the ground is generally the accepted minimum, though for best results something considerably in excess of this is preferable. Where earthwork photography requiring strong sunlight and sharp shadows is concerned, a more or less cloud free sky is also desirable. Fortunately, now that satellite images and Met Office data are widely available on the web, cloud is much easier to predict than it used to be. However thin layers of high altitude stratus or cirrus, which can inhibit the formation of shadows just as effectively as cloud at lower altitudes, may still cause problems particularly as it may not be reported by air traffic control. Likewise, the possibility of cloud many miles west of the target area should be taken into consideration if there is a chance that it may obscure the sun as it drops down low towards the horizon.

Over the years I have improvised a technique which allows me to photograph substantial areas of ground while at the same time obtaining a good proportion of overlapping stereo pairs. Flying in either a Cessna 150/2 or 172 with a crew of two (the pilot sitting in the right-hand seat as usual), the plane is guided by myself – the photographer/navigator – along a series of more or less straight, parallel runs. On days when the wind speed aloft is in excess of, say, 5 knots, it is a considerable advantage if the track of the aircraft can be adjusted so that it heads directly into the wind on each active run. The point here is to minimise the aircraft's tendency to drift downwind each time the wing is dropped before taking a shot. When the moment comes to take a photograph it is my role to indicate to the pilot the precise point at which to dip the wing. Then, immediately after the shot has been taken, the pilot levels the plane while at the same time applying right rudder to bring it back onto its former course. In this way the plane advances in what is basically a straight line interrupted at more or less regular intervals by a series of rapidly executed left and right turns. From time to time, as required, the plane can also be brought round in a full circle so as to allow selected targets to be photographed from different angles.

For this technique to work successfully the pilot and photographer must work closely together as members of a team. Ideally, too, the photographer should also have a well-developed spatial sense as he, or she, must be able to hold in mind a visual image of the ground that has been covered while at the same time directing the plane systematically over the remaining territory. This must necessarily be done mainly from memory as there will only be time to refer to a map at intervals between successive runs while at the same time maintaining a careful lookout for other aircraft. For those with weak stomachs it must be admitted that the repeated turning and levelling of the aircraft at 10- or 15-second intervals can have an unsettling effect! Although it requires intense concentration, this technique can be used to record areas in excess of 10sq km in, say, one and a half to two hours, yielding perhaps as many as

200 frames depending on the complexity of the landscape that is involved.

The desire for blanket photographic cover of upland landscapes arises not only from the extensive and often complex nature of the archaeological remains, but also the wish to record field monuments which, being low in stature or shaped in such a way as not to produce easily recognisable shadows, are very likely to be missed by the airborne observer. Indeed a whole range of unobtrusive field monuments and cultivation remains are apt to be overlooked if too much reliance is placed on the observer's ability to select targets from the air (*cf.* Palmer 2001). In these circumstances comprehensive cover of the whole survey territory is a way of safeguarding against this particular kind of bias. This does not of course mean that areas covered by blanket peat or which are otherwise clearly sterile may not be omitted after preliminary reconnaissance.

PEAT DRYING PLATFORMS AND CORD RIG: SOME RESULTS OF PHOTOGRAPHY IN LOW-ANGLED SUNLIGHT

Many examples might be given of upland sites which are especially difficult to see from the air. Amongst the most elusive are groups of small cairns, seemingly the

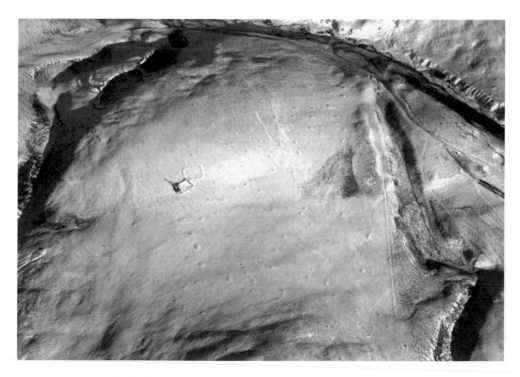

62 Prehistoric cairnfield, White Law (NT 946 290). Cairns like this are normally very difficult to pick out from the air but on this photograph are emphasised by low sun and a light covering of snow. *Copyright: Tim Gates, 18 March 1985*

by-product of stone clearance for agriculture rather than burial, which can rarely be identified except perhaps when picked out against a light covering of snow (*62*).

Another, less familiar, type of site which has likewise proved difficult to recognise can be illustrated by reference to a group of recently discovered earthworks on Simonburn Common, 2.5km north-west of Carrawburgh Roman fort (*63*). As seen here, individual monuments may be oval, circular, or sub-rectangular on plan, the perimeter in each case being defined by a shallow trench up to 0.5m broad and 0.2m deep. Those which are rectangular generally have overall dimensions of the order of 4-6m long by 2-3m broad, though a small number exist which are up to twice this in length. At the time of writing neither the date nor the function of these enigmatic monuments has been satisfactorily determined, though it seems unlikely that they are of any great antiquity. For the time being the best that can be said is that they bear a certain resemblance to the so-called 'turf steads' on Bodmin Moor as well as to platforms in Scotland which, it is thought, also served as temporary platforms for drying peat or turf before it was carted away for use as a domestic fuel (Herring *et al.* forthcoming: Boyle 2003) What matters here is that no sites of this type had been identified anywhere in Northumberland or, so far as I am aware, elsewhere in northern England, until they were revealed, unexpectedly and by chance, on

63 Possible turf drying platforms, Simonburn Common (NY 837 726). This group of small earthworks may represent peat drying platforms. Each structure is defined by a trench no deeper than 0.2m. *Copyright: Tim Gates, TMG 13892/77, 18 May 1992*

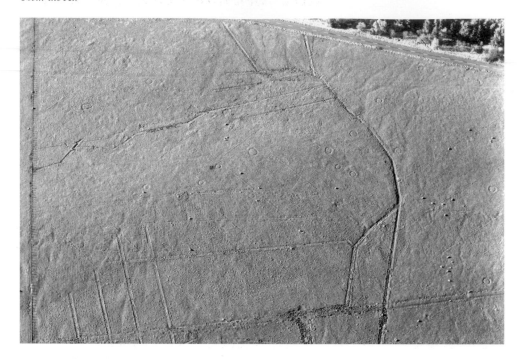

64 Possible turf drying platforms, Hartington Common (NZ 000 898). These small earthworks resemble those illustrated in *(63)* except that the majority are circular on plan. *Copyright: Tim Gates, NT/01/C/2, 11 May 2001*

oblique photographs taken in low-angled sunlight. Nor, one should add, were most of these unobtrusive earthworks noted from the air at the time when the photographs were taken. However, once they had been recognised, further examples soon followed and the distribution of these sites now extends far more widely across upland Northumberland than could have been foreseen when the initial discovery was made 10 years ago. In 2001, for example, a group of more than three dozen sites came to light on an outlying part of the Wallington Estate *(64)*. Although comparable to those on Simonburn Common, a high proportion of the Wallington platforms are strictly circular rather than sub-rectangular on plan inviting comparison with the 'silt circles' recorded on the edges of the Fens which have likewise been interpreted as platforms for stacking peat or hay (Riley 1946; Hall & Palmer 1996). One curious feature of the monuments newly recognised in Northumberland is the repeated occurrence of shallow, pit-like depressions in the bottom of the perimeter trench. Superficially at least, these have all the appearance of post-holes and can sometimes be seen spaced close together and forming an almost complete circuit round the edge of the platform. In the end the identity of these curious earthworks is likely to be settled only by resort to excavation. For present purposes what matters is how easily this whole category of site went unnoticed over a period of more than 50 years in an area as closely monitored as the Hadrian's Wall corridor.

In Northumberland, prehistoric fields and evidence of cultivation largely

evaded recognition until they too were eventually recognised on air photographs taken in the late 1970s. Here again, there can be no doubt that the fragile and often confusing nature of the remains and, paradoxically, their very extension over large tracts of rough hill country, made any precise determination of context in ground survey a more than usually hazardous business. It is therefore hardly surprisingly this should be another area where high resolution oblique photography has played a leading role, the result being that field systems of both prehistoric and Roman date are now recognised as a widespread and persistent component of the archaeological landscape in the uplands of Northumberland.

Within the scope of this short contribution it is not possible to do more than touch very briefly on one aspect of the role played by air photography in recording field systems in order to illustrate the particular benefits of the kind of photography that I have been describing. The example I have chosen is that of cord rig, a form of prehistoric cultivation in which hoeing or digging rather than ploughing is used to create a ridged soil surface. So far as readers of this volume are concerned, this may at least have the merit of a certain novelty given that the distribution of cord rig in the form of extant earthworks is a phenomenon largely restricted to counties in the far north and west of Britain.

As regards dating, air photography can usually do no more than suggest very

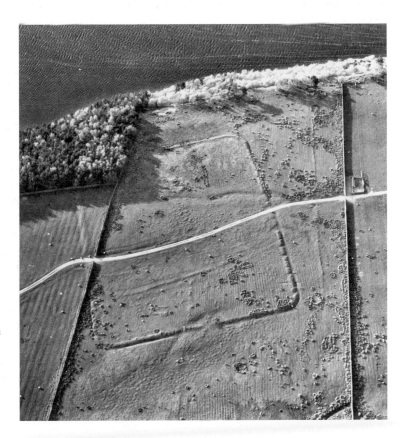

65 Cord rig underlying a Roman Temporary Camp at Greenlee Lough, Bardon Mill (NY 775 695). *Copyright: Tim Gates, TMG 14738/78, 4 May 1993*

approximate contexts for cord rig. For example there are a number of sites in the vicinity of Hadrian's Wall where Roman structures of one kind or another can be seen to overlie fields of cord rig, so providing a *terminus ante quem* for the preceding phase, or phases, of cultivation. Thus, in one already well-known instance, at Greenlee Lough, 1.5kms north-west of Housesteads Roman fort, air photographs (*65*) clearly show a Roman temporary camp superimposed on top of fields of cord rig (A on *66*; Welfare 1986). Likewise, on air photographs taken in 1992, the aqueduct leading to Great Chesters Roman fort was found to cut through a field of cord rig near Cawburn Shield (NY 726 684; B on *66*). Again, at Four Laws, air photographs suggest that cord rig underlies a group of Roman burial mounds situated next to the Stanegate Roman road (NY 705 659; C on *66*). Here, photographs taken by the RAF in 1930 indicate that as many as two dozen mounds may originally have been involved though no more than six of these now survive, all the rest having been levelled by ploughing over the past 70 years (Gates 2004).

As well as stratigraphic relationships of this kind there is a large and growing number of instances where cord rig has been recorded on air photographs in close proximity to settlements known or suspected to be of late prehistoric or Roman date. These include timber-built palisades, settlements of unenclosed round houses and native farmsteads of late Iron Age and Romano–British type. Here it is only necessary to stress that proximity does not always add up to association in the strict archaeological sense nor, in the case of sites with potentially long sequences of occupation, is it necessarily obvious to which phase or phases of settlement the cultivation belongs.

While reviewing the evidence for early cultivation in Northumberland and the Borders, Peter Topping (1989) listed 61 locations in Northumberland at which extant cord rig had been identified in the form of visible earthworks. In the context of the present discussion it is worth noting that roughly 80 per cent of these sites were initially identified from air photographs. Latterly, continuing reconnaissance has added very substantially to what is now a considerable and growing body of evidence. The net result is that the known distribution of cord rig in Northumberland now extends to most upland areas with the exception of the remote interior of the Cheviot massif and the high Fell Sandstone moorlands which extend southwards from the Kyloe Hills, passing east of Bewick and Chatton to Simonside and beyond. Here the all but complete absence of late prehistoric settlements suggests that the inherently fragile soils may already have been exhausted by the end of the Bronze Age.

By way of illustration, and to show its *apparent* association with different types of settlement, I have mapped the distribution of cord rig across a territory which spans the central section of Hadrian's Wall, extending westwards from Carrawburgh as far as Great Chesters (*66*). One reason for choosing this particular area is precisely because it has been subject to intensive survey from the air so that the distribution of cord rig is probably better documented here than in almost any other part of Northumberland. Today this territory consists mostly of rough grazing and unimproved grass moorland which includes some substantial tracts of ridge and furrow where land that has

66 South Tyne Valley: map showing the distribution of native settlements, fields and cord rig in the central section of the Hadrian's Wall corridor. *Redrawn by Georgina Brown from an original by Tim Gates*

been cultivated in the past has been allowed to revert back to permanent pasture. Accordingly, the general pattern of cord rig in the landscape is best appreciated in areas that have remained beyond the reach of destructive ploughing. So far as our survey area is concerned, this mainly involves land to the east of Broomlee Lough and north of Hadrian's Wall that once formed part of Simonburn Common. Here (in the north-east quadrant of 66) numerous fields of cord rig are scattered over the landscape. Most of these are small in size, extending to no more than 0.5ha, though some larger areas of cultivation, reaching 4.0ha or more, have also been recorded. Interestingly, no more than half of this cord rig can be shown to be accompanied by any sort of extant settlement though there are at least a dozen instances where cord rig forms an integral part of organised field systems that are adjacent to settlements of enclosed or unenclosed round houses. At Fold Hill, for example, fields of cord rig covering an area of a little more than a hectare lie next to a rectilinear settlement of late Iron Age or Romano-British type (67; D on 66). Strange as it may seem, this particular site was not discovered until 1992 even though it is situated only 2km north of Hadrian's Wall.

At this point it is worth pausing to consider whether this map could just as well have been produced using conventional vertical (as opposed to oblique) cover. The answer, I think, must be no and for the following reasons. In the first place it is not normally possible to identify cord rig, or indeed other earthworks of similarly low relief, on existing vertical photography which, more often than

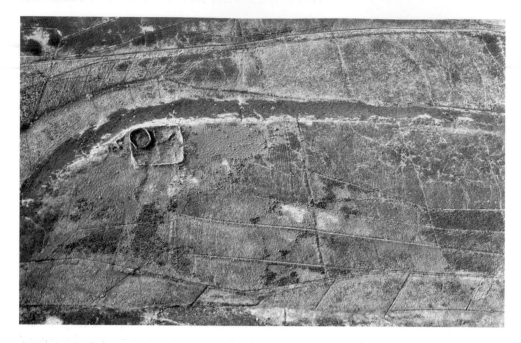

67 Fold Hill, near Sewingshields (NY 822 725). Here a native site of late Iron Age or Romano-British date stands on a rock outcrop with fields of cord rig to the east (right on the photograph). The structure within the settlement enclosure is a nineteenth-century sheepfold. *Copyright: Tim Gates, TMG 13892/41, 18 May 1992*

not, consists mainly of RAF National Air Survey 'split-verticals' and commercial verticals that were taken for non-archaeological purposes. In most cases this photography is simply at too small a scale, or was obtained under inappropriate lighting conditions and at the wrong time of year, for earthworks of this kind to show with any degree of clarity. Of course it should be said that these drawbacks are not ones which are inherent in vertical photographs as such. Indeed it is quite possible that better results could be achieved in future by commissioning vertical surveys to be undertaken in strictly specified conditions and using a survey camera fitted with the type of forward motion compensation mechanism that has been referred to above. But even this would not allow targets to be viewed from contrasting (oblique) angles which can often be important for the proper interpretation of very slight earthworks, as has already been noted.

For mapping purposes the main advantage of vertical photography is that it covers the survey territory with the minimum number of overlapping prints needed to permit stereo viewing. In this respect vertical photography might be said to be a more efficient method than the one I use, though this does not necessarily mean it is cheaper, nor indeed is stereo cover difficult to obtain using the technique I have described. Also, with the advent of ever more sophisticated transformation programmes using digital terrain models, it is now possible to map archaeological detail over variable terrain from oblique photographs to almost the same standard of accuracy as can be done with verticals.

Whatever method is employed, the requirement for seamless cover of a given territory may be a response to the complexity and extent of the archaeological remains as well as the perceived need to eliminate observer bias. For, as we have already seen, what John Hampton used to call 'the Mark I human eyeball' cannot always be relied on to pick out relevant archaeological detail from a moving aircraft. Indeed it is not difficult to find some remarkably prominent sites which appear to have been overlooked in this way even in a landscape as apparently well explored as the Hadrian's Wall corridor. Looking again at the sample territory, we may consider the case of two closely adjacent native farmsteads on Crindledykes Farm (*68*; E on *66*). Despite the fact that both settlements are prominently situated on rocky outcrops and well within sight of Housesteads Roman fort neither site was discovered until 1992, more than 60 years after aerial survey first started on the Wall. One likely reason for this is that Housesteads, perhaps the most spectacular Roman fort on the Wall, has simply proved so magnetically attractive to aerial photographers that they overlooked other, less eye-catching, targets that happened to be around in the same vicinity. In other words the fort seems to have created what might be described as a 'halo of invisibility' around it so far as some less tempting targets were concerned. In any case it was precisely with the idea of counteracting the natural

68 Green Brae, Crindledykes (NY 789 676). This native farmstead and field system, of late prehistoric or Roman date, is prominently sited on a rock outcrop within site of Housesteads Roman fort. It was unrecorded until this photograph was taken in 1992. *Copyright: Tim Gates, TMG 13889/48, 16 May 1992*

tendency towards this kind of bias that I set out to improvise a method of oblique photography which would allow me to cover a whole block of territory more fully than would otherwise be possible.

Again with reference to the study area (*66*), the landscape that I have mapped occupies some 75 square kilometres of ground lying between the southern edge of Wark Forest and the Stanegate Roman road. Within this territory approaching 100 plots of cord rig have been newly identified from oblique air photographs taken between 1992 and 2001 as part of a survey of the Hadrian's Wall corridor commissioned by the Northumberland National Park Authority. While this new evidence is clearly important in assessing the role played by arable agriculture as a component part of the native economy during the late prehistoric and Roman periods, our primary concern here has been with the technique that was used to record it. By taking cord rig as an example, I hope to have demonstrated how the particular tactics that were employed were important in determining the outcome of the survey and led to a deeper understanding of the landscape than might otherwise have been achieved.

BIBLIOGRAPHY

Boyle, S. 2003 Ben Lawers: An Improvement-Period Landscape on Lochtayside, Perthshire, in: Govan, S. (ed.) *Medieval or Later Rural Settlement in Scotland*, Historic Scotland

Gates, T. 1997 *Air Photography and the Archaeology of the Otterburn Training Area*, Unpublished report for the Northumberland National Park

Gates, T. 1999 *The Hadrian's Wall Landscape from Chesters to Greenhead: An Air Photographic Survey*, Unpublished report for the Northumberland National Park

Gates, T. 2000 *The Archaeology of the College Valley Estate: An Air Photographic Survey*, Unpublished report for the Northumberland National Park

Gates, T. 2002 *The Archaeology of the Wallington Estate: An Air Photographic Survey*, Unpublished report for the National Trust

Gates, T. 2004 *The Hadrian's Wall Landscape from Chesters to Greenhead: An Air Photographic Survey*, Unpublished report for the Northumberland National Park

Hall, D. 2001 *Turning the plough. Midland open fields: landscape character and proposals for management*, Northamptonshire County Council

Hall, D. & Palmer, R. 1996 Cambridgeshire Survey, the Isle of Ely and Wisbech, *East Anglian Archaeology* 79, 177-80

Herring, P., Sharpe, A. & Smith, J.R. forthcoming Turf, in: *Bodmin Moor − an Archaeological Survey, vol. 2. The Post-Mediaeval and Industrial Landscape*

Palmer, R. 2001 'The site was discovered on an aerial photograph', *AARGnews* 23, 46-7

RCAHMS, 2001 *'Well sheltered and watered': Menstrie Glen, a farming landscape near Stirling*, RCAHMS

Riley, D.N. 1946 Groups of Circles in the Silt Fens, *Antiquity* 20, 150-3

Topping, P. 1989 Early Cultivation in Northumberland and the Borders, *Proceedings of the Prehistoric Society* 55, 161-179

Welfare, A.T. 1986 The Greenlee Lough (Northumberland) Palimpsest: an Interim Report on the 1985 season, *Northern Archaeology* 7, part 2, 35-7

PATTERNS OF AERIAL PHOTOGRAPHY IN THE CENTRAL MIDLANDS OF ENGLAND

EVALUATING BIASES IN PAST PROGRAMMES OF AERIAL RECONNAISSANCE AND THEIR POTENTIAL IMPACT

Matthew Oakey

INTRODUCTION

Aerial reconnaissance and oblique photography forms an intrinsic and increasingly important part of archaeology today. It is claimed to be the most cost effective and efficient method of recording archaeological sites available (British Academy 2001, 35; but see Palmer this volume, for an alternative view). As well as a recording role, aerial photography also has an unparalleled ability to discover archaeology previously unrecorded by other means. This is most notably achieved through the photography of cropmarks, the ephemeral marks produced when the growth of a crop is affected by subsurface archaeological deposits.

Aerial survey has progressed through two stages. Firstly the basic techniques have been learned; secondly there has been a period of mass data acquisition that has left us with hundreds of thousands of oblique images. In England these are held in two national libraries, those of English Heritage's National Monuments Record (NMR) and Cambridge University, and local Sites and Monuments Records (SMRs). We are now at a third stage, that of analysis, interpretation and synthesis of the data amassed during the past 80 years.

From the mid-1970s in England there has been a shift in the focus of aerial survey and the way in which the data from aerial photographs is used. More emphasis has now been placed on interpretation and mapping rather than merely collecting images (Palmer 1989, 54). This is demonstrated in numerous aerial photograph interpretation projects but is perhaps exemplified in English Heritage's ongoing National Mapping Programme (NMP), established in 1992 to map archaeological sites from all available aerial photographs (Bewley 1998b). Furthermore, as this project has evolved there has been a move from considering sites as isolated monuments to a 'landscape approach' where sites are considered in a wider context.

This does, though, pose a problem. If we are to understand the archaeology that is being recorded through aerial photography and mapped from these aerial photographs fully, it is necessary to have at least a basic understanding of how this archive of photography may be biased. We cannot effectively synthesise and assimilate data unless we know to what degree the apparent distribution of sites recorded on aerial photographs reflects a true distribution or is skewed because of biases in the photographic record.

THE DEVELOPMENT OF AERIAL SURVEY IN BRITAIN

Aerial survey in Britain has a history spanning over 80 years. Since the first aerial photographs of Stonehenge were taken from a balloon by Col. P.H. Sharpe in 1906, literally millions of oblique and vertical aerial photographs have been taken for a variety of purposes, not just archaeological.

Aerial reconnaissance specifically for archaeological purposes did not begin in earnest in Britain until the 1920s. This inter-war period saw the foundations of archaeological aerial survey laid down by such pioneers as O.G.S. Crawford, Maj. G.S.M. Insall, Sqn Ldr G.W.G. Allen and their contemporaries. Many had been pilots or involved with military reconnaissance during World War I and after the war applied their skills and experience to the field of archaeology.

These early programmes of aerial survey were groundbreaking. For the first time the palimpsest of human settlement was illustrated through spectacular discoveries of cropmark complexes in the south of England such as that around the Big Rings henge monument at Dorchester (Allen 1938). However, they were limited both in terms of the amount of reconnaissance carried out and the areas that were subjected to survey. Photography was often directed to regions based on accepted views of settlement patterns and territorial extents gained from ground survey, which have subsequently been seen to be inaccurate. Furthermore, despite the cropmark discoveries photography was still predominantly of upstanding earthwork monuments.

The period after World War II saw a significant expansion in the use of aerial photography in archaeology. Again pilots who had served in the military during

the war played a significant role. Many flyers that would go on to contribute tremendously to aerial archaeology in future years began to undertake reconnaissance. Practitioners such as Arnold Baker, Jim Pickering and Derrick Riley, to name but a few, started annual programmes of survey (Bewley 1997, 200). Usually flying at a regional level within their 'core territory', locally based flyers such as these undertook photography for many decades and have amassed a very large archive of data. The network of local flyers that subsequently built up continues to the present day.

Parallel to the early work of local flyers Cambridge University also began reconnaissance. CUCAP had been formed in 1949, headed by Dr (later Professor) J.K.S. St Joseph (as of 2003 CUCAP is the Unit For Landscape Modelling). St Joseph had been undertaking limited reconnaissance with Cambridge University since the end of the war but after 1949 began regular programmes of aerial survey covering the whole of Britain (Wilson 2000, 20). The aerial photograph library of CUCAP is now the second largest in Britain.

In 1965 RCHME established its own flying programme, becoming the second organisation to fly at a national level (on 1 April 1999 RCHME merged with English Heritage). Up until the late 1980s flying was based in the south of England at Biggin Hill and later Oxford Airfield. However, in 1989 a northern office was established in York to redress the imbalance in the coverage. English Heritage now undertakes the greatest amount of reconnaissance in Britain.

The 1970s saw major changes in the structure of archaeology as a whole. The number of people involved in archaeology, especially at a professional level, increased greatly as did the amount of funding available. Aerial archaeology too went through significant changes in this period. By 1975 the number of locally based flyers had increased to over 50 and greater funding was available (Palmer 1989, 53). Coinciding with the expansion of rescue archaeology, this period was characterised by data collection on a very large scale as thousands of sites were recorded in advance of urban expansion, the development of the new towns and road building.

Up until 1976 the network of local flyers that had built up were reliant upon their own funding. In 1976 the Aerial Archaeology Committee of the Council for British Archaeology persuaded the Inspectorate of Ancient Monuments to provide a grant for regional reconnaissance (Bewley 1997, 201). Grants for regional flying have continued, to some degree or another, with responsibility for this funding transferring to RCHME in 1986 and then to English Heritage with its absorption of RCHME in 1999. At present the network of sponsored local flyers continues to complement English Heritage's own flying programme.

The development of aerial archaeology in this way has led to a situation where the photographic record has been built up in an *ad hoc* and piecemeal fashion. The photographic archive that we have today is the cumulative result of many different surveys undertaken by numerous individual flyers and organisations, each to some degree or another with their own research aims, flying strategies and other biases

that have affected how, where and when reconnaissance has been carried out. The funding of these surveys has also differed, both in terms of the source of funding and, perhaps most crucially, the amount available to flyers.

The evolution of the aerial photographic record in this way means that each individual survey with its own inherent biases will, in turn, bias the cumulative distribution of aerial photographs that we have today. This will thus affect our understanding of the archaeological record from these photographs.

The word bias tends to have negative connotations but this is not necessarily the case (see Brophy this volume). In archaeological aerial survey, just as in many other fields of investigation, a degree of bias is always inherent in some form. Indeed it is necessary for a practitioner to have a degree of personal bias to target all too often limited resources in the most effective way (see Wilson this volume). This may vary depending on the local landscape and is very much the case in cropmark sensitive areas where the evidence that is being recorded can disappear in a matter of days and may not be seen again for many years when the combination of crop, weather and of course a photographer being present occurs. Other biases may be present, for example, due to the need to meet the requirements of a specific research project or to record an area that is under threat from development.

It is also only in the past decade or so that sites such as those dating from World War II and the Cold War have begun to be considered as part of our heritage. Past programmes of survey will often not have targeted these monuments leaving gaps in the aerial photographic record.

Reasons for bias are in a way irrelevant. Whether arising from legitimate needs or bad practice, an awareness of these biases is necessary if we are to assimilate the data from any aerial photographs. We cannot begin to understand fully the archaeological record from aerial photographs unless we are aware of how the photographic record may be biased.

ANALYSING BIAS

The recognition of this issue begs the question of how we go about studying these biases. How can we use the information available to begin to dissect the pattern of photography for any given area? The rest of this paper presents a case study of an area of the Central Midlands of England, in which I will consider briefly some of the techniques that may be brought to bear and look at some of the results of the analyses.

A brief caveat is, however, necessary before we do so. There are two main limitations on using the techniques outlined below. Firstly there are a multitude of variables ranging from local weather conditions to availability of aircraft that can affect the strategies of any given survey. Many of these factors cannot be taken into account by using these techniques although detailed studies of flight logs and journals, where available, can inform to some degree. Secondly, and

perhaps most importantly, it must be emphasised that analyses such as these can only identify areas that have been photographed. They do not take into account 'negative' evidence, that is to say those areas that have been reconnoitred but no archaeology found, although with the routine use of GPS derived flight patterns this can now be done.

The maps illustrated here also are only accurate to 1km². The analyses are intended to demonstrate repeat photography within a given area rather than of an individual site. Repeat photography within a square may be photography of a number of different sites rather than the same one. Rates of photography can be shown, however, to reflect well rates of photography at 100m² accuracy.

THE ANALYSES

Bias in aerial survey is, of course, only one of the many factors that can affect the distribution of aerial photographs. Factors such as meteorology, modern land use and the combination of soils and geology can affect whether a site has survived or, if it has been destroyed, whether the remaining features will produce crop- or soilmarks which are visible from the air.

In analysis of the pattern of aerial photography I have identified three principal variables which lie behind the existing collections of aerial photography: the spatial location of each photograph, when it was taken and who took it. It is through combined analyses of these variables that an otherwise uninformative scattering of aerial photographs can be dissected to give an insight into the development of the distribution.

Furthermore, the distribution as a whole may be studied or broken down for each flyer for separate analyses that can then be compared and contrasted. This combination of approaches is particularly informative when studying areas that have been covered by more than one flyer. The comparison between flyers can be especially informative, highlighting geographical and chronological variation and how different strategies may have produced different results.

The first step in analysis is to consolidate all the available data into a coherent form that can then be interrogated in a number of ways. For this case study this involved the creation of a database recording the photographer, grid coordinate and date for each of the available oblique photographs, just under 9,000 in total. Basic analysis of this dataset involved queries to establish the number of photographs recorded for any given year and all the photographs taken by individual photographers. However tables can be hard to interpret, especially when potentially dealing with data from thousands of photographs. Far easier to understand are graphical outputs.

From the database line graphs were created charting the rates of total, new and repeat photography through time (*69*). These can be created for the survey area as a whole or for individual flyers. For this case study new photography was defined as photography in a grid square that had not been subject to photography on a

69 Graph showing the rates of total, new and repeat photography through time. *Copyright: Matthew Oakey*

previous occasion and repeat photography as photography within a square that had previously been subject to photography.

To further understand this data it is necessary to consider the development of photography geographically – the spatial element. The most effective way to do this, especially when dealing with a large amount of data, is to use a Geographic Information System (GIS) computer package. GIS packages can be used to interrogate large amounts of complex data in sophisticated ways and produce results in a graphical form. They can also enable the user to deal with many different graphical layers that can be interrogated on screen.

In the Midlands study the database was inputted into a GIS and distribution plots of photographs were produced from it and overlain on a digital map background. At the simplest level this distribution is shown by dots indicating the location of a photograph but the GIS can also alter the graphical output in a number of ways based on other sets of data within the database.

Examples of these types of outputs are illustrated (*70, 71*), reproduced in greyscale for the purposes of this publication. They show a region of Staffordshire where the River Tame joins the River Trent; this particular area is considered in a case study below. One (*70*) shows a graduated tone map based on new photography. Each tone represents a different period in which each square was first subjected to photography. The other illustration (*71*) shows the same distribution but this time the tone graduation is based on the rate of repeat photography. The darker the shade, the greater the number of years that photography was taken within that square.

70 Graduated tone map showing the first year of photography *Copyright: Matthew Oakey*

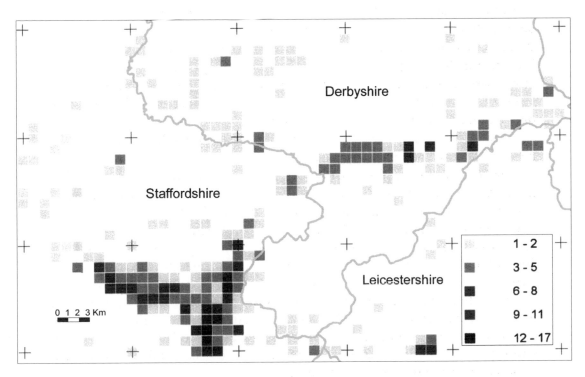

71 Graduated tone map showing the rate of repeat photography. *Copyright: Matthew Oakey*

CASE STUDY 1: THE TRENT AND TAME

This case study lies at the confluence of the Rivers Trent and Tame in the south-east of Staffordshire. It is one of the few places in the county with a combination of light, well-drained soils and an underlying geology of river gravel terraces that is conducive to the formation of cropmarks. Analysis has given an interesting insight into the development of photography in the region.

The summer of 1959 was dry and it was in this year that the river gravel terraces of the Midlands were first recognised for their archaeological potential. This is clearly reflected in the pattern of photography. The first recorded aerial photographs in this region were taken by Jim Pickering in 1955. At a similar time to the early work by Pickering it is also possible to see a shift in the pattern of photography by Cambridge University. Until 1956 reconnaissance by Cambridge in the region had concentrated on upstanding earthwork archaeology such as that in the Peak District. It is possible to observe a pattern of widely dispersed photography over a large area. However from 1956 a distinct change in strategy is evident, with a nucleation in new photography, concentrating on the Trent and Tame. Between 1956 and 1961 nearly all photography by Cambridge University concentrated on the river gravels. As well as reflecting a general shift in photography to the recording of cropmarks this also represents work carried out by St Joseph for the publication *A Matter of Time* (RCHME 1960).

The river gravel terraces of the Trent and Tame have evidently been subject to continuous and intensive photography for over three decades. The core of discoveries was made in this region by the late 1960s, subsequent photography representing a filling out of the coverage. Cross-referencing rates of new and repeat photography with the distribution maps identifies re-flying of areas that had previously been productive in the past. The patterns of photography demonstrate that the area has had comprehensive and regular coverage over a long period of time by a number of flyers.

The areas away from this core of photography do not demonstrate the same pattern of development. They have, on the whole, been subject to a lower rate of repeat photography and were not photographed for the first time until a comparatively late date. This disparity in photography will raise obvious questions when comparing archaeological evidence from these two regions. It also suggests that the presence of the cropmark rich landscape of the Trent and Tame has drawn away reconnaissance from the surrounding region, an inevitability where flyers are looking for good results.

This should clearly be a caveat to any interpretation of the archaeology in the region. The comparison of distributions of sites on and away from the gravels of the Trent and Tame will need to be tempered by the knowledge that sites on the periphery of the river gravels are unlikely to represent as accurate a picture of the archaeology in the region due to less intensive coverage. Conversely, though, a far higher degree of confidence can be placed on the data gained from aerial

photographs of sites on the river gravels of the Trent and Tame confluence. Regular re-flying of this region has greatly increased the likelihood of sites being identified and recorded.

CASE STUDY 2: CHESHIRE

In contrast to the Trent and Tame, Cheshire is characterised by heavier clayey soils that are primarily used for pastoral farming. These conditions are not conducive to the formation of cropmarks but survival of earthworks in this landscape is more likely. This region is characterised by, on the whole, a low rate of repeat photography.

Cheshire has been subject to reconnaissance since the early 1940s by CUCAP. However, early photography was both sporadic and on a small scale and a low incidence of repeat photography can be identified, concentrating on known upstanding monuments and other extant remains. Unlike the river gravels the first regular reconnaissance over the county did not begin until halfway through the dry summer of 1976 when Rhys Williams started aerial survey. From then on regular programmes of reconnaissance have continued up to the present day, primarily by three flyers who flew annual programmes of reconnaissance roughly in succession: Rhys Williams (1976-84), Nick Higham (1984-9) and Rob Philpott (1987-2000).

What is immediately obvious from the analyses is that each flyer took on a different strategy of reconnaissance. Early photography in Cheshire demonstrated a pattern of exploratory reconnaissance followed by more targeted photography later on. Until 1983 there was a very low rate of repeat photography and the concentration of photographs was in the south-west of the county; not until after 1983 were any photographs taken towards the east.

A very different strategy to reconnaissance appears to have been taken by Nick Higham. For the first time a significant amount of photography was taken in the north and east of Cheshire. The distribution of photographs complements the surveys that were undertaken in previous years. Analyses of new and repeat photography show a very compartmentalised flying strategy. Higham has a very low rate of repeat photography and it can be seen from the maps of new photography that this is due to photography being undertaken in discrete areas in each year. The pattern of revisiting previously productive areas that can be seen elsewhere is not apparent here and may well be a response to a predominantly earthwork landscape.

The distribution of photography for Rob Philpott differs again. A close correlation between funding and both the patterns and rates of photography is apparent. From 1996 to 1998 funding for the local flyer network was depleted severely but then increased in 1999. So between 1996 and 1998 there is a drop in the rate of photography which then increased sharply in 1999. What is more, the ratio of new to repeat photography also altered in this period of reduced funding. The proportion of repeat photography increased between 1996 and

1998 suggesting that the limited resources were being directed at areas that had proved productive in the past, therefore guaranteeing a return, a good strategy in the longer term battle for funding.

The distributions have demonstrated that the concentration of photography has been in the west of the county, partly due to the fact that the majority of flights have been from airfields in either the south-west of Cheshire or to the north-west. The maps of repeat photography show that as well as diffusion in photography to the east of Cheshire, the rate of repeat photography also falls.

CONCLUSION

This paper has illustrated that patterns of aerial photographs hide a complexity that is not self-evident, requiring systematic analysis to bring them out. A series of interrelated factors can affect how, where and when aerial surveys are carried out. By breaking a distribution up into its constituent parts and analysing those individual elements, a greater understanding of how the photography has developed and where it may be biased can be gained.

The application of results may differ from region to region and their implications may also depend on specific questions that are posed. Used in conjunction with mapping of aerial photographs, the results of the analyses of distributions can give a more rounded understanding of the archaeological data that has been mapped. Analyses should also be a key element in targeting future programmes of aerial survey more effectively.

BIBLIOGRAPHY

Allen, G.W.G. 1938 Marks seen from the air in the crops near Dorchester, Oxon, *Oxoniensia* 3, 169–171

Bewley, R.H. 1997 Aerial photography for archaeology, in: Hunter, J. & Ralston, I.B.M. (eds) *Archaeological resource management in the UK*, Sutton IFA, 97–204

Bewley, R.H. (ed.) 1998a *Lincolnshire's archaeology from the air*, Occasional Papers in Lincolnshire History and Archaeology No 11

Bewley, R.H. 1998b England's National Mapping Programme: a Lincolnshire perspective, in: Bewley, R.H. (ed.) 1998, 9–17

British Academy 2001 *Aerial survey for archaeology: a report of a British Academy working party*, http://www.britac.ac.uk/news/reports/archaeology/asfa.html

Carter, A. 1998 The contribution of aerial survey: understanding the results, in: Bewley, R.H. 1998a (ed.), 96–104

Palmer, R. 1989 Thoughts on some aspects of air photo-archaeology, in: Kennedy, D. (ed.) 1989 *Into the sun: essays in air photography and archaeology in honour of Derrick Riley*, J.R. Collis Publications, 53–60

RCHME 1960 *A Matter of Time. An archaeological survey*, RCHME

Wilson, D.R. 2000 *Air photo interpretation for archaeologists* (second edition), Tempus

TRADITION IN POWER: VICIOUS CIRCLE(S) OF AERIAL SURVEY IN POLAND

Włodek Rączkowski

INTRODUCTION

It has long been recognised (i.e. Bradford 1957, 62) that aerial survey is conditioned by the researcher's subjectivity. Some approaches to this issue have sought to circumvent the subjective factors that influence the procedure of taking and analysing photographs (e.g. Scollar 1978). This can be observed in the procedures introduced by processual archaeology (e.g. Ebert 1989) and related approaches that have developed under the direct or indirect influence of processual archaeology (e.g. Redfern 1997; cf. also Rączkowski 2002). The importance of experience (that of an archaeologist, pilot or interpreter) as one of the factors 'objectivising' aerial survey results has also been stressed (e.g. Pickering 1980), reaching the conclusion that the more experienced the researcher carrying out aerial survey is, the more credible (factual) the results are.

Since the introduction of post-modern thought into archaeology (e.g. Hodder 1985; Shanks & Tilley 1987) we have become increasingly aware that the methodology of aerial survey is heavily influenced by socio-cultural factors. Indeed, all decisions taken during the process, from embarking on aerial reconnaissance to final interpretations, must be looked upon from the cultural perspective (e.g. Brophy 2002; Rączkowski 2001). Any attempt at 'objectivising' the processes are undertaken by social agents and become structured by institutions and beliefs beyond their conscious awareness or direct control (e.g. Bourdieu 1977).

Aerial archaeology today is the result of many generations of archaeologists, pilots and interpreters. To understand these aerial archaeological pasts and the present-day conditions governing the process of aerial survey, one needs to

study their perspective as individual social agents. Archaeologies in Great Britain, France and the Near East are lucky in that respect, but in attempting to write an aerial text from Poland, I may be contributing to a misunderstanding as, to date, the achievements of Polish aerial archaeology are poor. This paper will thus outline the context of aerial survey in Poland, discussing the lack of Polish aerial archaeology and the future of aerial survey.

The knowledge of archaeological sites and their location, chronology and function is the most basic requirement to a study of the past. In a cultural-historical approach which advocates an inductionist model of explanation, there is a widespread belief that the more archaeological sites are known the fuller our knowledge of the past becomes. Archaeology has developed a number of survey methods to discover and record archaeological sites. On the surface it seems that Central European archaeology, which is still dominated by the cultural-historical approach (Kobyliński 1991; Minta-Tworzowska & Rączkowski 1996), must be particularly eager to make use of all available methods to broaden the archaeological record. However, the experience of Polish archaeology is different. Considering the two essential methods of large-scale survey, field-walking survey and aerial survey, in Poland field-walking survey alone is widely regarded as the correct method of finding and recording archaeological sites. The reasons for this discrepancy between the theoretical postulate (find as many sites as possible) and the practice (neglecting aerial survey almost completely) lie in the circumstances of the introduction of both methods into Polish archaeology.

FIELD-WALKING SURVEY

During the nineteenth century many archaeologists undertook 'field trips' to find valuable antiques (Abramowicz 1991, 63), but it was after the First World War that Józef Kostrzewski, the most eminent Polish archaeologist, transformed these trips into an important method of surveying. With groups of students, chosen areas, usually situated along river valleys, were examined to find archaeological materials, to gather data on site, and to place the sites on 1:25,000 scale topographical maps. Kostrzewski's approach was very effective and established field-walking survey and recording as a standard field procedure in Polish archaeology. Its pre-eminence was further strengthened by the growth of interest in micro-regional studies (introduced by Witold Hensel in 1968) and settlement pattern archaeology, much of which was based on archaeological material gathered in this way. Micro-regional studies generated lively interest mainly as it was easier to apply interdisciplinary studies in micro-regions. The possibilities presented by various natural science analyses to study long-term processes gave hope of making archaeological studies more historical (Central European archaeology is historical rather than anthropological in orientation). As a result of these processes field-walking survey became the primary method of data collection, seen as providing locational, chronological and functional information as a background for deciding on excavation strategies.

The 1970s brought about significant socio-political changes in Poland, with an opening up to the West, and a dramatic intensification of economic activity. This constituted a serious threat to archaeological heritage, the protection of which required detailed site data. Experience had shown that the information hitherto available on archaeological resources was fragmentary, and this lead to the recognition of the need to record all existing archaeological sites and evaluate their scientific value and conservation requirements. This recognition lead to the formulation of a nationwide programme called The Polish Archaeological Record (the 'AZP', see Woyda 1974; Jaskanis 1992; 1996). The programme commenced in 1978 and field-walking survey played a crucial role. Other methods of archaeological survey, including aerial survey, were considered in the programme, but were treated solely as a specific supplementary form of documentation for sites already known (Kempisty *et al.* 1981; Kobyliński 1999, 113-114). Now, after over 25 years of the AZP programme, it is appropriate to review its progress.

The programme has produced an incredible increase in information about archaeological sites and over 500,000 sites have been newly discovered, taking in different regions of Poland, and this data has brought about a fundamental revision of ideas about various aspects of past settlement systems. This programme has been of immense value to the heritage protection services. And yet, despite the positive aspects listed above, there are limitations and even dangers of the programme, which raise doubts about both its scientific credibility and its usefulness to archaeological heritage management.

Dating of sites is a key element of the AZP, but it is also one of its major weaknesses. Material culture may be undiagnostic and there is a lack of specialists that can characterise material accurately. Categories may thus be 'forced' onto material, while increasingly ambiguous classifications may also be applied e.g. 'indefinite' or 'prehistoric'. In addition the AZP programme requires determining the function of the site, based on very simplistic principles that are very misleading. In this system one to three potsherds are a settlement trace, four to nine potsherds a settlement point or campsite and a site with more than 10 pieces of pottery is a settlement. The pitfalls of this system can be illustrated with the example of a Bronze Age cemetery found in central Poland. Over several years some 100 graves had been found, though only a few pieces of non-characteristic pottery were recorded on the surface. Thus, according to the AZP instruction the site should be described as a chronologically indefinite campsite or perhaps settlement. Similar examples are numerous, and stem from the rigid constraints imposed by a system that has failed to evolve.

Questions can also be raised about how representative the records of the AZP are, based as they are largely on field-walking. Lech Czerniak (1996) carried out an interesting experiment to examine this issue. A 12 km² area was examined twice by field-walking. In the first survey of the area 56 sites were found. The second investigation gave a similar total, with 61 sites found, but of these, 34 were new and 26 sites known from the first survey were not found. Together these two surveys gave a total of 90 sites in the area, that is 38 per cent and 29 per cent greater than the

number of sites revealed in the first and second surveys respectively. Thus only about 50 per cent of the results of the first and second surveys were comparable and gave a 30 per cent lower number of sites than the results of both surveys together. In general, the results were confirmed when a new field-walking survey was done prior to the construction of a gas pipeline from the Yamal Peninsula in Russia to Germany via Poland. Clearly the AZP survey is not very representative and its results may be quite unpredictable. These experiments have not, however, brought about any revision of the commonly held opinion that field-walking alone is the best method for site discovery and recording which archaeologists have at their disposal.

AERIAL SURVEY

The tradition of taking aerial photographs of archaeological sites in Poland dates back to the end of the 1920s. The first, currently known such photographs were taken by Air Force pilots in 1929 of the excavation by Józef Kostrzewski of a late Neolithic site (Okupny 1998, 26) in Rzucewo, to the north of Gdańsk. These photographs characterised, in a metaphorical sense, the thought process of many generations of Polish archaeologists regarding the possible application of aerial photographs in archaeology. The photographs do not show the site, but the area where the site is located, and since no cropmarks or soilmarks are identifiable the photographs do not record information on the spatial structure or category of the site itself, nor its character and preservation. This sort of photograph provides an illustration of a known site, or rather of its spatial location, which can itself be valuable archaeological information.

Somewhat more directly archaeological were the photographs taken at the excavations of Biskupin. From 1935, Zdzisław Rajewski and Wojciech Kóčka regularly documented the progress of the excavations photographically using an anchored balloon from which a camera was suspended. This allowed them to take vertical photographs from a height of 5-150m (Kostrzewski 1938; Rajewski 1938). Such photographs supplied very precise information about the spatial structure of the site and its condition (http://www.muzarp.poznan.pl/muzeum/muz_pol/ Arena/Biskupin/index_pl.html). A similar documentation technique was also used during the excavations of a stronghold dating from the early Middle Ages in Kłecko near Gniezno (Okupny 1998, 218), and more recently at the Neolithic sites at Brześć Kujawski and Osłonki (Grygiel & Bogucki 1997). In 1935, with the aid of the Air Force, a series of oblique photographs of early medieval fortified sites in the Wielkopolska region were taken. These photographs showed the earthworks, their environmental context and state of preservation (Kowalenko 1938).

In the period before World War II aerial photographs were used for documentary purposes on excavated sites and on early medieval stronghold sites, which were already known. After World War II it was not possible to undertake aerial surveys (e.g. Rączkowski 1995) and only in the 1960s did interest in this

method revive. Photographs were taken in many regions of Poland, their main subject being early medieval strongholds, often using a helicopter (Rajewski 1975). In the 1970s and 1980s photographs continued to be taken of known sites and there was a growing use of vertical photographs taken by the Air Force or for cartographic purposes. Due to the lack of publications, it is hard to judge explicitly how these vertical photographs were to be used.

In the history of Polish aerial archaeology a number of trends in the use of aerial photography have been noted (e.g. Barford 2000). Firstly, there is the documentation of excavations, as exemplified by Biskupin. Secondly, has been the documentation of known earthworks, begun in the 1930s and continuing to the present, as an essential element in monitoring the state of preservation. Amongst these photographs of known sites it is possible to find, especially from the 1980s, quite regularly photographed plough-levelled sites, where the photography shows neither cropmarks nor soilmarks. It seems that these photographs of archaeological sites, in which it is impossible to distinguish any structures in a definite manner, have contributed to the formation of the opinion that aerial photographs are of little use in Polish conditions. This view stems from a lack of basic, but essential knowledge, about aerial archaeology concerning when and why archaeological features appear as crop- or soilmarks.

The third trend stems from collaboration with geographers, which has turned archaeologists' attention to the environment surrounding archaeological sites and the role of photographs, usually Air Force verticals, in the study of palaeoenvironment (Miszalski 1966; Ostoja-Zagórski 1969; 1998; Modrzewska-Marciniak 1984; Kijowski & Wyrwa 1989; Rączkowski 1995; Miałdun & Świątek 1993; Miałdun 1995). Fourthly, attempts have also been made to use aerial photographs to take land survey measurements of archaeological sites (Miałdun - pers. comm.), to allow the creation of DEM site models (results are not very promising yet). Finally, and very occasionally aerial surveys were linked to the search for new sites and compared with field-walking survey results (Bielenin 1962; Rączkowski 1995).

The essential characteristics of all applications of aerial photography in Polish archaeology were their dispersion, low level of intensity, limited publication (especially in major journals) and administrative limitations. The archaeologists involved struggled with basic problems of the method from the very start, they were self-taught and very often tried 'to reinvent the wheel', and results were not always good. Paradoxically, the cooperation with geographers and military pilots did not contribute to the evolution of thought on aerial photography in Polish archaeology. Geographers look at pictures in a different way and they search for different elements. They often work with pictures taken at the time of year when cropmarks or soilmarks are not likely to be revealed. Their pictures are taken at a different scale, which makes it impossible (or at least difficult) to see relatively small archaeological features. Air Force photography was often taken at scales or at times of year when archaeologists' requirements (to be honest, usually imprecisely formulated requirements) could not be satisfied. An atmosphere of mutual sympathy and cooperation was not enough

to remove the discrepancies arising from different conceptions of the importance of aerial photographs in archaeology (for a detailed analysis of the problem, see Lidka Żuk 2002; 2005). Multiple shots of the same earthworks did not bring any satisfaction either – after all, how many photographs of the same medieval strongholds do we really need? A lack of spectacular discoveries of new archaeological sites gradually enforced the notion that aerial photographs were of little use in Polish conditions and that the cost of acquisition was too high.

FIELD-WALKING SURVEY VERSUS AERIAL SURVEY

Clearly field-walking occupies a predominant position in Polish field investigation, and while the reasons for this are undoubtedly very complex, a key factor is what archaeologists think about field-walking and aerial survey. The perceived advantages and disadvantages of these methods are summarised below (72).

Field-walking survey	Aerial survey
cognitive effectiveness	poor cognitive effectiveness
discovery of many new sites	apparent lack of new site discoveries
easy access to fields*	organisational problems (permission necessary)**
low costs	relatively high costs
possibility of dating	little possibility of dating
possible to carry out, regardless of geomorphologic and soil conditions	thought to be unsuitable in Polish conditions
easy to teach	complicated processes to teach
no need for specialised equipment	specialised equipment is necessary (cameras and now also computers)

* Still possible, though not as easy as back in the 1980s and 1990s (cf. Rączkowski 1996)
** Not needed today, though not too many specialists are aware of it

72 The advantages and disadvantages of field-walking survey and aerial survey as seen by Polish archaeologists

This tabulation clearly indicates the huge advantages field-walking survey has in prevailing professional opinion. Any attempts whatsoever at changing it are met with determined resistance or are totally ignored at best. Moreover, any attempt at pointing to the advantages of aerial survey is treated as an attack on the proven method (field-walking survey) and a camouflaged wish to take over its financial resources (a very important argument since most conservation projects suffer from insufficient funds).

Archaeological conservators, however, are increasingly aware that the method is useful. This is the result of activities undertaken in the mid 1990s, instigated mainly by Zbigniew Kobyliński, who was then Chief Inspector of Archaeology in the Ministry of Culture and Fine Art (Barford 1998; Kobyliński 1999). An increase in the number of aerial survey projects undertaken (Kobyliński 1999) stimulated discussion about the application of aerial photography in the protection of the archaeological heritage (Nowakowski, Prinke & Rączkowski 1999). Archaeological conservators' most convincing argument was, and still is, that structures which are visible on aerial photographs in the form of cropmarks usually represent very well-preserved archaeological features. On the other hand, sites where large amounts of ceramic material have been discovered on the surface may be significantly damaged and at the same time may not be visible on aerial photographs (Rączkowski 1995; Nowakowski, Prinke & Rączkowski 1999); key factors in the protection of archaeological heritage and a problem that requires extensive study (e.g. Hall & Palmer 2000).

THE POTENTIAL OF AERIAL SURVEY IN POLAND

In the second half of the 1990s many reconnaissance flights shook the widespread belief that aerial photography was of little use in Polish conditions. Particularly good results were obtained during the Aerial Archaeology Workshop held in Leszno in July 1998 (Barford 1998), when over 100 sites were discovered as cropmarks. The majority of these sites were settlements revealed by house-pits and other pits, and more rarely traces of wooden dwellings. Many settlements in Poland share this characteristic and it poses a problem of the interpretation of cropmarks as representing archaeological features (73). In many cases the registered sites overlap with those that were registered as a result of the AZP and in these instances the photographs provide information about the site structures and their spatial layout in the area (74, 75). There are also many new sites discovered despite earlier field-walking surveys carried out in the same area (76). New types of sites, which up until now were unknown in Polish archaeology (77, 78), have also been recorded on aerial photographs.

These factors highlight the limitations of the AZP from the conservation point of view. Field-walking surveys have not been conducted evenly due to permanent (woods, groves, pastures, meadows, built-up areas, wastelands) or

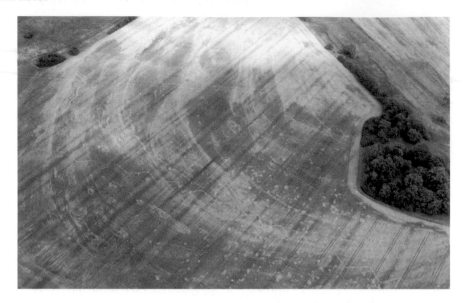

73 Lipowiec, comm. Niechlów, site 3 (AZP 68-22/19) – an example of an early medieval settlement located next to an early medieval stronghold (circular feature covered by trees); also visible are different sized pits scattered over a large area and a trench possibly from World War I or II. Excavations on the site confirmed the occurrence of well-preserved archaeological features (Nowakowski, Prinke & Rączkowski 1999, 116). *Photograph: J. Nowakowski, 5 July 1998*

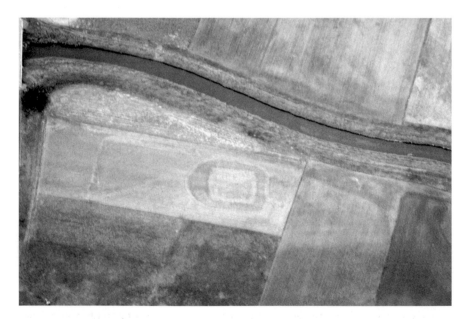

74 Pobiel, comm. Wąsosz, site 53 (AZP 70-26/42) – a site revealed during a field-walking survey and described as an early medieval settlement point and late medieval settlement point; on the basis of the aerial photograph the square feature surrounded by a deep ditch can be interpreted as a late medieval moat. *Photograph: J. Nowakowski, 5 July 1998*

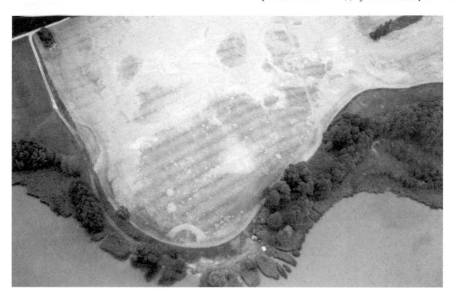

75 Osieczna, comm. Osieczna, site 4 (AZP 62-2f (107) a site discovered during a field-walking survey and described as a Neolithic settlement trace, a Roman Iron Age settlement and an early medieval settlement, the aerial photography reveals a scatter of pits, a square feature and a broad ditch describing a semicircle close to the lakeshore. *Photograph: J. Nowakowski, 4 July 1998*

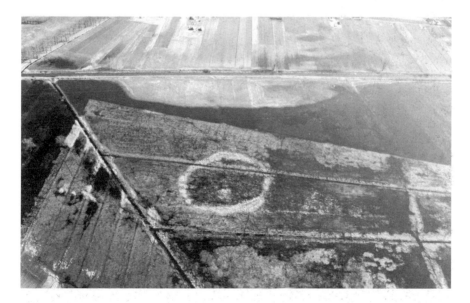

76 Jurkowo, comm. Krzywiń, site 49 – a previously unknown fortified settlement of Late Bronze Age/Early Iron Age date, discovered during aerial survey due to the high level of water that inundated the meadows and revealed a slight embankment. The settlement had not been found during field-walking survey because the area was not easily accessible (Nowakowski & Rączkowski 2000). *Photograph: W. Rączkowski, 26 March 1999*

temporary (cultivation, agro technical practices) limitations to observation. The results are empty spaces on the very maps on which development plans and investment projects are evaluated. Lacking information on sites, conservators cannot make decisions about rescue excavations or archaeological supervision. And it is beyond all doubt that lack of sites on maps does not mean that they do not exist there in reality. On the contrary, lack of any traces on the ground surface may suggest that the site is deep under the surface and well preserved. Experience has shown, however, that an AZP based map is thought to objectively reflect past settlement patterns. In consequence, sites that for different reasons have not yet been discovered, run the risk of being destroyed. The question arises why the AZP programme has been limited to registering sites exclusively by field-walking surveys, excluding other methods like geophysical studies and aerial photographs. Aerial photographs seem ideally suited to serve as an additional source of information about sites discovered by field-walking. Aerial photography can also discover sites not known from other surveys, and help determine the scope and function of sites.

The recent experience of aerial survey in Poland, undertaken with limited financial resources for flights and the analysis of the results, has shown that there is enormous potential for the application of aerial photography, with consequential benefits for the protection of archaeological monuments. In addition, the benefits for the research are also extensive. Aerial photographs reveal new categories of archaeological remains to Polish archaeology and demand a new approach to past societies. Aerial reconnaissance and the mapping of sites should demand a radical departure from the interpretation of an area through the distribution of individual sites, moving attention to the wider understanding of the landscape. Linking AZP information to aerial photographs may create an enormous supply of potential information about archaeological remains, which may have multiple uses in both academic archaeology and archaeological heritage management (e.g. Palmer 1995; 1996; Rączkowski 1996). However, it must be remembered that carrying out a single field-walking or a single air reconnaissance is not sufficient (Jaskanis 1996; Riley 1987). In both methods surveys must be repeated regularly (e.g. Riley 1987; Palmer 1995; Bewley 2000) and integrated effectively to maximise returns.

THEORY, PRACTICE AND HERMENEUTICS: TRADITION IN POWER

Does this situation indicate that aerial photography in Poland has great prospects? I allowed myself to doubt such an optimistic forecast (e.g. Kobyliński 1999). My doubts are based on certain aspects of Polish archaeology that are connected to the role of theory in archaeology. Since the beginning of the second half of the nineteenth century archaeologists believed that they were independent of any theory or philosophy. Today we can find the influence of

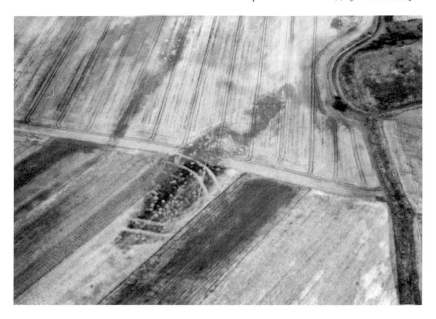

77 Kromolin, comm. Żukowice, site 24 (AZP 67-17/19) – a site discovered during field-walking survey and described as a Neolithic settlement point (the Corded Ware Culture), a Roman Iron Age settlement and a medieval settlement point. The aerial photography reveals, among scattered, different sized (mostly round) pits, two ditches describing an almost circular shape, probably the first feature of this kind discovered in Poland. *Photograph: J. Nowakowski, 5 July 1998*

78 Kurowo, comm. Kościan – a previously unknown site discovered during aerial survey. The aerial photography records a large rectangular feature with rounded-off corners, a type of site never previously identified in Polish archaeology. *Photograph: J. Nowakowski, 5 July 1998*

different philosophical traditions in archaeology. Positivism, which is accepted by the Polish archaeologist (usually subconsciously), assumes that: 1) archaeology is objective, that is, separate from people and cultural, political and metaphysical commitments; 2) facts discovered by archaeology are distinct from values held by archaeologists; 3) the process of discovery is thought to be distinguishable from the process of explanation; 4) observations and theories are distinct; 5) the facts themselves are not theory-dependent; 6) consequently, there is only one way to do science (Hodder 1999, 24).

What does this mean in terms of archaeological survey? Archaeological survey was, for many years, a systematic inspection of an area of land to search for sites from which several would be chosen for excavation. The product of the survey and excavations would be archaeological knowledge built as a result of inductive generalisation. Pure description would become an explanation of the past. Knowledge of human's past can be obtained as easily through the collection of information from many sites within a large geographical area. On the surface, it is possible to imagine that from this point of view aerial survey should be completely accepted before long. But it is not so. Why?

One can also look at this problem from the hermeneutic context. Hermeneutics is a theory of interpretation and its components are currently defined as: the hermeneutic circle; pre-understanding; and the historical nature of knowledge. For the issue of aerial survey in Polish archaeology pre-understanding seems to be the crucial concept. In our research procedures pre-judgements always appear, whether consciously or not. They influence the way in which questions are formulated, the definition of terms, the criteria by which significant facts, goals and expected answers are identified, the choice of tools, methods and all other aspects of our research. When we undertake any survey we do so with a large amount of pre-understanding (Hodder 1999, 32-4). At this moment I do not want to concentrate on the role of pre-judgements in the explanation of analysed facts. More important for me at this stage is the role played by pre-judgement in the decision-making process regarding which method to use for the collection of data within a given area. In different archaeological traditions, varying types of tools and methods may be used to gather types of information. Polish archaeology clearly inclines to field-walking survey, and it is difficult to imagine a sudden about-turn towards aerial survey. The role of pre-understanding is so great that the thought of using aerial photography does not even cross the minds of the majority of Polish archaeologists when considering a new research project. To them, there exists only one useful method of researching an area and this is the field-walking survey.

Let us have another look at the tabulation of the perceived advantages and disadvantages of field-walking and aerial survey by Polish archaeologists (72). From what has been said so far, the situation is paradoxical. Positive opinions on field-walking survey are as easily deniable as negative opinions on aerial survey, though the general attitude towards both methods remains unchanged. However,

I have been repeatedly asked to photograph this site or that – does this mean that attitudes are changing? The truth behind these questions, however, reflects a lack of fundamental knowledge about aerial survey and the nature of cropmarks and soilmarks (lack of knowledge is also an element of pre-understanding). The person asking the question has heard about aerial photography and theoretically recognises its usefulness. S/he is expecting spectacular results: fly over site X (at any time, the sooner the better), shoot some pictures and interpret them. S/he usually: 1) ignores the necessity of a preliminary analysis of archive photographs, 2) does not know anything about the crops on site X, 3) expects the photographs to be taken at the time convenient to her/him. The temptation is to refuse such proposals, but the opportunities to undertake aerial survey in Poland are so limited that any opportunity should be grasped. My experience tells me that in most cases neither cropmarks nor soilmarks will be visible on site X, but usually several other interesting sites will be revealed during the process. Nevertheless, what will the reaction of the contractor be? The method is 'no good' because pictures of her/his site revealed nothing, and negative opinions on aerial photography will be confirmed. Positive examples found in the vicinity of site X will not be taken under consideration. The vicious circle of expectations will be solidified: lack of knowledge → unrealistic expectations → disappointing results at high costs, at least with reference to a single site → the belief is strengthened that in Polish conditions aerial photographs are not effective → no need to deepen knowledge and so on. The same happens if an archaeologist decides to buy vertical photographs. The vicious circle looks the following way: purchase of archive photos (in Poland photographs cannot be viewed prior to purchase!) → lack of knowledge → unaided (always without a stereoscope) analysis of photographs (anyone can identify a site in a picture!) → disappointment → conclusion: Polish sites are not visible on aerial photographs → money has been wasted → there is no point in bothering with aerial photographs any longer. One should stick to the proven method of field–walking survey.

Hodder (1999, 40–50) identifies social structure among the types of pre-understanding in archaeology. This includes relations amongst archaeologists, the domination, distance and respect expected by archaeologists in the educational and research hierarchy. Is it realistic to expect that a person who does not acknowledge the benefits of aerial photography, but makes decisions about the allocation of funds for excavations projects, will ever think of allocating any amount at all to such aerial projects (see above)? Experience suggests this is doubtful and a good example is the motorway construction project in Poland. The archaeologists responsible for archaeological excavations within this programme totally ignored the potential of aerial photography (e.g. Maciszewski & Bukowski 1998; Bukowski 1999). Pre-understanding (alone?) is in this instance so strong that even obvious examples of positive aerial reconnaissance do not have an impact and the traditional role of field–walking survey is, in this context, unshakeable.

Establishment hierarchies also exert a powerful influence in scientific circles, where cultural-historical models dominate Polish archaeology. As it is widely believed that data gathered within the model represents the true image of the past, the introduction of any alternative models is doomed because it will be assumed false from the start. The same applies to survey methods. Taking this, and the hierarchical structure of Polish archaeology into account, it becomes obvious that new and original solutions and ideas will struggle to gain acceptance. Those at the top of the hierarchy have the knowledge of the past (within an uncritically accepted cultural-historical approach) and they are the only ones who can decide what is right and what is wrong. Unfortunately, disputes on new research studies never run in public and opinions are formed behind closed doors. It seems difficult to see how this situation will change (*cf.* Marciniak & Rączkowski 1991, 64-5). The structure in itself is perhaps not to blame; rather the way many social agents (partly formed in the totalitarian system) behave within it – since it is the society of researchers that constructs a situation in which people act (*cf.* Dobres & Robb 2000, 11). This method of wielding power demonstrated by social agents in Polish archaeology results in conventional thinking. 'Students' imitate their 'Masters' to be able to pursue their scientific careers. And in the context of this paper, their pre-understanding strengthens the myth that aerial survey is not applicable in Poland. Another vicious circle is created: 'Masters' know the truth and have power → in their opinion aerial survey is useless → 'Students' do not seek original solutions because it risks their careers → new generations of archaeologists continue the negative opinion of aerial photographs → 'Students' become 'Masters' and so on.

CONCLUSIONS

While there is great potential for aerial survey in Poland, the method is not fully exploited. Fundamental changes in Polish archaeology are needed for this method to find a more accepted place within the procedure of archaeological survey. One of the prerequisites is novel theoretical reflection on post-modern philosophy. This will enable the acceptance of pluralism in education, which will enrich our thinking about the past and at the same time various methods of survey will be accepted. Post-processual archaeology opens fields for many alternative images of the past, moving beyond the straight-jacket of researching and understanding the past in one, obligatory fashion any more.

We need spectacular discoveries to draw public attention (such as Insall's discovery of Woodhenge), as sites composed of pits alone do not generally excite the archaeological imagination. Summer 2000 (as well as 2003) was exceptionally conducive to revealing cropmarks in Poland, and while several new sites were discovered, the potential could not be fully exploited due to insufficient funding. Among the spectacular sites, those at Radojewice, comm. Dąbrowa Biskupia

(Czerniak *et al.* 2003), where a Brześć Kujawski's type settlement was recognised, can powerfully draw attention to the advantages of aerial photography. We need several discoveries such as in Radojewice and Jurkowo from different periods to fight the sceptical attitude of the majority of archaeologists.

Aerial photographs have huge interpretative and persuasive potential. If spectacular discoveries are made and are 'sold' in the right way, then conditions will appear for aerial archaeology to finally enter the consciousness of both the professional archaeologist and the public. Patient effort of archaeological conservators is necessary today to gradually build records of aerial photographs in the hope that at some point in the future they will be discovered by academic archaeology.

BIBLIOGRAPHY

Abramowicz, A. 1991 *Historia archeologii polskiej. XIX i XX wiek*, IHKM

Barford, P. 1998 Reflections of on the Leszno Aerial Archaeology School, *AARGnews* 17, 20-30

Barford, P. 2000 A bibliography of Polish aerial archaeology, *AARGnews* 20, 55-6

Bewley, R. 2000 Aerial survey in the Danebury Environs area, 1981-1997, in: Cunliffe, B. (ed.) *The Danebury Environs Programme. The Prehistory of a Wessex Landscape, vol. 1: Introduction*, English Heritage and Oxford University Committee for Archaeology, 20-9

Bielenin, K. 1962 Sprawozdanie z badań nad starożytnym hutnictwem świętokrzyskim w 1960 i 1961 r., *Materiały Archeologiczne* 4, 353-8

Bourdieu, P. 1977 *Outline of a Theory of Practice*. Cambridge University Press

Bradford, J. 1957 *Ancient Landscapes. Studies in Field Archaeology*, Bell & Sons

Brophy, K. 2002, Thinking and doing aerial photography, *AARGnews* 24, 33-9

Bukowski, Z. 1999 (quoted in discussion), in: Dworaczyk, M., Kowalski, K., Porzeziński, A., Słowiński, S. & Wilgocki E. (eds) *Acta Archaeologica Pomoranica, vol. II: Konserwatorskie badania archeologiczne w Polsce i w Niemczech - stan prawny, problematyka, osiągnięcia*, Stowarzyszenie Naukowe Archeologów Polskich, 237-8

Czerniak, L. 1996 Archeologiczne Zdjęcie Polski – co dalej?, in: Jaskanis, D. (ed.) *Archeologiczne Zdjęcie Polski – metoda i doświadczenia. Próba oceny*, MKiS, 39-46

Czerniak, L., Rączkowski, W. & Sosnowski, W. 2003 New prospects for the study of Early Neolithic longhouses in the Polish Lowlands, *Antiquity* 77, 297, http://antiquity.ac.uk/ProjGall/czerniak/czerniak.html

Dobres, M.A. & Robb, J.E. 2000 Agency in archaeology. Paradigm or platitude?, in: Dobres, M.A. & Robb, J.E. (eds) *Agency in archaeology*, Routledge, 3-17

Ebert, J.I. 1989 Techniques, Methods and Theoretical Goals in American Archaeological Remote Sensing: 'Predictive Modelling' as an Example, in: Kennedy, D. (ed.). *Into the Sun: essays in air photography in archaeology in honour of Derrick Riley*, J.R. Collis Publications, 86-101

Grygiel, R. & Bogucki, P. 1997 Early Farmers in North-Central Europe: 1989-1994 Excavations at Osłonki, Poland, *Journal of Field Archaeology* 24, 161-178

Hall, D. & Palmer, R. 2000 Ridge and furrow survival and preservation, *Antiquity* 74, 29-30

Hensel, W. 1968 W sprawie metody mikrogeograficznej w archeologii, *Sprawozdania z prac naukowych Wydziału Nauk Społecznych PAN* 3, 27-9

Hodder, I. 1985 Postprocessual Archaeology, in: Schiffer, M. (ed.) *Advances in Archaeological Method and Theory*, vol. 8, Academic Press, 1-26

Hodder, I. 1999 *The Archaeological Process: An Introduction*, Blackwell

Jaskanis, D. 1992 Polish National Record of Archaeological Sites, in: Larsen, C.U. (ed.) *Sites &*

Monuments. National Archaeological Records, Nationalmuseet Copenhagen, 81-7

Jaskanis, D. 1996 Próba oceny metody Archeologicznego Zdjęcia Polski na podstawie doświadczeń ogólnokrajowego koordynatora, in: Jaskanis, D. (ed.) *Archeologiczne Zdjęcie Polski - metoda i doświadczenia. Próba oceny*, MKiS, 9-38

Kempisty, A., Kruk, J., Kurnatowski, S., Mazurowski, R., Okulicz, J., Rysiewska, T. & Woyda, S. 1981 Projekt założeń metodyczno-organizacyjnych archeologicznego zdjęcia ziem polskich, in: Konopka, M. (ed.) *Zdjęcie archeologiczne Polski*, MKiS, 22-7

Kijowski, A. & Wyrwa, A.M. 1989 Fotointerpretacja i weryfikacja archeologiczna zdjęć lotniczych ze stanowiska nr 3 w Łeknie, *Studia i materiały do dziejów Pałuk* 1, 121-35

Kobyliński, Z. 1991 Theory in Polish archaeology 1960-1990: searching for paradigms, in: Hodder, I. (ed.) *Archaeological theory in Europe: the last three decades*, Routledge, 223-47

Kobyliński, Z. 1999 Siedemdziesiąt lat archeologii lotniczej w Polsce, *Światowit* 1 (nowa seria), fasc. B, 112-22

Kostrzewski, J. 1938 Biskupin: an early iron age village in Western Poland, *Antiquity* 12, 311-17

Kowalenko, W. 1938 *Grody i osadnictwo grodowe Wielkopolski wczesnohistorycznej (od VII do XIII wieku)*, Towarzystwo Prehistoryczne

Maciszewski, R. & Bukowski, Z. 1998 *Archeologiczne badania ratownicze. Poradnik inwestora*, Ośrodek Ratowniczych Badań Archeologicznych

Marciniak, A. & Rączkowski, W. 1991 The Development of Archaeological Theory in Poland under Conditions of Isolation, *World Archaeological Bulletin* 5, 57-65

Miałdun, J. 1995 O możliwości wykorzystania fotointerpretacji w badaniu stanowisk archeologicznych związanych ze środowiskiem wodnym, *Archeologia podwodna jezior Niżu Polskiego*, UMK, 115-39

Miałdun, J. & Świątek, B. 1993 Zdjęcia lotnicze jako źródło danych o obiektach archeologicznych na Żuławach Wiślanych, *Zeszyty Naukowe AR-T Olsztyn* 23, 75-88

Minta-Tworzowska, D. & Rączkowski, W. 1996 Theoretical traditions in contemporary Polish archaeology, *World Archaeological Bulletin* 8, 196-209

Miszalski, J. 1966 Środowisko geograficzne grodu wczesnośredniowiecznego w Chodliku w świetle interpretacji zdjęć lotniczych, *Fotointerpretacja w Geografii* 3, 5-17

Modrzewska-Marciniak, I. 1984 Próbna analiza fotografii lotniczych wybranych stanowisk archeologicznych, *Archeologia Polski* 29 (2), 267-89

Nowakowski, J. & Rączkowski, W. 2000 Refutation of the myth: new fortified settlement from Late Bronze Age/Early Iron Age in Wielkopolska region (Poland), *Antiquity* 74, 765-6

Nowakowski, J., Prinke, A. & Rączkowski, W. 1999 Latać czy nie latać?: zdjęcia lotnicze jako kolejny element standardowej procedury w ochronie stanowisk archeologicznych, in: Dworaczyk, M., Kowalski, K., Porzeziński, A., Słowiński, S. & Wilgocki, E. (eds) *Acta Archaeologica Pomoranica, vol. II: Konserwatorskie badania archeologiczne w Polsce i w Niemczech – stan prawny, problematyka, osiągnięcia*, Stowarzyszenie Naukowe Archeologów Polskich, 113-52

Okupny, B. 1998 Fotografia lotnicza w archeologii. Uwagi metodyczne, in Śmigielski, W. (ed.) *Nauki przyrodnicze i fotografia lotnicza w archeologii*, Muzeum Archeologiczne w Poznaniu, 215-44.

Ostoja-Zagórski, J. 1969 Możliwości wykorzystania fotointerpretacji w badaniach archeologicznych, *Fotointerpretacja w Geografii* 7, 93-8

Ostoja-Zagórski, J. 1998 Wykorzystywanie zdjęć lotniczych w interpretacji procesów osadniczych w pradziejach, in: Śmigielski, W. (ed.) *Nauki przyrodnicze i fotografia lotnicza w archeologii*, Muzeum Archeologiczne w Poznaniu, 203-14

Palmer, R. 1995 What an opportunity!, in: Kunow, J. (ed.) *Luftbildarchäologie in Ost- und Mitteleuropa*, Forschungen zur Archäologie im Land Brandenburg 3, Brandenburgisches Landesmuseum für Ur- und Frühgeshichte, 23-31

Palmer, R. 1996 Integration of air photo interpretation and field survey projects, *Archaeological Prospection* 2, 167-76

Pickering, J. 1980 Pickering's Piece – a comment column 'Interpretation versus Plotting', *Aerial Archaeology* 6, 50-2

Rajewski, Z. 1938 Sprawozdanie z organizacji badań w latach 1936 i 1937, in: Kostrzewski, J. (ed.)

Gród prasłowiański w Biskupinie w powiecie żnińskim: sprawozdanie z badań w latach 1936 i 1937 z uwzględnieniem wyników z lat 1934-1935, Instytut Prehistoryczny UP, 1-14

Rajewski, Z. 1975 Aerofotografia w badaniach terenowych w Polsce, *Wiadomości Archeologiczne* 39, 560-6

Rączkowski, W. 1995 Aerial Archaeology and the Study of Settlement Systems: some examples from the Middle Pomerania (Poland), in: Kunow, J. (ed.) *Luftbildarchäologie in Ost- und Mitteleuropa, ed. by J., Forschungen zur Archäologie im Land Brandenburg* 3, Brandenburgisches Landesmuseum für Ur- und Frühgeshichte, 265–70

Rączkowski, W. 1996 Aerial reconnaissance and field-walking survey: British and Polish reality, *AARGnews* 12, 16-17

Rączkowski, W. 2001 Science and/or art: aerial photographs in archaeological discourse, *Archaeologia Polona* 39, 127-46

Rączkowski, W. 2002 Beyond Technology: do we need 'meta-aerial archaeology'?, in: Bewley, R.H. & Rączkowski, W. (eds) *Aerial Archaeology – Developing Future Practice*, IOS Press, 311-327

Redfern, S. 1997 Computer assisted classification from aerial photographs, *AARGnews* 14, 33-38

Riley, D.N. 1987 *Air Photography and Archaeology*, Duckworth

Scollar, I. 1978 Progress in Aerial Photography in Germany and Computer Methods, *Aerial Archaeology* 2, 8-18

Shanks M. & Tilley C. 1987 *Social Theory and Archaeology*, Polity Press

Woyda, S. 1974 O pracach nad zdjęciem archeologicznym terenu Mazowsza i Podlasia, *Wiadomości Archeologiczne* 39 (1), 11-?

Żuk, L. 2002 *Interpretacja zdjęć lotniczych w archeologii i naukach geograficznych*, Instytut Prahistorii UAM Poznań (unpublished MA thesis)

Żuk, L. 2005 W poszukiwaniu Salomonowego rozwiązania, czyli o tym, kto powinien interpretować zdjęcia lotnicze słów kilka, in: Nowakowski, J., Prinke, A. & Rączkowski, W. (eds) *Biskupin ... i co dalej? Zdjęcia lotnicze w polskiej archeologii*, IP UAM, PTP

USING PHOTOGRAPHY IN ARCHAEOLOGY

Andrew Baines

INTRODUCTION

This paper is inspired by John Berger's 1978 essay *Uses of Photography* (reprinted in *About Looking* in 1980). Berger argues that photographs cannot stand alone, or speak for themselves, but must be placed in contexts where they contribute to temporal and social narratives. It seems to me that Berger's argument is of great relevance to the way photography is used in archaeology. Despite, or perhaps because of, their ubiquity, photographs are often used uncritically by archaeologists, and their potential as an interpretative tool through which ideas and concepts emerge, remains largely untapped.

Although photography is a ubiquitous recording tool in almost every kind of archaeological project, its use is mainly in recording the practical processes of field archaeology and as a source of raw images in areas such as field survey and aerial reconnaissance. Photography is seldom used as a primary tool in the more selective creation of archaeological data, this being the domain of graphic representation, and still less as an interpretative medium through which ideas emerge. For most archaeologists, photography is thought of as a secondary visual medium, one that captures or illustrates the unearthing of data or the explication of ideas, but does not participate in the interpretative process itself. Aerial photographs, for instance, tend to be thought of as a detached 'record' of what already exists, rather than as a practical means of intervention in the world through which ideas and categories emerge (Rączkowski 2002, 318). Perhaps the very familiarity of such photographs has bred contempt. Although there have been technical works on photography for the archaeologist for many years (e.g. Conlon 1973; Barker 1982, 160-72; Dorrell 1989), theoretically minded writers have been noticeably silent on the subject (but see Shanks 1997), despite a

growing critique of other graphic and pictorial techniques used in archaeology (Shanks 1992; Bradley 1997; Lucas 2001; Chadwick 2003). Here, I will consider how photography is used in archaeology, and I will try to point out facets of the kinds of photographs archaeologists take that cross traditional intra-disciplinary boundaries. I will then suggest ways in which photography might be more fully and honestly integrated into archaeological practice. Finally, and in the spirit of this volume, I will try to show how aerial photographs, perhaps the very epitome of impartial, impersonal 'record' shots, might be used interpretatively to draw ideas and narratives from their subjects.

PHOTOGRAPHY AS A SECONDARY MEDIUM

To understand the way photography is used in archaeology, we must first understand why photography, among representational media, occupies a unique position in the discipline; photography is at once everywhere yet it escapes our notice *as* a medium in the sense that the subject of the photograph is our concern, not the process through which the image was created. This is as true of the illustrative uses of photography as it is of its use as a primary recording tool. One reason for this might be that most of those taking pictures in archaeological situations are, first and foremost, archaeologists not photographers (although see Edmonds & Seaborne 2001 for a collaboration between an archaeologist and photographer). Although attention is given to the technical aspects of photography in some branches of archaeology (one thinks of aerial reconnaissance, for instance), in most cases it is enough to ensure that exposure and focus are within acceptable limits. For the most part, photography in archaeology is an extension of everyday 'snapshot' photography: the camera is used as a tool with little regard for underlying technical aspects. Contrast this with the painstaking attention to composition, lighting, exposure, depth of field and so on of so-called fine art photography or, more pertinently, to the effort required to learn and apply the skills required to produce archaeological drawings. These skills have little or no place in everyday life; consequently, their application is neither routine nor natural. One must concentrate when drawing a plan or section, and concentration serves to draw attention to the specialised nature of the activity.

Photography is now fully integrated into daily life, but it was not invented until the 1820s. Lightweight, hand-held cameras using light-sensitive paper rather than glass plates did not become available until the 1880s. Most antiquarian accounts from the early to mid-nineteenth century are illustrated with line drawings and etchings. Even in many late nineteenth-century publications, drawings and sketches predominate, partially as a result of the expense involved in reproducing photographs in print. As a result of photography's late arrival on the scene, archaeology was wedded to primarily graphic forms of representation

from the outset. Although photographs have now replaced perspective drawings and sketches for more informal illustrative purposes, graphic techniques derived from other disciplines still form the basis of recording on archaeological excavations. Contour maps, derived from cartography, depict the location and arrangement of sites at a large scale; plan and section drawings, derived from architectural illustration, show individual elements of excavations. Of course, these graphic techniques do not merely depict processes that exist independently of them. Rather, excavation techniques and recording techniques have grown up together – each serves to reinforce the other. Thus it is the case that many photographs taken on excavations are pictures of clean, level surfaces designed for two-dimensional recording (*79*). It is in other, less formal, aspects of excavation recording that photography has gained the most ground. Most excavation reports contain photographs of sites as they were when discovered or before excavation started, of features and finds at the moment of discovery and working shots showing digging actually under way. It is probably the character that photography has of appearing to show the world as it is that has prompted its use as a primary recording technique in those branches of archaeology that do not involve a direct intervention by the archaeologist, for instance aerial reconnaissance and field survey. Photography has also been used widely in recent approaches to landscapes that emphasise a subjective viewpoint, such as the 'phenomenological' archaeologies that have been fashionable since the mid-1990s (especially Tilley 1994). Photographs have been a primary illustrative technique for such accounts, probably because they seem to offer a human perspective on the world, in which the objectifying character of graphic representations is reduced. In photographs, subject and medium appear to merge. It is as though photographs were transparent, being merely windows onto a particular time and place.

This presumed transparency of photographic images with regard to the world, once lauded as the aim and ideal outcome of photographic practice, has more recently been challenged by the growth of a post-modern tendency in photography (Grundberg 1991). Photographs are no longer seen as simple representations of the real world, but as active creations of the photographer, themselves enmeshed in social relations. They are no more real or transparent that any other artwork. Yet photographs are so ubiquitous, so fully integrated into modern life that, in archaeology at least, they have largely slipped through the net of 'post-processual' critique. Archaeologists continue to treat the photographic medium as though it is transparent to the object, and the photographic image in archaeology has failed to assert itself as an *image*. There is no archaeological photography as such. Thus, the existence of normative elements in the photographs used in archaeology remains largely unexplored, and archaeologists continue to take photographs for granted.

79 A sequence of 12 images of the excavations at Claish Farm, Stirlingshire, in August 2001.
Copyright: Gordon Barclay

THE PHOTOGRAPHIC EYE

Photographic seeing

In the twentieth century, photographers stopped trying to reproduce the look of paintings. They began to view the world as a source of photographic images in their own right. Once photographs were present in all areas of life, what had previously been thought of as photographic distortions – those discrepancies between the world as it appears to the human eye and the photographic image

– were noticed and commented on less and less. Sontag argues that people began to think and to see photographically, to view the world as 'an array of potential images' (1978, 97). This habit of 'photographic seeing' has made the world as it is depicted in photographs appear normal. Early photographs have an exaggerated stillness, as their subjects were required to keep absolutely motionless in order to combat the blurring created by long exposures and slow emulsions. The faint ghosts of children and animals, who could not be cajoled or coerced into standing still, often populate nineteenth-century street scenes. Contrast this with present day images: despite an overall increase in sharpness resulting from advances in film and camera technology, photographs still contain distortions introduced by the camera. Movement blur, out of focus backgrounds and foregrounds, exaggerated or flattened parts of the subject caused by wide angle and long focus lenses, distorted perspective, all of these are present in modern photographs. The difference is that these distortions are now so common, so familiar to us through the use of photography in media of all kinds, that we no longer notice them. The habit of 'photographic seeing' also allows us to ignore the selective nature of photographs. Taking a picture is partly a process of inclusion and exclusion, and of *mise en scène* (Shanks 1997), the arrangement of elements in the camera's viewfinder.

The selective character of photography was incorporated knowingly into photographic practice quite early in its history. By the early decades of the twentieth century, photographers had begun to make territorial claims on the world of art, to shift perceptions of photography, from a mere record of the content of the world or a pale shadow of painting towards a separate art form with its own aesthetic. Although a reliance on the world of objects remained, aspects of selection and perspective particular to photography came to the fore. The world was not just a source of views to be passively captured, but through photography began to yield images of striking and surprising beauty. By using lighting, perspective, degrees of magnification and juxtapositions to which the human eye is unaccustomed, photographers began to create an alternative world of angles, surfaces and textures, often drawn from the most mundane of objects. According to Weston (1980), photographs are the realisation of images composed in the mind of the photographer. What is in front of the camera becomes a 'nominal subject', subordinated to the aesthetic of the photograph itself.

The emphasis on the primacy of the subjective view, as part of a straight-forwardly modern approach has, predictably, been subject to more recent post-modern critique. On the latter view, photographs are not simply represen-tations of an exterior world, however distorted or selective. For postmodernists, representation is all there is (e.g. Baudrillard 1985). Photography cannot any longer be regarded as a kind of dialogue with a world of objects; rather it is itself the act of creating an entirely new object, the photograph, with its own internal coherence (Edwards 1989). However, this obsession with surface representation in photography draws attention away from, even denies, the processes that

give rise to photographs in the first place. Photographs embody a connection between the material world and its representation through the optical and chemical processes of the medium. As such, they contain a physical trace of their subjects in a way that other pictorial forms do not. While we must recognise that photographs are not transparent to the world, they can be used to depict it in new ways, from uncommon viewpoints, without losing the sense photographs give us of 'being there'.

Time and photography

It is often said that photographs capture 'frozen moments', the implication being that whatever forms the subject of a photograph is shown as it was at a particular, timeless instant. However, photographs always involve exposures that take time. They therefore encapsulate duration, however short. As we have seen, this temporality was obvious in early photographs, which were either exaggeratedly still or uncontrollably kinetic. It is less apparent in modern photographs, which make use of fast emulsions and short exposure times. These technological advances create the illusion of time arrested. They present things captured at a temporal scale that was once unfamiliar, indeed awe-inspiring. It is easy to forget that before Muybridge's pioneering photographs of the 1870s people had never seen objects halted in mid-air, or people and animals captured mid stride. We have become accustomed to the short fragments of time that photographs offer to us. Through seeing photographically we are able to accept images of things abstracted from the contexts of motion and change that normally enfold them. Indeed, there are many events that we remember through the photographic images associated with them, in which the particular effects of photographic duration form a central part of our memories. There are images of famous sporting events, for instance, in which the ball is forever frozen on its way to the goal, or the athlete extended as a blur along the track. Similarly, there are photographs of disaster or war zones in which buildings are suspended mid-fall, people are frozen between life and death. We know how to read such images, and do not mistake the effects of duration for distortions of the physical world itself. It is only when we see photographs of ourselves or those close to us that we become aware of the temporality of photographs. Faces appear static and unfamiliar, lacking habitual expressions that are played out over durations longer than that of the camera's shutter speed.

As well as seeming to stop time, photographs also have the ability to make things appear timeless. Images of things otherwise enmeshed in ongoing processes and relations can be used to abstract them from their immediate context, so that they may be endlessly recontextualised in new situations. This is how things subject to decay can be made to appear timeless – it is the sense of decay arrested that lends things romance. They become ruins (Shanks 1997, 89). Through photography, a veneer of classical, romantic beauty may be lent to anything, even things usually thought of us unbeautiful or unremarkable. Such

photographs are engaged in what Sontag calls 'antiquing reality' (1978, 80). This aesthetic of timelessness has been naturalised within photographic practice, and may be seen in all kinds of archaeological photographs. Attempts to restore a living context to monuments are, ironically, often undermined by presenting them through the visual language of photographic romanticism, as ruins. This view is very much of the present, as it shows a decayed past which is over and done. The idea of photographs as records ignores the workings of temporality: it assumes that the essence of things can be captured in an instant and that processes played out in time are irrelevant.

ASPECTS OF ARCHAEOLOGICAL PHOTOGRAPHY

Photography has attracted the notice of theorists almost since its invention, but little attention has been paid to photographic theory in archaeology. Although archaeologists use photographs in a largely unreflexive way, the specific charac-teristics of photography in archaeology are discernible. Here, I will try to draw out some themes in archaeological photography. I will use some general examples drawn from specific areas of photographic practice in archaeology, but the themes discussed cut across the various branches of archaeology.

Recording/illustration : representation/evidence

Perhaps the most basic mode in which photography features in archaeology is as a tool of primary record. In all areas of archaeological fieldwork, cameras are used to capture images of features as they emerge or are discovered. Many of these images will receive little further attention, other than being placed in an archive. Some will be referred to later as evidence in the process of interpreting a site, landscape or other material formation. A still smaller number of images will be used to illustrate the final presentation, either in printed form or as images used to accompany lectures. How do we accomplish this gradual reduction in the numbers of images deemed relevant at each stage of the archaeological process? Clearly, a change in status is involved. This involves a movement from raw, unselected images to those chosen for a particular purpose. This purpose is often a mobilisation in support of an argument, which constitutes a movement from data to evidence. The transformation of data into evidence is accomplished to different degrees in different branches of archaeological photography. At one extreme, aerial photographs, although targeted on particular sites and features, by their nature tend to be difficult to control. They invariably and unavoidably include parts of features other than the ones forming the ostensible subject of the photograph (Cowley 2002), features as yet unidentified as archaeological, natural features and bits and pieces of the modern landscape. Some of these modern features are necessary, control points for potential mapping, a purely functional element of the image. Others are viewed as irrelevant, and are barely noticed.

Often, however, elements of photographs regarded as extraneous at the time they were taken attract interest as prevailing interpretations change, and it is therefore possible for what is considered the most interesting element of, and therefore the subject of, a photograph itself to vary over time (*ibid.*). Aerial photographs maintain their status as data, never entirely making the transition to evidence, for one never knows what one will find in them. At the other extreme are photographs specifically intended as illustrations (and see Palmer this volume). One may find such photographs in publications synthesising the archaeology of a particular region or period or outlining a particular theoretical or practical approach. There are even a few 'coffee table' books in which photographs of sites and monuments are the central element. Illustrative photographs of this kind are mobilised entirely in support of a narrative. As such, control is exercised over technical aspects such as focus, depth of field, contrast and especially the distorting effects of long and short focal length lenses, which render the subject more or less visually dominant within the frame. Framing is also used selectively, in order to include elements supportive of the argument being advanced and to exclude those that might undermine it.

Excavation photographs are particularly interesting with regard to their status as evidence. Although photographs are taken of entire excavations at important junctures, from the beginning of their careers field archaeologists become accustomed to hours of towelling, cleaning and tidying in preparation for them Such photographs do not depict a site as a work in progress, something that is brought into being by archaeology as a 'materialising practice' (Lucas 2001, 212). By eliminating every trace of humdrum archaeological practice (tools, spoil heaps, diggers), the site may be presented as something found rather than made. In other words, the site is presented as data. This process also happens on a smaller scale, when photographs are taken of individual features of the site. Again, objects used in the excavation of features and contexts are removed or excluded from the frame, as are the people responsible for their production. Thus, features and contexts are presented as having merely been uncovered, discrete fragments of the past existing independently of the archaeological process. Benjamin (1973), describing Atget's photographs of empty Paris streets, likens them to scene of crime photographs, deserted scenes photographed for the purposes of establishing evidence. There is also something of this about excavation photographs. They are produced as evidence of things that have happened. They present features and contexts as fixed and timeless arrays of objects, but in reality they exist only briefly, before they are covered up once more or excavated away. That the surfaces depicted in excavation photographs are unnaturally flat and clean, lacking the texture that photography can reveal, should alert us to the possibility that they are the product of archaeological practice. Such photographs seek to present the relation between the past and its traces, while hiding the archaeological practices through which these traces have emerged. To accept these images, often incomprehensible to non-archaeologists, as representations

of a past reality rather than the product of the archaeological process requires a kind of photographic seeing particular to archaeologists. The ability to read these images, to see them as natural, is acquired as part of the process of becoming an archaeologist.

Photographs and reality

The relationship between data and evidence in archaeological photography is not co-extensive with that between record and illustration. Photographs are made in relation to a background of ideas, and they embody a certain perspective. Why, then, do we accept them as fragments of reality where we would be less accepting of a drawing or text description? The answer to this question may be sought partially in the habit of photographic seeing. So familiar are photographic images, and so widely are they accepted as fragments of reality rather than partial representations of it, that this everyday practice is transferred to archaeology without question. The way photography is used in archaeology also contributes to its realism. Whether in excavation reports, more general texts or public presentations, photographs partake of a particular brand of archaeological empiricism. This does not involve the quantitative methods of the new archaeology, but a more subjective sense of 'being there'. To doubt what one is shown in a photograph, in an excavation report or lecture, is to doubt the evidence of one's own eyes. In this way, photographs sidestep suspicions of selection or (ironically) subjective bias, which may be held about graphic means of representation (see Rączkowski 1999). That photographs are often fussy, rich in detail, is an asset: it helps to convince the viewer that nothing has been deliberately obscured or left out. As Szarkowski (2003, 100) notes, the function of the photograph is to privilege realism over clarity. Photographs become a particular kind of evidence: rather than evidence that is obviously constructed, archaeological photographs, with all their excess of information, appear to speak to us *directly*. In so doing, they make a further transition, from evidence to *testimony*.

Photographs forge a link between subject and object, viewer and view, and their realistic effect remains very much tied to the subjective viewpoint. Archaeological photographs are usually human in scale, the effect being like a temporarily abandoned room, with all of its constituent objects still in place. This may explain the rather different effect of aerial photographs, in which the distant viewpoint places a human presence, past or present, beyond the scope of vision. The flatness of aerial photographs also allies them to the a-temporal, two-dimensional perspective of maps rather than the inherently temporal 'frozen moment' created by the hand-held camera. This quality of distance encourages a perception of aerial photography as a technical exercise akin to the production of scale drawings, and they are seldom used in interpretative archaeologies that exploit a subjective viewpoint. I will question this perception in the following section.

Reality, then, as it is presented in most archaeological photographs, is of a particular kind, a subjective, grounded viewpoint. Considerations of the kinds of viewpoint, broadly defined, adopted by archaeology have concentrated on a critique of the distanced, aerial view (Thomas 1993; Tilley 1994, 3). The subjective viewpoint has become a norm, an unquestioned way of presenting the world. Yet, as we have seen, such photographs involve both exclusion and distortion, as well as a lesser or greater degree of obliquity. To be accepted unquestioningly as approximating the norms of reality, the viewpoint employed in archaeological photographs must mesh not only with that of day-to-day reality (the 50mm lens on 35mm cameras is often referred to as a 'normal' lens as it gives an angle of view which approximates that of human vision). More importantly, it must be congruent with viewpoints familiar from the wider context that photography itself provides. So, we are accustomed to seeing photographs in which the subject, perhaps a standing stone or other megalithic monument, is photographed in wide angle, looming large in the foreground and dominating other areas of the frame. Or the subject may be placed to one side of the frame, according to the rules of harmonious composition. The point is that such viewpoints are specific to a practice of visual representation identifiable to a particular visual practice, that of post-medieval western art. Yet this practice does not simply govern the depiction of fragments of the past, but affects our view of the past itself, and subjugates it to the constraints of pictorial representation. It becomes difficult to bring to mind certain sites and monuments without also recalling a certain, photographic viewpoint, or to experience them without looking at them in this way.

Text and sequence

Photographs are seldom presented alone. Although we expect them to speak for themselves as testaments to reality, their testimony is ordered and directed by association with a text. The most basic association between photograph and text involves a caption. Captions summarise the content of a photograph in such a way as to direct how the viewer approaches it. They draw out the elements that are necessary for a particular argument or narrative and place a photograph within the timescale of a narrative account such as an excavation report. References are also made to photographs from within archaeological texts, usually in order to emphasise particular points. Photographs are also used where prose descriptions and graphic representations are inadequate, or where the descriptive content exceeds the scope of other visual media. Placing text around photographs is the way that they are most effectively pressed into service in archaeology. Photographs offer the ability to lift the traces of events from one context, the situation in which the things depicted actually existed, and to place them in another, the narrative construction of the text (Berger 1980, 55). Text at once directs and controls the meaning of photographs, at the same time drawing on their testimony to the reality of the scenes depicted.

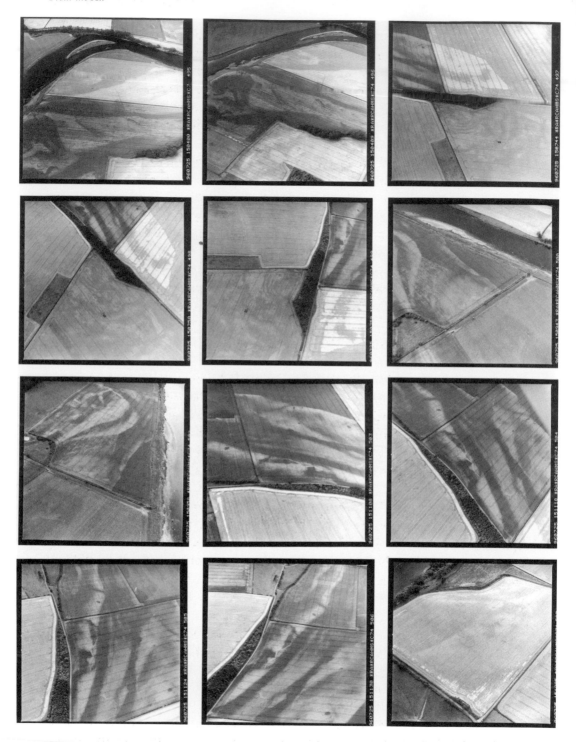

80 A sequence of 12 images from a sortie on 25 July 1996 along the River Tweed between Kelso and Coldstream, recording cropmark sites including settlement remains, a fort and a four-post setting. *Crown Copyright: RCAHMS, C74495 − 500, C74502-507*

Relationships may also be established *between* photographs by placing them in a sequence. Usually, in archaeology, the sequence in which photographs are placed follows the structure of the narrative with which they are associated. For instance, phenomenological accounts often use sequences of photographs to illustrate the different views experienced when moving across a particular landscape (e.g. Tilley 1994, 160-5). Similarly, excavation photographs are sequenced so as to mirror visually the process of excavation (*79*). Placing photographs in sequence, then, has an inherently temporal quality. One is apt to read sequences of photographs like a film, as a succession of fragments of reality or memories. However, there is no guarantee that the photographs used thus were actually taken in the order they are presented – the sequencing of photographs involves the *construction* of a narrative. Although aerial photographs are often available to the researcher in sortie order, they are almost never presented as a sequence in published accounts, nor are multiple images of the same site presented to the viewer. Images are selected, decontextualised and pre-interpreted (*80*).

SOME EXAMPLES: SUBVERSIVE AERIAL PHOTOGRAPHS

So far, I have presented a critique of the use of photography in contemporary archaeology. It is not my intention, however, to suggest that the use of photography is irretrievably compromised or, indeed, that it has not been used to positive effect. The photographs in Christopher Tilley's work, in particular, make this point eloquently (e.g. Tilley 1994). For me, Tilley's photographs are interesting because they do not rely on the conventions of landscape photography to make their point. Their subjects are not immediately apparent, and the eye does not rest naturally on any particular feature. Instead, the photographs achieve their effect by establishing a relationship between image and text, in the form both of the caption and the main body of the work. I think that this is an honest relationship. By this, I mean that the photograph functions as neither data nor evidence: Tilley does not use it as a fragment of reality on which his argument is based, neither does it merely reinforce and augment his prose description. Instead, the photograph works alongside other facets of the work, the text and its place in the sequence of images, to *generate* a narrative about monuments and landscape (with the book described on back cover as 'an extended photographic essay' (*ibid.*)). Tilley's photographs represent the landscape not by using pre-constructed meanings carried by familiar visual cues, but as problems to be resolved, mysteries to be explored. As Ingold (2000, 208) argues, 'meaning is there to be discovered in the landscape … every feature … is a potential clue, a key to meaning rather than a vehicle for carrying it'. Photography plays its part in this process, offering the relationship between picture, caption and text as one possible solution.

It seems to me that aerial photographs share with images like Tilley's a people-less emptiness, and can only be drawn into narratives and interpretations

on a human scale in association with a caption or text. Of course, most aerial photographs are taken *of* something (usually an archaeological site or its traces), and do not exist outside of the selective processes of photography in general, or of the categories and narratives of archaeological discourse in particular. Nevertheless, I also think that the aerial viewpoint is unjustly maligned in favour of the grounded, subjective viewpoint within interpretative archaeology. I think that valuable narratives can be drawn from aerial photographs over and above their role in the identification and classification of sites. The aerial view undercuts many of the sedimented archaeological perspectives that we assume are natural; one is suddenly placed at a great distance, partially freed from the constraints of the subjective viewpoint. From the air, we can view the relations between sites, see the patchwork of relations woven into the landscape over time. As with Tilley's images, there is an implicit temporality in aerial photographs that, in association with text, can subvert the frozen moment. In order to explore this perspective, the remainder of this section offers two extended captions to existing photographs, which aim to set them in an interpretative narrative context.

Winterbourne Stoke crossroads barrow cemetery

In my view, perhaps the most extraordinary aerial views of any British archaeological site are those of the barrow cemetery at Winterbourne Stoke crossroads, Wiltshire (*81*). Construction of barrows at the site began, in the Neolithic, with a long barrow. During the Bronze Age, a bewildering array of barrows of various kinds (usually classified as bowl, bell, disc and pond barrows) was constructed on and to either side of the longitudinal axis of the long barrow. Secondary burials were placed in the long barrow during the Bronze Age. Burials were also recovered from all of the round barrows except the pond barrows, which seem to have formed some kind of recessed surface for cremations and other funerary practices. Barrett (1994, 127) argues that the construction and reuse of barrows at cemeteries like this resulted in the construction of lines of genealogical identity, linking mourners and the recently dead to distant and semi-mythical ancestral figures.

I came across this aerial photograph during my first year as an archaeology undergraduate. I found it to be the most striking archaeological illustration I had seen. The barrows at Winterbourne Stoke appear almost to be eruptions from the ground itself rather than artificial mounds, and the pond and disc barrows look for all the world like craters left over from some long forgotten impact. The scene resembles a fragment of the moon's surface, somehow transported to the corner of a field in rural south-west England. This essentially static scene is lent a sense of dynamism by the perspective of the aerial photograph. The long barrow makes an arrow or pointer, establishing an axis from south–west to north–east, along which round barrows proliferate in ever more diverse forms. It seems to me a fair bet that a viewer with no knowledge or experience of

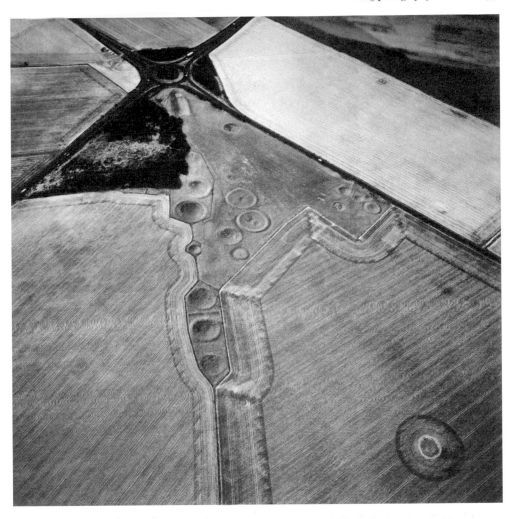

81 Aerial view of the Winterbourne Stoke barrow cemetery. 15205/07. © *Crown copyright. NMR*

British prehistory would still be able to construct a temporal narrative about the site on the basis of this photograph, such is its sense of dynamism. Features of the modern landscape also contribute to the impact. The edges of the ploughed fields surrounding the site weave around and between the barrows, creating a striking and graphic effect. Two modern tarmac roads run to either side of the site, both enclosing it and separating it from the rest of the mundane landscape. Finally, the traffic island at the junction where the roads meet lies on the same axis as the cemetery itself, and seems to form its figurative end point, a full stop to the flow of movement and of prehistoric time.

Although the photograph itself represents a split second in the continuing history of this group of barrows, it has an implicit temporality. The arrangement of the barrows suggests a process of addition and change lasting many hundreds

of years, but it also embodies practices with much shorter timescales, such as the deposition of individual burials and movements around the barrows. The photograph also depicts at a glance the continued existence of the barrows within the modern world, and the way that the modern landscape has wrapped itself around the site. The photograph is able to do this precisely because its viewpoint is not a grounded one that implies the subjective outlook of a single individual. Rather, the aerial viewpoint, in failing to present an immediately familiar view of the world, encourages the viewer to think about the photograph, to reflect on the processes that gave rise to this extraordinary place and the possible encounters people might have with it in ways that would not have been possible in relation to a photograph taken from a single point within the site. In many ways, the photograph presents a more rewarding experience than visiting the site itself. Some time after first seeing the photograph, I was able to visit Winterbourne Stoke. I experienced a sense of disappointment. The variations between the different kinds of barrow, so clear in the photograph, are far less apparent on the ground. Their once-sharp outlines have been blunted by millennia of erosion, vegetation growth and grazing; what once were shining chalk monuments are now dull green mounds in the corner of a field. Although the photograph does not necessarily show us more than we may see on the ground, or may learn from excavation, it introduces the possibility of thinking about space and temporality in the history of the site in ways that a more grounded experience might not provoke.

The Keiss brochs

This aerial photograph (*82*) depicts two of three brochs that lie close to the village of Keiss in Caithness in northern Scotland. Brochs are monumental dry-stone roundhouses, built between the second half of the first millennium BC and the first half on the first millennium AD. They are emblematic of the Atlantic Iron Age, perhaps the most intensively studied era in Scottish later prehistory, and as such have been subject to intensive arguments over their definition, function and meaning in recent years. This is not the place to delve into this debate at any length; suffice to say that it has been more about how brochs may be characterised and interpreted as a class of monuments, and less about how our understanding of them might be affected by the local circumstances in which they are found (Baines 2003). The two sites in the photograph form part of a group of three brochs that has been the subject of periodic attention over the years (MacKie 1971; Heald & Jackson 2001), especially on the subject of why three monumental buildings, generally assumed to be implicated in structures of control over people and land, should have been constructed within a few hundred metres of one another (*ibid.*). I have considered this issue myself in previous research, and have used the photograph to illustrate it (Baines 2000, 251). Rather than becoming enmeshed in this question here, I want to explore instead how the photograph might help us to generate ideas about these buildings that subvert, or at least sidestep, the usual arguments.

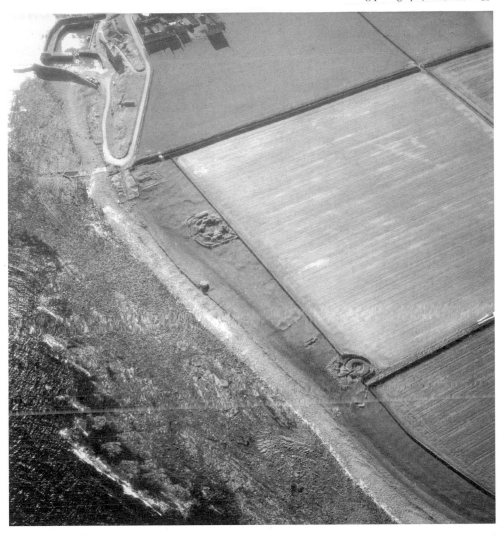

82 Aerial view of the Keiss brochs, Caithness. *Crown Copyright: RCAHMS, B49632*

I want to suggest that brochs might be understood as defined not only in relation to their status as members of a group or class of sites defined by the presence or absence of architectural traits (the classic typological approach), none of which are really visible in the photograph, but also in their relations with the surrounding landscape. The photograph makes this point eloquently – the two sites are set within a landscape defined by the boundaries between land and sea, present visually as a series of bands running diagonally across the frame – the open sea itself, the rocky foreshore, the boulder beach, a strip of grassy pasture on which the brochs themselves sit, itself defined by a dry stone wall forming the boundary of cultivated land. Behind this, modern field boundaries run perpendicularly away from the beach, setting up an immediate tension between

the squared-off enclosures of the tamed, domestic landscape and the serpentine strata of the shore. The agricultural landscape has, without doubt, been subject to immense change since the time when the brochs were built and occupied (this is evident in the photograph from the extension of ridge and furrow beyond the current boundary of the fields and the faint traces of post-medieval farm buildings). Nevertheless, the photograph shows us that the brochs must always have been situated at the very edge of the agricultural landscape, at the boundary of the everyday domestic world. Indeed, many brochs elsewhere in Caithness are situated in similarly liminal positions.

In comparing brochs to more recent, more familiar, agricultural settlements, then, we tend to downplay or overlook this curious liminality, since in the familiar domestic world settlements are usually located at the heart of the land with which they are associated. Thinking about the photograph introduces the possibility of a radically different way of ordering the domestic landscape, where the human presence lies at the edge rather than the centre. It is conceivable that people in the Iron Age in Caithness lived in a world where the routines of tilling the soil, nurturing crops and animals were thought of as a timeless, fundamental essence, the spiritual and conceptual core of human life. By contrast, relations between people, both within and between social groups, as materialised by the complex, hierarchical architecture of the brochs and the spatial relations between them, may have been conceived of as unpredictable and capricious. Social relations may have been situated, both conceptually and physically, at the edges of the human world, on the margins of uncontrollable nature represented, for example, by the sea. In such a context, it may have been eminently appropriate for brochs to be placed close to one another but outside the ambit of the agricultural landscape, in a place where the ebb and flow of relations between them would be controlled and its tensions and stresses dissipated.

CONCLUSION: USING PHOTOGRAPHY IN ARCHAEOLOGY

I have tried in this paper to identify some of the aspects of photography that are specific to archaeological subjects, but which may be set against the background of a wider photographic practice. There is little critical literature on the use of photography in archaeology, and as a result my discussion has drawn on more general photographic sources. I have also discussed two existing aerial photographs, in order to show how photographic practice that illuminates, undermines or diverges from an uncritical, normative archaeological photography might be possible. I do not wish to suggest that such readings of aerial photographs may be viewed as yielding archaeological data in themselves. I do, however, think that photographs may be more closely integrated with the other practices through which archaeological ideas and concepts are generated and expressed, rather than mere representations or illustrations of them.

I want to conclude with some general remarks and suggestions about ways in which we might use photography differently in order to make a more explicit contribution to archaeological practice. Perhaps the most important point I have tried to make in this paper is that photography *is itself* a practice. That is, it does not passively record or capture parts of the world or images of things, but generates images. This is as true of the most unselfconscious snapshot photograph as it is of the most contrived advertising image. Although photographs are, of course, causally related to the physical world through the chemistry and physics of photography, the photographer exercises choice at all stages of the process, and is able to depict the world as they wish. Photographs are therefore an integral part of archaeological practice, its processes of justification and narrative construction, not a dispassionate source of data. It is my contention that we should embrace photography as a practice for making images through which ideas and narratives about the past emerge. This means engaging in what Shanks (1992; 1997, 73-4) calls 'photowork', an 'act of cultural production' embodying both creativity and critique. As I suggested in relation to the aerial photographs, photographs need not merely illustrate our narratives of the past, but can be used to tell them. We can use photographs creatively, not merely content to reproduce the familiar subjective viewpoint of mundane images, but making use of varied angles of view, human figures, photographic effects like motion blur, time- and multiple-exposure and artificial colour and lighting, as well as photomontage (Shanks 1992, 188-90). Aerial photographs provide one such source of changed perspective (e.g. stereo pairs), and there seems no reason why they cannot be a primary source of archaeological narratives.

Visual effects are becoming ever more widely available as a result of the expansion of digital photography over recent years. Far from representing a threat to the integrity and truthfulness of photographs, digital techniques offer unlimited prospects for the creative use of images in archaeology. A sense of narrative and temporality may be achieved within the frame of a photograph, as I have argued for my aerial examples. But powerful narrative effects can also be achieved by combining photographs and text. To return to where we began, with Berger's point, we should not be content to let photographs illustrate our texts, but should use the written word to create a context within which our photographs are true to the kinds of narrative about the past which we aim to create. Image and text can support and inform each other. Indeed, instead of simply using photographs to punctuate and add verisimilitude to textual narratives, we can use combinations and sequences of photographs to tell our stories (for an example of entirely photographic narratives see Berger & Mohr 1995). We all have the ability to read temporality into images. By combining sequences of images with different kinds of viewpoint, framing and magnification, we may be able to generate new ways of looking at the world, and perhaps get a little closer to understanding other ways of being.

BIBLIOGRAPHY

Baines, A. 2000 *An Archaeology of Iron Age Domestic Settlement in Northern Scotland,* Unpublished PhD thesis, University of Glasgow

Baines, A. 2003 The inherited past of the broch: on antiquarian discourse and contemporary archaeology, *Scottish Archaeological Journal* 24, 1-20

Barker, G. 1982 *Techniques of Archaeological Excavation,* (second edition), Batsford

Barrett, J.C. 1994 *Fragments from Antiquity: An Archaeology of Social Life in Britain, 2900-1200 BC,* Blackwell

Baudrillard, J. 1985 *The Ecstasy of Communication, Postmodern Culture,* Pluto

Benjamin, W. 1973 The work of art in the age of mechanical reproduction, in: *Illuminations,* edited with an introduction by Arendt, H., Fontana

Berger, J. 1980 Uses of photography, in: Berger, J. *About Looking,* London Writers and Readers, 52-67

Berger, J. & Mohr, J. 1995 *Another Way of Telling,* London Writers and Readers

Bradley R. 1997 To see is to have seen. Craft traditions in British field archaeology, in: Leigh Molyneaux, B. (ed.) *The Cultural Life of Images: Visual Representation in Archaeology,* Routledge, 62-72

Chadwick, A. 2003 Post-processualism, professionalization and archaeological methodologies. Towards reflective and radical practice, *Archaeological Dialogues* 10.1, 97-117

Conlon, V.M. 1973 *Camera Techniques in Archaeology,* J. Baker

Cowley, D.C. 2002 A case-study in the analysis of patterns of aerial reconnaissance in a lowland area of southwest Scotland, *Archaeological Prospection* 9, 255-65

Dorrell, P. 1989 *Photography in Archaeology and Conservation,* Cambridge University Press

Edmonds, M. & Seaborne, T. 2001 *Prehistory in the Peak,* Tempus

Edwards, S. 1989 Snapshooters of history: passages on the postmodern argument, *Ten.8,* 32

Grundberg, A. 1991 The crisis of the real: photography and postmodernism, in: Younger, D. (ed.) *Multiple Views,* Museum of New Mexico Press

Heald, A. & Jackson, A., 2001 Towards a new understanding of Iron Age Caithness, *Proceedings of the Society of Antiquaries of Scotland* 131, 129-47

Ingold, T. 2000 *The Perception of the Environment: Essays in Livelihood Dwelling and Skill,* Routledge

Lucas, G. 2001 *Critical Approaches to Fieldwork: Contemporary and Historic Archaeological Practice,* Routledge

MacKie, E.W. 1971 Continuity in the Iron Age for building traditions in Caithness, in: Meldrum, E. (ed.) *The Dark ages in the Highlands – Ancient Peoples, Local History, Archaeology,* Inverness Field Club, 5-24

Rączkowski, W. 1999 Power of image: some ideas on post-processual aerial archaeology, *AARGnews* 19, 10-14

Rączkowski W. 2002 Beyond Technology: do we need 'meta-aerial archaeology'?, in: Bewley, R.H. & Rączkowski, W. (eds) *Aerial Archaeology – Developing Future Practice,* IOS Press, 311-27

Shanks, M. 1992 *Experiencing the past. On the character of archaeology,* Routledge

Shanks, M. 1997 Photography and archaeology, in: Leigh Molyneaux, B. (ed.) *The Cultural Life of Images: Visual Representation in Archaeology,* Routledge, 73-107

Sontag, S. 1978 *On Photography,* Penguin

Szarkowski, J. 2003 Introduction to the Photographer's Eye, in: Wells, L. (ed.) *The Photography Reader,* Routledge, 97-108

Thomas, J. 1993 The politics of vision and the archaeologies of landscape, in: Bender, B. (ed.) *Landscape: Politics and perspectives,* Berg, 19-48

Tilley, C. 1994 *Phenomenology of Landscape: Places, Paths and Monuments,* Berg

Weston, E. 1980 Seeing photographically, in: Trachtenberg, A. (ed.) *Classic Essays on Photography,* Leete's Island Books

INDEX

If you are interested in purchasing other books published by Tempus,
or in case you have difficulty finding any Tempus books in your local bookshop,
you can also place orders directly through our website

www.tempus-publishing.com